What Painting Is

What Painting Is

How to Think about
Oil Painting,
Using the
Language of
Alchemy

James Elkins

Routledge
New York • London

Published in 1999 by
Routledge
29 West 35th Street
New York, NY 10001

Published in Great Britain by
Routledge
11 New Fetter Lane
London EC4P 4EE

10 9 8 7 6 5 4 3 2 1

Library of Congress Cataloging-in-Publication Data

Elkins, James, 1955–
 What painting is / James Elkins.
 p. cm.
 Includes bibliographical references and index.
 ISBN 0-415-92113-9
 1. Painting. I. Title.
 ND1135.E44 1998
 750'.1'8—dc21 98-14702
 CIP

To my father
with thanks for:

Cornus, Tyrranus, Catocala, Lamnia, Polistes, Bombus,
Spirogyra, Acer, Salix, Carya, Fraxinus, Quercus, Boletus,
Caprinus, Lycopodium, Ranunculus, Rudbeckia, Samia,
Culex, Argiope, Photinus, and all the Ichneumonidæ.

Wer lange lebt, hat viel erfahren,
nichts Neues kann für ihn auf dieser Welt geschehn.
Ich habe schon, in meinen Wanderjahren,
kristallisiertes Menschenvolk gesehn.

(There is nothing new on earth
For a person who lives long and experiences much.
In my years of youthful wandering
I have seen crystallized people.)

— Goethe, *Faust* II. ii. 36 (6861–6864)

Contents

Color Plates

All color plates except PLATE 8 are by the author.

1 Sassetta, *Madonna and Child,* detail. c. 1435. National Gallery of Art, Washington.

2 Claude Monet, *Artist's Garden at Vetheuil,* detail. 1880. National Gallery of Art, Washington.

3 Jean Dubuffet, *The Ceremonious One,* detail of left flank. 1954. National Gallery of Art, Washington.

4 Alessandro Magnasco, *Christ at the Sea of Galilee,* detail. c. 1740. National Gallery of Art, Washington.

5 Jackson Pollock, *No. 1, 1950 (Lavender Mist),* detail of lower left center. National Gallery of Art, Washington.

6 Claude Monet, *Rouen, West Façade, Sunlight,* detail of clock. 1894. National Gallery of Art, Washington.

7 Rembrandt van Rijn, *Self-Portrait,* detail. 1659. National Gallery of Art, Washington.

8 Emil Nolde, *Autumn Sea XVIII,* entire. 1911. Stiftung Ada und Emil Nolde, Seebüll, Germany.

Introduction

WATER AND STONES. Those are the unpromising ingredients of two very different endeavors. The first is painting, because artists' pigments are made from fluids (these days, usually petroleum products and plant oils) mixed together with powdered stones to give color. All oil paints, watercolors, gouaches, and acrylics are made that way, and so are more solid concoctions including pastels, ink blocks, crayons, and charcoal. They differ only in the proportions of water and stone—or to put it more accurately, medium and pigment. To make oil paint, for example, it is only necessary to buy powdered rock and mix it with a medium, say linseed oil, so that it can be spread with a brush. Very little more is involved in any pigment, and the same observations apply to other visual arts. Ceramics begins with the careful mixing of tap water and clay, and the wet clay slip is itself a dense mixture of stone and water. Watery mud is the medium of ceramists, just as oily mud is the medium of painters. Mural painting uses water and stone, and tempera uses egg and stone. Even a medium like bronze casting relies on the capacity of "stone"—that is, the mixture of tin, lead, copper, zinc, and other metals—to become a river of bright orange fluid.

So painting and other visual arts are one example of negotiations between water and stone, and the other is alchemy. In alchemy, the Stone (with a capital S) is the ultimate goal, and one of the purposes of alchemy is to turn something as liquid as water into a substance as firm and unmeltable as stone. As in painting, the means are liquid and

the ends are solid. And as in painting, most of alchemy does not have to do with either pure water or hard stones, but with mixtures of the two. Alchemists worked with viscid stews, with tacky drying films, with brittle skins of slag: in short, they were concerned with the same range of half-fluids as painters and other artists.

That is the first point of similarity between alchemy and painting. There is a second similarity that runs even deeper, and gives me the impetus to explain painting in such a strange way. In alchemy as in painting, there are people who prefer to live antiseptically, and think about the work instead of laboring over it. In alchemy, those are the "spiritual" or "meditative" alchemists, the ones who read about alchemy and ponder its meaning but try not to go near a laboratory; and in painting they are the critics and art historians who rarely venture close enough to a studio to feel the pull of paint on their fingers.[1] Perhaps because they are uncomfortable with paint, art historians prefer meanings that are not intimately dependent on the ways the paintings were made. Consider, for instance, the first of the color plates in this book (COLOR PLATE 1). An historian looking at this painting might recognize Sassetta, a fourteenth-century painter from Siena. Sassetta is known to art history as a late medieval artist who slowly adjusted his work to the emerging sensibility of the Florentine Renaissance. He knew about the important new works that were being made in Florence, and there are echoes and hints of them in his paintings, though in the end he remained faithful to the conservative Sienese ways.[2] We know a little about his life, and about his patrons and commissions; and we can guess at his friends, and the places he visited. Pictures can have many meanings of those kinds, and art history is a rich and complex field. But a painting is a painting, and not words describing the artist or the place it was made or the people who commissioned it. A painting is made of paint—of fluids and stone—and paint has its own logic, and its own meanings even before it is shaped into the head of a madonna. To an artist, a picture is both a sum of ideas and a blurry memory of "pushing paint," breathing fumes, dripping oils and wiping brushes, smearing

and diluting and mixing. Bleary preverbal thoughts are intermixed with the namable concepts, figures and forms that are being represented. The material memories are not usually part of what is said about a picture, and that is a fault in interpretation because every painting captures a certain resistance of paint, a prodding gesture of the brush, a speed and insistence in the face of mindless matter: and it does so at the same moment, and in the same thought, as it captures the expression of a face.

In Sassetta's painting little brushstrokes form the face: they are delicate light touches that fall like lines of rain over the skin, coming down at a slight angle over the temples and next to the mouth. Brighter marks spread from the top of the forehead, crisscrossing the canted strokes over the temple. There are larger milky dapples just under the pink of the cheek—almost like downy hair—and curling marks that come around the neck and congregate on the collar bone. Sassetta has clasped three bright rings of sharp white (they are called Venus's collars) around the neck. The sum of brushstrokes is the evidence of the artist's manual devotion to his image: for Sassetta painting was the slow, pleasureful, careful and repetitious building of a face from minuscule droplets of pigment. The initial strokes were darker and more watery, and as the contours began to emerge he used whiter paint, and put more on his tiny brush, until he finally built up the forehead to a brilliant alabaster. This is a tempera painting, and in its period many painters used the medium as a way of showing devotion. Sassetta's lingering patience and fastidious attention remain fixed in the painting for everyone to see: they are a meaning of the method itself.[3]

Recently, some art historians have become more interested in what paint can say. They suggest that since art history and criticism are so adept at thinking about what paint represents (that is, the stories and subjects, and the artists and their patrons), then it should also be possible to write something about the paint itself. What kinds of problems, and what kinds of meanings, happen *in* the paint? Or as one historian puts it, What is thinking in painting, as opposed to

thinking about painting?[4] These are important questions, and they are very hard to answer using the language of art history.

This is where alchemy can help, because it is the most developed language for thinking *in* substances and processes. For a "spiritual" alchemist, whatever happens in the furnace is an allegory of what takes place in the alchemist's mind or soul. The fetid water that begins the process is like the darkened spirit, confused and half-rotten. As the substances mingle and fuse, they become purer, stronger, and more valuable, just as the soul becomes more holy. The philosopher's stone is the sign of the mind's perfection, the almost transcendent state where all impurities have been killed, burned, melted away, or fused, and the soul is bright and calm. Alchemists paid close attention to their crucibles, watching substances mingle and separate, always in some degree thinking of the struggles and contaminations of earthly life, and ultimately wondering about their own souls and minds.

It was the psychologist Carl Jung who first emphasized this aspect of alchemy, and since then everyone who has studied alchemy has either followed the outline of his interpretation, or rebelled against him.[5] I am not a follower of Jung, and I do not agree with his single-minded pursuit of spiritual allegories, or with his theories of the psyche. But to me what is wrong with Jung is not the basic idea that some alchemists saw their souls in their crucibles, but the fact that he made alchemy virtually independent of the laboratory. There is much more to the experimental side of alchemy than Jung thought; alchemical procedures vary from routine formulas for soap to ecstatic visions of God. Even today there are recipes using straightforward ingredients that are so intricate they cannot be reliably duplicated by chemists.[6] What mattered to all but a very few purely spiritual alchemists was the laboratory itself, and the manipulation of actual substances. The laboratory made their ideas real, and had a grip on the imagination that no speculative philosophy could hope for. Jung's reading slights the everyday alchemists who imagined they were making medicines or becoming rich: they were just as much enthralled,

and took just as much of the meaning of their lives from their crucibles, as the spiritual alchemists who wrote so beautifully about darkness and redemption.[7]

The moral I take from this is that neither alchemy nor painting is done with clean hands. Book-learning is a weak substitute for the stench and frustration of the laboratory, just as art history is a meager reading of pictures unless it is based on actual work in the studio. To a nonpainter, oil paint is uninteresting and faintly unpleasant. To a painter, it is the life's blood: a substance so utterly entrancing, infuriating, and ravishingly beautiful that it makes it worthwhile to go back into the studio every morning, year after year, for an entire lifetime. As the decades go by, a painter's life becomes a life lived with oil paint, a story told in the thicknesses of oil. Any history of painting that does not take that obsession seriously is incomplete.

So this is not a book about paintings, but about the act of painting, and the kinds of thought that are taken to be embedded in paint itself. Paint records the most delicate gesture and the most tense. It tells whether the painter sat or stood or crouched in front of the canvas. Paint is a cast made of the painter's movements, a portrait of the painter's body and thoughts. The muddy moods of oil paints are the painter's muddy humors, and its brilliant transformations are the painter's unexpected discoveries. Painting is an unspoken and largely uncognized dialogue, where paint speaks silently in masses and colors and the artist responds in moods. All those meanings are intact in the paintings that hang in museums: they preserve the memory of the tired bodies that made them, the quick jabs, the exhausted truces, the careful nourishing gestures. Painters can sense those motions in the paint even before they notice what the paintings are about. Paint is water and stone, and it is also liquid thought. That is an essential fact that art history misses, and alchemical ideas can demonstrate how it can happen.

It may seem odd to write a book about the experience of oil painting, and even odder to explain it by appealing to a subject as dubious as

alchemy. I would not deny that this book is eccentric, with its alchemical signs strewn among the English words, and its descriptions of outlandish laboratory experiments. It is not a book I could have imagined myself writing even two years ago, when I was thinking about these problems from the more sober perspective of art history. But necessity forced the issue. According to the Library of Congress there are over 7,400 books on the history and criticism of painting, enough for several lifetimes of reading. Another 1,500 books cover painters' techniques—most of them popular artists' manuals describing how color wheels work, or how to paint birds and flowers. In all that torrent of words I have found less than a half-dozen books that address paint itself, and try to explain why it has such a powerful attraction *before* it is trained to mimic some object, *before* the painting is framed, hung, sold, exhibited, and interpreted.[8] But I know how strong the attraction of paint can be, and how wrong people are who assume painters merely put up with paint as a way to make pictures. I was a painter before I trained to be an art historian, and I know from experience how utterly hypnotic the act of painting can be, and how completely it can overwhelm the mind with its smells and colors, and by the rhythmic motions of the brush. Having felt that, I knew something was wrong with the delicate erudition of art history, but for several years I wasn't sure how to fit words to those memories.

When a subject appears nearly impossible to understand, and when all the ordinary principles of explanation fall short, authors are compelled to experiment and to seize on the most powerful explanation no matter how remote it seems. There is a long history of books that make disparate connections, linking two subjects that are utter strangers in an effort to say something new. Even Homer supposedly wrote a book about a battle of frogs and mice, in order to be able to talk freely about how he thought the gods were getting along.[9] Closer to the subject of this book, several writers have linked alchemy with very different subjects: Jung used it to explain psychology, and

Paracelsus, the Renaissance physician, used it to explain medicine.[10] I take some inspiration from those examples, though they differ from my purpose here. The best precedent for this book, and the one that is closest to its tenor, is Harold Bloom's *Kabbalah and Criticism*.[11] Bloom is a literary critic, who for a while despaired of explaining poetry by means of the usual philosophy. He turned to kabbalah, Jewish mysticism, and wrote a strange book introducing literary critics to the obscure medieval Hebrew words for the ineffable states of God. Part of the joy of *Kabbalah and Criticism* is seeing familiar names like Tennyson and Blake in the same sentence with words like *hochmah* and *binah*. One reviewer complained it was a shame Bloom had to reach so far to explain something so common, but I think he might have answered the way I do for this book: that what seemed common, poetry, was almost entirely misunderstood, and that kabbalah was the best recourse he had.[12]

Alchemy may never recover from its tainted reputation. It may always seem like a wrong-headed, moth-eaten precursor to proper chemistry, a whimsical and arcane pursuit that has lost whatever allure it may once have had. In a sense Jung has buried it even more deeply by lavishing his suspect psychology on it and making it appear as a font of wisdom about the depths of the human soul. Alchemy is neither.[13] It is an encounter with the substances in the world around us, an encounter that is not veiled by science. Despite all its bad press, and its association with quackery and nonsense, alchemy is the best and most eloquent way to understand how paint can *mean:* how it can be so entrancing, so utterly addictive, so replete with expressive force, that it can keep hold of an artist's attention for an entire lifetime. Alchemists had immediate, intuitive knowledge of waters and stones, and their obscure books can help give voice to the ongoing fascination of painting.

And one last note: all the color photographs of paintings (except COLOR PLATE 8) were taken in the National Gallery of Art and the

Hirshhorn Museum in Washington, DC. Most are tiny details nestled in the paintings, and for the most part I have deliberately kept silent about how they fit in their places and serve the paintings as wholes. After you have read the book, you might want to visit the paintings and see for yourself how alchemical and painterly ideas work hand in hand.

James Elkins
Baltimore, March 1995–Chicago, January 1998

1

A short course in forgetting chemistry

PAINTING IS *alchemy*. Its materials are worked without knowledge
of their properties, by blind experiment, by the feel of the paint. A
painter knows what to do by the tug of the brush as it pulls through
a mixture of oils, and by the look of colored slurries on the palette.
Drawing is a matter of touch: the pressure of the charcoal on the
slightly yielding paper, the sticky slip of the oil crayon between the
fingers. Artists become expert in distinguishing between degrees of
gloss and wetness—and they do so without knowing how they do it,
or how chemicals create their effects.

Monet's paintings are a case in point. They seem especially simple
to many people, as if Monet were the master of certain moods—of
moist bluish twilight or candent yellow beaches—but nothing more: as
if he had no sense that painting could be anything but a method for
fixing light onto canvas. In his singleminded pursuit of the grain and
feel of light, he seems to forget who he is, and who he is painting. He
has only a weak attachment to people, and he treats the figures who
stray into his pictures as if they were colored dolls instead of friends
and relatives.[1] Instead, his attention is riveted to the blurry shapes that
come forward through the imperfect atmosphere, and on the shifting
tints of light that somehow congeal into meadows and oceans and
haystacks. In that respect Monet's paintings are masterpieces of
repression, keeping every thought quiet in order to concentrate on

light: in order to pretend that there is nothing in the world—to borrow a phrase of Philip Larkin's—but the wordless play of "any-angled light," congregating endlessly on shadowed cliffs and ocean waves.[2]

Recently, art historians have learned to see that more is happening, and that Monet tried to give his paintings the sense of freedom and civility that he thought was appropriate to bourgeois society. He painted contemporary scenes, recent technology such as steamboats, and the life of leisure that he valued most. But still the idea persists that Monet is "just an eye," as Cézanne said, and for good reason: his paintings are ravishing, even for people who don't particularly like glaring multicolored sunlight or soggy green gardens. These days, art historians are apt to be a little indifferent to Monet's eye, and the Impressionists can easily seem less interesting than the generations before them, who were tortured by history and the pressure of great painting, or the generations that followed, with their pseudoscientific and mystical preoccupations. A large part of that lack of engagement on the part of historians comes from Monet's technique itself: the paintings seem so obviously daubed, as if his only thought for the canvas was to cover it with paint as efficiently as possible. It can look as if he allowed one stroke for a leaf, another for a flower, and so on, building up meadows and forests through a tedious repetition. Often there is not much variety in the marks—no difference between thin and thick passages, no places where the canvas is suddenly bare, no contrasts between flat areas and corrugated impasto. Everything has a monotonous texture, like a commercial shag rug. In the later paintings, his technique only seems to get rougher and less controlled, until finally he ends up making lily pads and flowers out of swarms of haphazard brushstrokes, flailed over the canvas as if he didn't care. The paintings look easy, and even more childlike than the Abstract Expressionist paintings that used to be maligned for their supposedly childish technique.

But as I learned by trying to copy Monet's paintings, that idea is completely mistaken (COLOR PLATE 2). It is not possible to reproduce the effect of a Monet painting by jousting mechanically with the

canvas, jabbing a dot of paint here and planting another one there, until the surface is uniformly puckered in Monet's signature texture. A painter who does that will end up with a picture that looks soft and uninteresting, with a dull pattern of swirling circles like the ones left by some electric rug cleaners. A brush that's loaded with paint and then pushed onto the canvas makes a circle, more or less, but Monet's pictures do not have any circles in them. There is only one slightly rounded mark in this detail from one of his garden paintings—the blue patch at the lower right—and it's *rectangular,* not circular at all.

Nor does it help to make the usual sideways swipes at the canvas, because then the picture turns into a rainstorm of oval droplets, all falling in one direction. Some second-rate painters of Monet's generation tried to paint that way, and the result is pictures that have a windswept effect, as if they were greasy surfaces smeared by a cleaning cloth. (Sassetta's Madonna has the windswept effect in miniature, since he painted by slight flexes of his thumb and index finger, each time bringing the brush a few millimeters down and to the left.) But Monet's pictures have no direction: they are perfectly balanced, and marks go in all directions equally. Would it be possible to tell which way is up in this detail? It is omnidirectional, with no sign of the diagonal fall of brushmarks that is the sure sign of an ordinary painter. To a nonpainter, it may sound like an easy matter to make marks in all directions: after all, an artist could try painting with both hands, or experiment with rotating the canvas. But getting real directionlessness is immensely difficult: repeated gestures naturally fall into line with one another, and artists have to work hard against their own anatomy to make sure that one kind of mark does not overwhelm the others.

Not all painters want the effect Monet achieved: many prefer the energy that directed brushstrokes give, and they work *with* the marks as Sassetta did, leading them up and down figures, and around contours. Painters who prefer to hide the signs of their brushwork normally do so by smearing their brushstrokes into uniform areas, or else miniaturizing their brushstrokes so they fall below the threshold

of normal vision. (Sassetta almost does that: in the original, the Madonna's head is quite small.) But for Monet and other Impressionists those strategies wouldn't have seemed right. They wanted something painterly, where the brushmarks show, and they wanted a more exacting lack of directional motion, something like the inhuman stasis that nature itself seems to have. A distant landscape might shimmer and sparkle in the sunlight, but it will not show any sign of running diagonally up or down. It merely exists: it's not going anywhere, it doesn't move from place to place. To achieve stasis in a painting, it turns out that it is not enough to make marks equally in all orientations as if they were scattered matchsticks. Such a painting will be a flurry of crisscrossing lines. To do what Monet did in this painting, it is necessary to make marks that have no set orientation *and* no uniform shape, so they can never congregate into herds and begin to march up and down like Seurat's dots sometimes do. Each mark has to be different from each other mark: if one slants downward, the next has to go up. If one is straight, the next must be arcuate. Lancet strokes must follow rounded ones, zigzags must be cut across by ellipses, thickened strokes must be gouged by thin scrapes. Any pattern has to be defeated before it grows large enough to be seen by a casual eye.

And even this is too simple. An ordinary square inch in a Monet painting is a chaos, a scruffy mess of shapeless glints and tangles. His marks are so irregular, and so varied, and there are so many of them, that it is commonly impossible to tell how the surface was laid down. There is a zoo of marks in this detail that defy any simple description. At the top right is a bizarre boat-shaped trough, made by gouging wet paint with the brush handle, and then pulling back in perfect symmetry. A pool of Yellow Ochre has been dropped just to its left, and it ran slightly over the lip of the trough before it congealed. To the left of that, a streak of Vermilion or Indian Red comes down, leaving an irregular trail over a layer of Cerulean Blue and Lead White. The Japanese call this technique "flying white," because a partly dry inkbrush will leave flashes of white as it drags across the

silk. In the West, there is no such poetic name, and drybrush technique is normally just called scumbling (a word that can mean many other things as well). At the far upper left, some Ochre has just barely skimmed the surface of the canvas, depositing little yellow buds at each intersection of the weave. None of those marks have names: they are all irregular and none is like any other. And there are even more unclassifiable examples even in this little detail: a double, snaking mark of deep Ultramarine Blue enters the scene at the left center, scratches and skims its way to the right, skips a few centimeters, and then hooks left and doubles back. It's a scumbled stroke, not a continuous brushstroke but a trail of shimmering vertical marks, like specters walking in a parade.

Twenty years ago, the art historian Robert Herbert noticed that it is often possible to see a pattern of brushstrokes that is actually underneath the painted scene, as if Monet painted on top of a rolling landscape of brushstrokes.[3] If the paintings are lit from one side, those strokes can seem to make a painting by themselves: they are often thick, and they form a bas-relief of textures, like the fake oil paint texture that is pressed onto cheap reproductions of paintings. The "texture strokes," as Herbert called them, do not follow the shapes and colors of the objects in the finished paintings. The burs and ridges of a single texture stroke might run across part of a meadow and into the sky, or across part of a house and into a tree. Often it is impossible to tell what color the texture strokes were, since they are completely covered by the thinner colors of the final scene. To Herbert, that was evidence that Monet was not as spontaneous as people thought, and that he had a "method": a layered technique that required planning and patience in the manner of the Old Masters of the Renaissance. Apparently Monet had painted those brushstrokes, let them dry, and then made his paintings on top of them. But things are more chaotic than that. Monet did not lay down entire textured surfaces, and then leave the painting for two weeks while they dried, and then paint his pictures on top of them. (If he had, then the plastic reproductions would mimic his methods perfectly, since they are

made by casting textured surfaces, coating them with photographic emulsion, and printing the paintings onto the surfaces.)

Instead, the texture strokes are themselves built up in layers, and the layering went on continuously and without premeditated method until the paintings reached the magical point where it became impossible to tell how they had been painted: then they were finished. That moment is well known to painters. If an artist begins to paint a field, say by coating the canvas with a layer of green and then going over it with lighter and darker green, it will be obvious that the lights and darks are resting on top of the original middle green. After a while the different shades might nearly cover the first green, but even if that green shows through in tiny crevices, it may still look as if the meadow was made by floating local colors on top of a uniform background. In Monet as in other very different painters, part of the object is to work until it is no longer possible to tell what paint is on top and what is underneath. When that happens, it is a magical moment because the painting suddenly stops looking like a flat color-by-number with a few added touches, and takes on a rich and confusing aspect. The meadow is no longer a green card scattered with cutout plants, but a rich loam matted with plant life and moving with living shadows. Monet's texture strokes help that happen by raising glints of light that sparkle randomly among the painted stalks and leaves, confusing the eye and mimicking the hopeless chaos of an actual field. In this detail, the raw canvas shows through in a couple of places: one of them is just at the end of the snaking blue mark, short of the Emerald Green. But what color went down first? In the top half of the detail, it looks as if the light Cerulean Blue might be underneath, and the other colors on top of it—but on closer inspection, there is no uniform layer of Cerulean Blue. It's a mixture, already layered with overlapping pigments. And in the lower half, it is hard to say if blue is on top of white, or vice versa: they seem to be tumbling together at the bottom.

The trick, then, which is much more than a simple trick, is to lay down strokes that are different from one another, and to keep over-

lapping and juxtaposing them until the entire surface begins to res-
onate with a bewildering complexity.[4] The marks must not be simple
dabs, or shaped dashes, or any other namable form, but they must
mutate continuously, changing texture, outline, smoothness, color,
viscosity, brilliance, and intensity in each moment. I have taught
classes in the Art Institute of Chicago, in which students try to copy
paintings; the first student of mine who set out to copy a Monet
nearly gave up in frustration. Every time she put her brush to her can-
vas she ended up with some predictable pattern of marks. The first
day, she tried to sketch in a scene of the ocean, which Monet had
painted in a light greenish blue. She produced a white canvas, sprin-
kled with blue polka dots. We examined the original from a few
inches away, and we saw the ocean was made of four colors: a deep
purplish hue signifying the depths of the ocean, a light Cobalt Blue
reflecting the sky, hints of Malachite Green, and Lead White foam for
the breaking waves. So she tried again, and made an awful Op Art
pattern of colored circles. We looked more closely at the original,
and saw that some of the marks were laid down almost dry, and
brushed hard against the canvas, and others were wetter, and set
down more lightly. She tried again, not wiping anything away, but
building up the paint, and it began to look a little better. But then she
had to stop working on the ocean, because the wet paint was begin-
ning to slur together into a single hue.

 She went on like that for two months, letting portions dry while
she worked on other passages, exactly as I imagine Monet doing.
Eventually she had built up the "texture strokes" that Herbert
described, and she had succeeded in obscuring the layers of the
painting, so it was no longer possible to be absolutely sure of which
colors had gone down first. But still something was missing. Her pic-
ture looked mechanical, and it was too soft, like a blurry computer-
screen version of a painting. (Or like the pricey framed reproductions
that sell in museum shops, which are also nauseatingly blurry.)
Monet's seascape is rough-edged, harsh, and scintillating, and hers
was bleary and damp. The difference, and the key to the method,

turned out to be the exact gestures that made the individual brush-marks. When we compared them, one of hers to one of his, we always found his were more pointed and creviced, more wildly asymmetric, than hers. His were as you see them in the detail: brilliant, fragmented, and disheveled. Hers were pats of butter, with rounded edges. We began trying to emulate his touch, and to turn her obvious inventory of marks into Monet's unpredictable starry shapes. How is it possible, we wondered, to load a brush with paint, touch it to a canvas, and come away with something as intricate as a corrugated swirl or a burst of sharp pieces? How can a single brush produce an interrupted pattern as fronded and curled as a lichen? Eventually we began to have some success, much to the delight of the crowds that regularly gathered around, watching us flounder; and the secret was a combination of two nearly indescribable elements.

First, it is necessary to have paint at the exact right texture. As it comes from the tube, oil paint is too thick, but if it is thinned with even a little turpentine, it is too dilute. My student used a combination of oils and varnishes, and she worked up the paint into stiff greasy lumps on the palette. Monet's paint must have been very much like what we made: it was shiny and resilient, thicker than cream, more liquid than vaseline, more rubbery than melted candle wax. If it was smeared with the finger, it would leave a ribbed gloss where the lines of the fingerprint cut tiny furrows; if it was gouged with the tip of a knife, it would lift and stretch like egg whites beaten with sugar. Only paint like that could smear across the canvas for a moment, and then suddenly break into separate marks. We succeeded in making many of the outlandish shapes that populate Monet's paintings, and the student's copy began to take on some of the mesmerizing intricacy of the original.

The second secret is in the gestures that Monet made when he was laying down the paint. The student let small gobs of paint rest on the top of the brush, so she could push the dry brush-end over the canvas, making a light scumble, and then suddenly turn the brush, plunging the wet paint into the weave and planting a thick

blob as part of the same mark. Lifting the brush again, she could let the body of the mark trail off into a thin wisp or a series of trailing streamers as the paint broke away from the hairs of the brush. Everything depended on the way she moved in those few instants of contact. The best motions, the ones Monet must have made habitually, were violent attacks followed by impulsive twists and turns as the brush moved off. First the brush would scrape wildly, epileptically, against the canvas, jittering across its own trail, breaking it up, laying down thick paint alongside dry paint, and then it would abruptly lift and swivel, turning the jagged edges into little eddies. The gestures are a mixture of timidity and violence, of perfect control in the preparation and perfect abdication of control in the execution. Some of Monet's marks had real force, and the brush jabbed into the canvas and scraped off to one side. His canvases must have been stretched tightly, because he did not paint softly. The detail I am reproducing here is a graveyard of scattered brush hairs and other detritus. At the center left, glazed over by Malachite Green, are two crossed brush hairs, one of them bent almost at a right angle. Just below them are two of Monet's own hairs, fallen into the wet paint. A faction of an inch to the right of the green is a short piece of a brush hair, broken off by the impact with the canvas. The study of gestures reveals a Monet that I would not have suspected: to make paintings the way he made them, it is necessary to work roughly, with unexpected violence and then with sudden gentleness, and to keep turning the body against itself, so it never does quite what it wants to do—so it never falls into the routine of oval marks, all pelting down in one direction. The gestures tell the story of a certain dissatisfaction, and itchy chafing of the body against itself, of a hand that is impatient and deliberately a little out of control.

As far as I am concerned, those two elements are Monet's secret. The paintings are certainly not the instantaneous records of nature that they once seemed, but neither are they deliberate products of some academic method.[5] They depend from first to last on two nearly indescribable requirements: the precariously balanced viscosity

of the pigment, and a nearly masochistic pleasure in uncomfortable, unpredictable twists and turns. The paintings are narcissistic, to use a word that is usually reserved for inward-turning twentieth-century art: they are about that beautiful moment when the dull oil paste, squeezed from the lead tube, becomes a new substance that is neither liquid, solid, cream, wax, varnish, or vaseline; and they are about the body's turning against itself, and within itself, to make shapes that the eye cannot recognize as human marks.[6]

The science, or the pedagogy, that can describe these two secrets does not exist. Chemistry cannot help to define Monet's mixture, since the ingredients have to be adjusted depending on the picture, the passage, the weather, and the oils and colors that happen to be available. Every act of mixing has to start from scratch, resulting in a batch that is infinitesimally different from every other. A painter knows it by intuition—that is, by the memory of successful mixtures, by the look of the painting, by the scratchiness of the canvas's warp and woof, by the make and age of the paints, by the degree of fraying in the brush. It can just barely be taught, and it can never be written down. Likewise, anatomy or physiology cannot help to define Monet's gestures, because they depend on the inner feelings of the body as it works against itself, and on the fleeting momentary awareness of what the hand might do next. The state of mind that can produce those unexpected marks is one divided against itself: part wants to make harmonious repetitive easy marks, and the other wants to be unpredictable. Books on painting are no help either, since they can only give gross formulas. Only being in the Art Institute with the student, standing next to the original, and taking up the brush myself, made it possible to communicate these thoughts.

Books cannot put Monet's "tricks" and "secrets" into words, but there is a discipline that has been working on the same kinds of problems since the time of the Greeks, and has a large vocabulary and wide experience in describing unnamable and unquantifiable substances. At first it seems that alchemy could not possibly teach us how to paint like Monet, and in fact it can't. Although many painters

have been alchemists, those coincidences are usually not very interesting.[7] Alchemy cannot provide a painting manual: luckily, nothing can do that but painting itself. But it can provide something more fundamental, which defines the experience I have been trying to describe. Alchemy is the art that knows how to make a substance no formula can describe. And it knows the particular turmoil of thoughts that finds expression in colors. Alchemy is the old science of struggling with materials, and not quite understanding what is happening: exactly as Monet did, and as every painter does each day in the studio.

"It is difficult to get the news from poems," William Carlos Williams said, "yet men die miserably every day for lack of what is found there."[8] To "get the news" from alchemy, it is necessary to pause in our headlong pursuit of useful knowledge, and spend some time thinking about the world as the alchemists saw it. At least the leap from painting to alchemy is not as big as it seems, because the ingredients of painting have never been too different from those of alchemy. Back in the seventeenth century, when alchemy was being practiced in every little town, painters and alchemists shared many substances—linseed oil, spirits, brilliant minerals for colors—and painters' manuals sometimes used the language of alchemy, calling for alchemical ingredients such as vitriol, sal ammoniac, and blood. Realgar and Orpiment are pigments that can be found in Renaissance paintings (they are bright orange and warm yellow) and they were also favorite alchemical ingredients because they yield arsenic and sulfur. The most famous artist's material, lapis lazuli, was also prized by alchemists, though it was too expensive for anything but the most lavishly funded work until the discovery in 1828 of artificial ultramarine. (Lead-tin white was also well known to the alchemists, and so were greens made with copper resinate.) Artists have made paints from a pretty red mineral called cinnabar, which is usually found in an impure state, "admixed with rocky gangue" as one author says. Because it is hard to purify, it is more common to make red paint out

of Vermilion, which is the same chemical synthesized from mercury and sulfur.[9] Mercury and sulfur are the two principal substances in alchemy, and even the method for making Vermilion has its alchemical connections. In the Dutch technique, mercury and melted sulfur were mashed together to make a black clotted substance called Ethiops mineral or Moor. When the Moor was put in an oven and heated, it gave off vapor that condensed onto the surface of clay tablets. The Moor is black, but its condensed vapor is bright red—a typical piece of alchemical magic—and it could be scraped off and ground into Vermilion for paint.[10] So Vermilion is an artist's pigment, composed of the two most important alchemical materials, and synthesized according to a method that was used by Greek alchemists. (Vermilion, incidentally, was the crucial evidence in the debunking of the Turin shroud: samples of the "blood" were sent to Chicago and analyzed in the McCrone Research Laboratories, by specialists in artists' pigments; they found that the red was composed of mercury and sulfur instead of hemoglobin: it was cinnabar, not blood.)

Alchemists and artists also share a predilection for bizarre ingredients. Early in this century a gelatinous extract from the swim bladders of sturgeons was used as an ingredient in oil paint; and before the introduction of collapsible paint tubes in the mid-nineteenth century, artists bought their colors in packets made from pigs' bladders. In the Renaissance, fish glues were sold in rancid wafers; the artists would pop them in their mouths to rehydrate them. Painter's glue (called size) has been made from horses' hoofs, stags' antlers, and rabbit's skin, it is still made from animal hides. Paint has been mixed with beeswax, the milky juice of figs, and resins from any number of exotic plants. Painters' media have included dozens of European and Asian plants, oils made of spices like rosemary and cloves, and even ground-up fossilized amber.

Painters have always used outlandish methods, very much like the alchemical methods of their day. Rubens and his contemporaries boiled oil and lead into a stinking mixture called black oil, which was stored in airtight containers. To extract the particles of blue lapis

lazuli from the colorless rock surrounding it, painters used the "pastille process": they pulverized ore samples in a bag, mixed them with melted wax, plant resins, and various oils, and then kneaded the bag under a solution of lye (made with wood ashes) to coax out the blue particles.[11] (The method works, but according to the sober voice of modern chemistry it does not require any of the exotic oils and waxes.) Lead White, the best white paint before the nineteenth century, was made by putting cast "buckles" of lead in clay pots partly filled with vinegar; the pots were stacked in a shed with fermenting horse manure or waste tanning bark. Every few weeks the painter's assistant would scrape the leprous flakes of lead carbonate off the buckles and put them back for more steeping.[12] Even traditional tempera painting, the mainstay of the early Renaissance, calls for an alchemical-sounding list of ingredients: it's a good bet that Sassetta's docile madonna is made of gold powder, red clay, calves' hoofs, egg yolks from eggs produced by "city hens" (as opposed to "country hens"), oils, minerals, water, old linen, and marble dust. Recently, archaeologists have analyzed the components of cave paintings in the American Southwest, and I have taught a class in those techniques, using vegetable juices, milk, and pig's blood, with frayed sticks for brushes. One student even tried to replicate the silhouetted hands that are found on cave walls by filling his mouth with wet powdered charcoal and spitting over his outstretched hand.

These days, artists tend to use whatever is available in stores, and so they are even more like alchemists in another respect: they do not know (or care) what modern chemistry might have to say about their favorite substances. Nearly any artist would fail an exam on the composition of paints. What painter understands how varnishes work? Could any artist name the pigments in the different oil colors? What muralist knows why fresco requires lime plaster, ordinary plaster, cement, and sand? For those few who become interested in artists' materials, there are some odd surprises. For example, Carmine, one of the deep red pigments, is not an inorganic chemical at all but an organic one, harvested by boiling small reddish insects and drying the

residue in the sun.[13] Most artists don't know such things because they don't matter: they have no connection to the meanings of the artworks they help produce. What counts, and what every artist must know, is how the different substances behave. Painters who buy their materials from art supply stores generally think that stand oil is the thickest medium for oil paints.[14] It is amber colored and shiny, and it oozes from the bottle like triple molasses, or dark Chinese soy sauce. If a painting calls for truly viscous paint, then stand oil can be mixed into the paint to make a gluey mass. But without some knowledge of how stand oil works, the results can be disappointing. Paint mixed with stand oil is like cornstarch mixed with water: if you stir a little water into cornstarch, it forms a thick wet clay that can be rolled between the hands; but as soon as you let it alone, it relaxes into a fluid. In the same way, paint made with stand oil will run off the canvas before it dries. A brushstroke, thickly smeared, will loosen and fall, taking on a gloss as it runs down the slope of the canvas. The answer is to use stand oil in combination with other media, or put some on the stove and slowly boil it down until it becomes an evil-smelling viscid paste. Those are the kinds of things that artists who use stand oil have to know, and they have no relation to the chemical composition of the oil.

The world of visual art is filled with unknown materials. After a lifetime of experience, an artist comes to know a very small number of them intimately. One painter might be an expert in stand oil, and another in crayons. Sometimes artists have a hard time mixing with friends who seem to have tremendous amounts of knowledge— lawyers, who have learned thousands of precedents and procedures, or doctors, who have memorized drugs and symptoms—but knowledge gained in the studio is every bit as engrossing and nuanced: it's just that instead of learning words, painters learn substances. Long years spent in the studio can make a person into a treasury of nearly incommunicable knowledge about the powderiness of pastels, or the woody feel of different marbles, or the infinitesimally different iridescences of ceramic glazes. That kind of knowledge is very hard to pass

on, and it is certainly not expressed well in books on artist's techniques. (One reason those books are so sterile is that they look at things from the point of view of science, as if everything has a fixed set of properties.) But it is a form of knowledge, and it is the same knowledge that alchemists had.

To learn the speech of alchemy it helps to think back to a time when there was no science: no atomic number or weight, no periodic chart, no list of elements. To the alchemists the universe was not made of molecules, which are made of atoms, which are made of leptons, bosons, gluons, and quarks. Instead it was made of substances, and one substance—say, walnut oil—could be just as pure as another—say, silver—even though modern chemistry would say one is heterogeneous and the other homogeneous. Without knowledge of atomic structures—or access to an *Encyclopædia Britannica* with a periodic table—how would it be possible to tell elements from compounds? As far as artists are concerned, linseed oil might as well be an element. To the alchemists, oils were not hydrocarbons: they were a kind of fluid among many others, with affinities to steams and vapors as well as spirits, waxes, and sludges. Oils were what rose to the surface of a pot of stewing plants, or sat dark and fetid at the bottom of a pit of rotting horseflesh. That is the uncertain world that needs to be evoked in order to think back to the world of alchemy.

A typical laboratory might have had ore samples of the common metals—some tin, a chunk of iron, copper in nodules, a hunk of lead— and shelves full of other rocks in no particular order—a miscellany of crystals, sulfur, quartz, lime, saltpeter, sand. There would have been bottles of oils extracted from plants and trees—limewood, olive, parsley, rose—and spirits of all sorts—beer, liquors from berries, grains, and fruits. Since this is a thought experiment, you can add in imagination any objects you might find around the place you live: oddly colored earths, suspiciously triangular pebbles, shorn barks, piths of weeds, gnarled roots, withered tubers, rare flowers, different hairs, the hollow shanks of feathers, curious silks, stagnant infusions, stale

waters of different colors and tastes. If you traded, as the alchemists did, you might have encountered even stranger things: horns reputedly from unicorns, red corals, powders allegedly from mummies, rocks in the shapes of fishes and loaves of bread. Dragon's blood was an especially rare substance: not only was it necessary to find a dragon, but the alchemist had to wait until the dragon attacked an elephant. When it wrapped itself around the elephant and began sucking the elephant's blood, the elephant would weaken, and eventually fall, taking the dragon with it. Once in a while (this must have been one of the rarer events in nature) the elephant would actually kill the dragon, and the two of them would die together. At that moment the alchemist could rush up and collect the proper alchemical dragon's blood.[15]

All these things, from the most common pebble to the precious dragon's blood, would be the raw materials of the alchemical laboratory. Some were real, and had to be collected; many more were clues and symbols, waiting to be interpreted. ("Dragon's blood," for example, might turn out to be a way of naming the alchemist's "sophic mercury," a substance of a different order altogether.) What might you deduce about such a world if you found yourself thrown into it, as the alchemists did, without any quantitative knowledge? How would you rearrange your miscellaneous collection so it reflected some rational or divine order? An actual alchemist would proceed by learning whatever metallurgy was known, and then move on to more esoteric experiments: but for this purpose, I want to imagine the basic condition of ignorance that any of us would face if we were put in an alchemist's shop—or an artist's studio—and told to work with what we found. For those readers who are already tainted by some knowledge of chemistry, an effective way to imagine the world before science is to recall experiences from childhood, when materials seemed to behave oddly or unpredictably. I do not remember the moment when I first learned that oil and water will not stay mixed, no matter how hard the cruet is shaken, but I have noticed it with annoyance many times since then. I do remember discovering that a

frozen wine bottle will explode, and that warmed liquor can be set on fire. For many people the most astonishing encounter with materials happens in the dentist's office, where they see the miracle of mercury: a cold, liquid, heavy, dry, opaque metal that wobbles and shimmers and weighs much more than any object should. The same substance baffled and entranced the alchemists.

Before the seventeenth century, and in my own childhood before I knew better, there was no triad of solid, liquid, and gas. (Not to mention the impossibly exotic new states that physicists and chemists study: plasmas, Bose-Einstein condensates, superfluids and supersolids.) Things had many colors, many tastes and odors and heavinesses. Some made you blink, some made you itch, or laugh, or gag. In prescientific European thought, substances were ordered in a continuous chain from solids through more refined, tenuous things like "mists, smokes, exhalations, air, ... ether, animal spirits, the soul, and spiritual beings."[16] And if you think about it, the solid-liquid-gas trichotomy does not even do a good job describing something as simple as water. Isn't hard-frozen ice, the kind that can grip the tongue onto a metal bar, different from the soft warm ice of an ice cube? And aren't the many senses of snow as different from one another as fog is from vapor or steam? If it weren't for high school science, few of us would normally associate ice, water, and steam as the same chemical. For me, there is not one ice, but several. Like the proverbial Eskimos, I would count hard cold ice as different from warm ice, and I would separate rocklike ice (as in glaciers) from black ice (as in deeply frozen lakes), singing ice (as in fracturing ice floes), and watery ice (as in spring slush). Snows would be different creatures, and water and vapor different again. The formula, H_2O, does not exist for me outside the laboratory. In its place is a welter of substances dispersed and hidden throughout the world, a whole unruly race of different creatures that only science claims are the single docile formula H_2O.

Another example is oils and waxes. According to modern chemistry, oils, waxes, gasoline, natural gas, and some plastics all share the same structure—they are chains of carbon atoms flanked by hydrogen

atoms. But it would be impossible, I think, to intuitively link wax and gasoline, or oil and polyethylene. In chemical terms, all that is required is to add a few carbon atoms to the chain. If the structure, called an alkyl radical, has between one and four carbon atoms, the result is a gas; if it has seven to nine, it is a volatile fluid such as gasoline (hence the phrase, "high octane," meaning a high percentage of eight-carbon chains); ten to twelve carbon atoms result in a less mobile liquid such as kerosene; thirteen to eighteen make sluggish liquids like diesel oil; more create slimy liquids, and, finally, soft solids like wax and hard ones like polyethylene.[17] But what chemistry sees as the rudimentary addition of atoms to a linear chain, the eye and hand know as mysterious and utter transformations. Kerosene is much more like water than it is like wax, and wax is more like soft-packed snow than it is like polyethylene. Those are the kinds of unscientific classifications that need to be taken seriously in order to understand alchemical and artistic choices.

If our imaginary laboratory has polyethylene, snow, wax, kerosene, and water, then we might want to put the wax with the snow, the water with the kerosene, and the polyethylene with the miscellaneous rocks. Of course it would be possible to put snows, ices, and waters on a burner and verify that they are all related, and alchemists did as much. Many metallurgists knew that metals existed as solids, liquids, and invisible vapors. But without atomic theory, there are limits to how systematic that knowledge could be.

Even something as fundamental as a stone is hard to define. What makes stones stony? If we think how the lumpish human body—which is nothing but slabs of steak and flaccid viscera—is animated by a spirit, then we can also conceive of an essence of stoniness, something that might creep into the damp earth and make it more stony. Agricola, the seventeenth-century metallurgist, was thinking along those lines when he spoke of a "juice" (*succus*) that was a "stone-forming spirit" (*lapidificus spiritus*).[18] Robert Boyle, one of the founders of modern chemistry, called it a "petrescent liquor," from the Latin word *petra,* rock; and he also thought there might be spe-

cial juices for metals and other minerals (those he called Metallescent and Mineralescent juices).[19] There were moments in the seventeenth century when no one could admit that fossils might be the records of animals that lived before the Biblical creation. People were dismayed by fossil shells on mountain tops and in mines deep underground, because they seemed to hint that the earth was much older than the 4,000 years that the Bible said it is. The idea of a stony spirit was used to help explain away the fossils: it was supposed that "stone marrow" (*merga*) "dissolved and percolated" through the earth, sometimes forming bone shapes and other fossils.[20] Alternately, people thought that fossil shells had been real shells that were invaded by the stony liquor, a stone-forming spawn that seeped quietly up from the depths of the earth and overtook the slow and the dead.[21] Anything might be turned into stone, and European collectors had specimens of men's tongues and hearts invaded by "stone-forming waters."[22] Some parts of the world had springs whose water turned to stone, which was allegedly proof that their liquid was stone seed and water commingled.[23]

So even an object as simple as a stone might be composed of earth and a stony spirit. It's a reasonable idea, if you think about it without the prejudice of science. Some stones are brittle and flinty, and they must have more stone sprit than friable chalks and clays. It might even be possible to give some order to the imaginary museum by ranking stones according to their stoniness. And what are the differences between stones and metals? Would we want to distinguish minerals or salts from earths?[24] Certainly gems and crystals are different from dirt, but which differs more: a crystal and a clod of earth, or gold and sulfur? Many authors thought gold, silver, iron, copper, lead, and some other substances were just as different from one another as gems, fossils, and other "earths."[25] It was routine until the mid-eighteenth century to keep fossils together with minerals as examples of "stones"—as if a fossil shell were a kind of rock, like a garnet. Michele Mercati, a sixteenth century doctor and botanist, thought there were ten kinds of stones:

1. earths,
2. salts and nitres,
3. clays,
4. acid juices (*succi acres*), including copperas and "metallic ink" (*melanteria*),
5. oily juices (*succi pingues*), including sulfur, bitumen, and pit coal,
6. marine stones, including sponges, corals, and the Halcyon Stone (*alcynium*), which was thought to be a "stony concretion" of sea foam,
7. earths resembling stones, including manganese, calamine, and the legendary Stone of Assos (*sacrophagus*),[26]
8. stones engendered in animals, including bezoar, stag's tears, toad-stone, and pearls,
9. stones in the shapes of animals and plants (*lapides idiomorphoi*), and
10. marbles.[27]

I wonder if anyone these days could do as well, juggling what could be actually seen with the legendary stories told by travelers and ancient authors.

Gases were especially hard to figure out, since they are mostly invisible. Jean-Baptiste Van-Helmont, who coined the word "gas," tried his hand at classifying them and ended up with six species of the new substance:

1. gas produced by burning wood, which he called "woody spirit" (*spiritus sylvestris*),
2. gas produced by fermenting grapes, apples, and honey,
3. produced by the action of acid on calcareous bodies,
4. produced by caverns, mines, and cellars,
5. produced by mineral waters, and
6. produced by the intestines.[28]

This list is probably more elaborate than anything we might draw up without calling on some memory of elements like nitrogen, helium, and oxygen. Even a modern chemistry lab, where the gases can be

sampled in their pure states, would not be much help. If we were to smell bromine—a choking red gas with a suffocating odor—would we know how to tell it from iodine vapor, or any number of disagreeable violet gases? And even if we managed to construct Van-Helmont's list, where would we go from there? Would it help to classify gases by their smells? Are "visible gases" such as steam different from invisible ones? Does each liquid have its own gas? These are all unanswerable questions without knowledge of modern chemistry, and so they correspond roughly to what the alchemists had to work with.

There were other problems as well. Since the alchemists had no graduated thermometers, they also had no way to quantify heat and cold. Instead of measuring temperatures, they classified "grades" or "species" of fire. Each species had its own essential properties. The medieval alchemist Artephius specifies three fires: the fire of the lamp, "which is continuous, humid, vaporous, and spiritous"; the fire of ashes (*ignis cinerum*), which makes a "sweet and gentle heat"; and the natural fire of water, "which is also called the fire against nature, because it is water."[29] Like many unscientific insights, this one has what we now can only call a poetic truth. Water *does* have its heat, and so it is like the heat of flame, but less strong. The seventeenth-century alchemist Johann Daniel Mylius said there are four heats: that of the human body, of sunshine in June, of calcining fire, and of fusion (he means chemical fusion, not nuclear fusion). Other authors specify the heat of a manure heap, or of a brooding hen, or of a virgin's breasts. (That is the mildest heat, the one closest to coldness.) Usually the hottest species of fire was "wheel fire," a heat so intense that the flames would encircle the crucible. The lack of thermometers was the despair of experimentally-minded alchemists who wanted to tell their friends how to make some special substance, because there was no dependable way to give the recipe. It is no wonder the Rosicrucians called fire "the great indescribable spirit, inexplorable in eternity."[30]

If it was to be possible to come even close to repeating an experiment, the alchemists needed to describe differences in heat, color,

and time without thermometers, spectrographs, or accurate clocks. In this vein Marius, a medieval metallurgist, tries to define the major metals as exactly as he can:

> Iron is made from dense quicksilver mixed with sulfur of a color halfway between red and white, and it is cooked for a long time, even longer than copper, by a moderate heat.... Copper contains a small amount of redness, so if iron lies undisturbed a long time, it becomes rusty and takes on a reddish color.
>
> Tin is made from pure quicksilver mixed with pure white sulfur. But it is only cooked for a short time. If the heat is too small and the time is too great, it will turn into silver.
>
> Lead is made from coarse quicksilver mixed with coarse sulfur that is white with just a little red.[31]

Needless to say, by modern standards most of this is mistaken: lead is not made from sulfur, but is an element in its own right, and so are tin and iron. Marius also struggles with the precision of language. What, a modern chemist might ask, is a "long time"? What is a "moderate heat," or a "small amount of redness"? Without quantifiers, Marius's distinctions are just rules of thumb, incomplete descriptions that have to be corrected by experience. That is the problem that confronts artists, because they are interested in nuances of mixture. It is not possible to make a recipe for the textures Monet used, or the colors he mixed; instead, the student has to see them made, and then repeat the process as accurately as possible.

Without the instruments of quantitative science the world will remain a blur. Here, as a last example, is a concerted attempt to order the world: a list summarizing an anonymous medieval treatise traditionally ascribed to the Arabic alchemist Gābir Ibn Ḥajjān. The book, called the *Summa perfectionis,* was widely consulted until well after the Renaissance, and it does an excellent job at bringing order to the study of "earthly things."[32] When I read through it, I marvel that so much clarity could be brought to the world of confused and nameless objects:

I. *Terrena* ("Earthly things")
 A. Four Spirits [i.e., volatile substances]
 1. Quicksilver
 2. Sal ammoniac [ammonium chloride, NH_4Cl]
 a. Mineral form
 b. Dirty, yellow form
 c. Artificial form produced from hair
 3. Auripigment [arsenic sulfide]
 a. Impure, mixed with stones and earth
 b. Yellow, opaque, earthy [impure As_2S_3]
 c. Yellow, golden, "alive" [purer As_2S_3]
 d. Yellow mixed with red [mixture of As_2S_3 and As_4S_4]
 e. Red, with dirty "eyes" [impure As_4S_4]
 f. Pure red, capable of splitting [purerAs_4S_4]
 4. Sulfur
 a. Red, difficult to find [apparently fabulous substance]
 b. Yellow, color of "pure varnish" [crystalline sulfur]
 c. Yellow, grainy [perhaps mineral sulfur with its matrix]
 d. White mixed with earth [an obviously impure form]
 e. Black [either sulfur mixed with asphalt, or iron sulfide]
 B. Seven bodies [i.e., the seven known metals]
 1. Gold
 2. Silver
 3. Copper
 4. Tin
 5. Iron
 6. Lead
 7. "Karesin" or "Catesin" [possibly bronze composed of copper, zinc, and nickel]
 C. Thirteen stones
 1. Marchasita [pyrites, including "fool's gold," FeS_2]
 a. Similar to silver in color

 b. Red, like copper

 c. Black, like iron

 d. Golden

 2. Magnesia [a miscellaneous category]

 a. Like black earth, presenting "shining eyes" when broken [probably manganese oxide with small reflective crystals]

 b. Ferrous, bitter, and masculine

 c. Similar to copper, with "shining eyes," feminine [probably "manganese-spar," i.e., rhodochrosite or rhodonite]

 3. Edaus [either iron ore composed of iron oxide, or iron filings or iron slag]

 4. Thutia [zinc compounds, especially zinc carbonate, $ZnCO_3$, and zinc oxide, the latter a sublimation product in brass-making]

 5. Azur [lapis lazuli, $Na_{4-5}Al_3Si_2O_{12}S$]

 6. Dehenegi [malachite, $CuCO_3 \cdot Cu(OH)_2$]

 7. Ferruzegi [turquoise, principally $CuAl_6(PO_4)_4(OH)_8 \cdot 4H_2O$]

 8. Emathita [hematite or "bloodstone," Fe_2O_3]

 9. Cuchul [antimony sulfide and lead sulfide (galena, PbS)]

 10. Spehen [misreading; perhaps a form of cuchul]

 11. Funcu [Latin *succen,* arsenic oxide]

 12. Talca [Arabic talq; not talc, but mica or layered gypsum]

 13. Gipsa [Arabic jibsīn, gypsum, $CaSO_4$]

 14. Glass

 D. Six atraments [metallic sulfates and their impurities]

 1. Black atrament [impure $FeSO_4$]

 2. Alum [$KAl(SO_4)_2$ in varying degrees of purity, as well as other metallic sulfates]

 3 Calcandis or white atrament [Arabic qalqant, a weathering product of iron or copper ores or alum]

4. Calcande or green atrament [Arabic qalqādis, iron and/or copper sulfate]
5. Calcatar or yellow atrament [Arabic qalqaṭār, either the decomposition product of sulfide-and sulfate rich copper or iron ores, or else burnt iron vitriol (iron sulfate), i.e., iron oxide]
6. Surianum or red atrament [Arabic sūrī, same as above]

E. Six boraces [$Na_2B_4O_7$]
 1. Red borax
 2. Goldsmith's borax
 3. Borax Zarunde [a geographical location]
 4. Borax arabie or alkarbi ["willow," apparently a reference to a gum and borax extracted from it]
 5. Nitrum [soda, $Na_2CO_3 \cdot H_2O$, often confused with borax]
 6. Tinchar [another designation for borax]
 7. Borax of bread [possibly potash or soda sprinkled on bread to produce a shiny surface]

F. Eleven salts
 1. Common salt [presumably NaCl]
 2. Bitter salt [perhaps a kind of rock salt]
 3. Salt of calx [slaked lime, $Ca(OH)_2$]
 4. Pure salt
 5. Sal gemma [rock salt]
 6. Salt of naphtha [NaCl contaminated with asphalt]
 7. Indian salt [not identifiable]
 8. Sal effini [not identifiable]
 9. Sal alkali [soda]
 10. Salt of urine [$NaNH_4HPO_4$ produced by decomposition and drying of urine]
 11. Salt of cinder [potash, K_2CO_3]

II. *Nascentia* (plants)
III. *Viventia* (animals)

To accomplish this feat of classification, Gābir takes common-sense categories—stones, salts, metals, spirits—and uses them to put everything from dirt to urine in its place. It is a tremendous accomplishment, but imagine how difficult Gābir's task would be if he were transplanted to a modern city. To the already bewildering list of objects in our imaginary alchemical laboratory, we could add the full roster of twentieth-century industry: the hundreds of kinds of commercial plastic, the varieties of glass, fiberglass, foams, rolled metal, laminates, composites, and look-alikes that make up our everyday world. At that point, it would become impossible to make even a simple list of all the substances, and there would be no hope of mastering their properties in a lifetime. Who knows the names of the substances in their toaster, their phone, or their car? Who could tell what metals or plastics comprise their "silverware"? That is one of the reasons why contemporary art still keeps to the simplest, most traditional materials. Despite the rise of multimedia, film, video, and installation, the majority of artists master their materials, and the majority of painters do not stray any farther toward modern technology than acrylic paints or brushed aluminum: not because they are suspicious of technology, but because there is so much to learn about even the simplest substances.

So this is what substances look like to painters: chemistry and science are there, but so far in the background that they might as well not exist. All that remains (all that counts) is what it looks like, what it feels like, what it does when it is mixed with something else. If I gently swirl a viscous, violet liquid into clear water, it finds its way slowly downward, turning and branching like an inverted blue tree. It drifts into spirals and curlicues. In a few moments the blue tendrils are faint and almost too small to see, and if I return in a half hour, the water is a uniform milky blue with no sign of motion.

Science can follow this as far as the production of swirls and eddies—the "chaotic dynamics" so beloved of contemporary science and art.[33] When the liquid settles, it becomes trackless and homoge-

neous, and its intricacies pass beyond human imagination. The glass seems quiet, and with its light blue tint, it looks like a new substance, a perfect mixture of the violet and the clear. At that point there is not much more to do or say. It is interesting that both a scientist (in this case, a specialist in fluid dynamics) and an artist (or anyone interested in reproducing the effects of swirling liquids) will be likely to find the middle stage the most intriguing. Before the liquids are mixed, they are less compelling, and after the mixture is complete, they are again a little boring.

Adam McLean, a contemporary Scottish scholar and spiritual alchemist, recommends this kind of simple experiment to understand how substances interact. He describes an afternoon's work in the laboratory using traditional alchemical substances—although kitchen chemicals would do just as well, and it would also be possible to use painting media, or the chemicals in a child's chemistry set. Even swirling blue food color into a glass of water is a simple alchemical experiment, and if the color is oil paint and the water is oil, it is also a routine artistic procedure. McLean tabulates his ingredients, giving their names in several different languages:

SODA	\ominus^{LL}	Sodium Carbonate	$Na_2CO_3 \cdot 10H_2O$
LYE, ALKALI	$\ominus\!\sim$	Sodium Hydroxide	$NaOH$
BLUE VITRIOL	$\oplus\!+$	Copper (Cupric) Sulfate	$CuSO_4 \cdot 5H_2O$
GREEN VITRIOL	$\oplus\!\sim$	Iron (Ferrous) Sulfate	$FeSO_4 \cdot 7H_2O$
WHITE VITRIOL	$\oplus\!-$	Zinc Sulfate	$ZnSO_4 \cdot 6H_2O$
VOLATILE ALKALI	$\ominus\!\!\ominus$	Ammonia	NH_3OH

The four columns nicely summarize four ways of knowing chemical substances. On the left is the alchemical name, then its alchemical symbol, followed by the modern chemical name and symbol. It is

typical that there are many variations in the alchemical names and symbols, and virtually none in the chemical nomenclature. Alchemists tended to love a measure of mystery, and many tried to keep things obscure even when they knew what they were dealing with. Some alchemical texts used symbols like these instead of words, both as a shorthand and also to keep the whole activity secret. The symbols express their frame of mind better than anything else, and I will be using some of them in this book when they fit my themes.

McLean is interested in the pure phenomenon of liquids mingling and separating, and how it conjures the idea that the mind might also be full of mingling and separating thoughts. He recommends working in a darkened room, and using three colored light bulbs to help see the changes in the liquids. The experimenter is to fill a flask with water and add a few crystals of one of the substances. McLean continues:

> Observe minutely the way in which the substance dissolves. One might for example, see streams of coloured liquid rising from the crystals, or a denser layer of liquid forming at the surface of the crystals may descend in the flask forming a layer at the bottom.
>
> Use illumination from the bottom and observe the changes using different colours of light. In some experiments, gently heat the base of the flask. . . . One will see convection currents forming in the flask, and dissolved material will be carried upwards and mix through the whole solute.
>
> Meditate upon this phenomenon . . . bearing the experience into one's inner world, inwardly picturing it, and allowing this inner picture to take on its own life. Return outwardly to the experiment in progress, and absorbing with one's senses the continuing events in the flask, then inwardly digest these again.[34]

Anyone who performs McLean's simple instructions, and is willing to forget their chemistry, will be swept into his frame of mind. Tentative

or explosive motions of one liquid through another are irresistibly metaphors for mental states. In alchemy, the Latin word *labor* is used to describe the procedures, methods, and techniques—the daily struggle with materials. Also in Latin, *ora* means prayer, and the alchemists never tired of pointing out that *labor* and *ora* spell laboratory. As in the artist's studio, so in the alchemist's laboratory: both of them mingle *labor* and *ora*. Here in McLean's laboratory, "meditating" and "inwardly picturing," *labor* effortlessly becomes *ora*.

The same kind of dynamic, swirling, unstable mixture of fluids can also be seen in paintings, wherever an artist has tried to mingle substances that do not go together easily. Leonardo's *Last Supper* is a crumbling ruin, the effect of media that could not harmonize with one another. One of his paintings of the Madonna developed terribly wrinkled skin, like paint on a car hood that is about to crack open and fill with rust. In the twentieth century that kind of experimentation is just as common as it was in the Renaissance. Like Gustave Courbet a century before, the French artist Jean Dubuffet mixed gravel and earth into his pigments, and he experimented with the kinds of oil and water mixtures that are bound to cause trouble in a painting. Some of his canvasses are like still photographs of the battling fluids McLean describes. COLOR PLATE 3 is a detail from the abdomen and left flank of a figure Dubuffet calls *The Ceremonious One*. (Note that it's been rotated ninety degrees; several plates in this book have been turned so they can be reproduced as large as possible.) From a distance, Dubuffet's figure is a quizzical, mottled-looking fellow, but from up close he is a roiling wreck. His skin is puckered and split, as full of cracks and oozes as a drying patch of mud. On the left there are great spreading blossoms of white and purple: they are oily pigments that were put down over watery ones. The same effect happens whenever you put a drop of oil on the surface of water. Next time you boil spaghetti, sprinkle the water with dried marjoram or thyme, and then add a drop of olive oil: the oil will spread the spices out, pushing them away and thinning itself into a film. If you look closely at the white splotches, you can also see faint tendrils where

the paint spilled outward in little rivulets, like mudslides down a mountain. In the middle of this detail there is a passage that looks like bark. It is the result of putting down an oily elastic layer over a smooth dry layer of blue: the white shrank as it dried, split, and pulled itself apart. To the right of the bark there are wet-in-wet experiments, where brown was dribbled into white. The weights and oilinesses of the two colors must have been about equal, because the brown stayed put—except that it couldn't mix with the white, so as the brown droplets spread out, they couldn't touch one another. Each rounded droplet of brown is separated from the next by a thin mortar of white. And at the far right margin is a huge spill, a greasy torrent that began to thicken and set halfway down. Dubuffet didn't control these effects, because they are too intricate and hard to predict. But he must have relished what he saw because he chose to leave the painting in this state. The blotches and splatters look like natural forms—bark, caked mud, flowers, bricks—but this is part of a human figure, so they also mimic skin that ages, dries, and finally splits. It is a fascinating and repulsive inventory of effects: wrinkles, cracks, sores, liver spots, and wounds, all remade in paint. If you stand in front of the painting, and step a foot or two farther back, they all recede into place and the painting becomes a portrait of a happy, disorganized-looking person with filthy clothes. But up close, the randomness and beauty of incompatible, degenerating substances is played out inch by inch in the paint itself. The paint depicts skin, but it also *is* skin. It is rich with the feelings of rotting, suppurating, mouldering, and desiccating. Just looking at it is feeling age and decay. This is the mystery and attraction of pure, nameless substances.

Though it's not my subject in this book, there are also parts of chemistry that are stranger, and less well known, even than the contents of the alchemists' fuming furnaces. *The Structures of the Elements* is an authoritative survey of the different crystal forms (the allotropes) of the chemical elements. The longest section is on sulfur, one of alchemy's principal players, and it ends with an astonishing list of

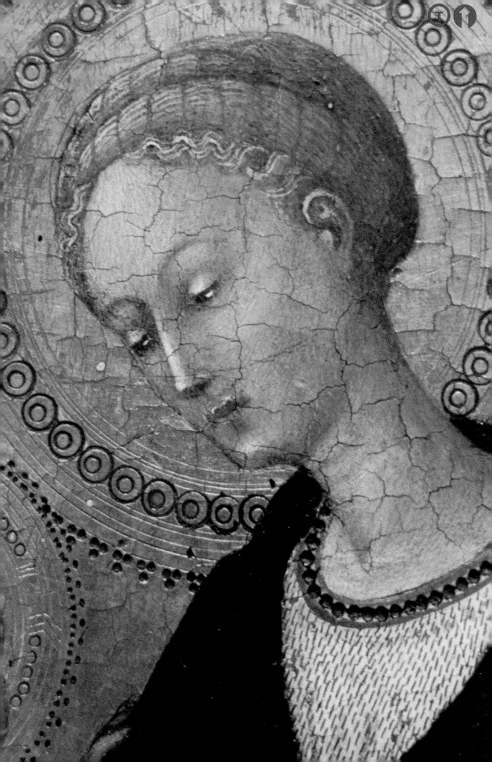

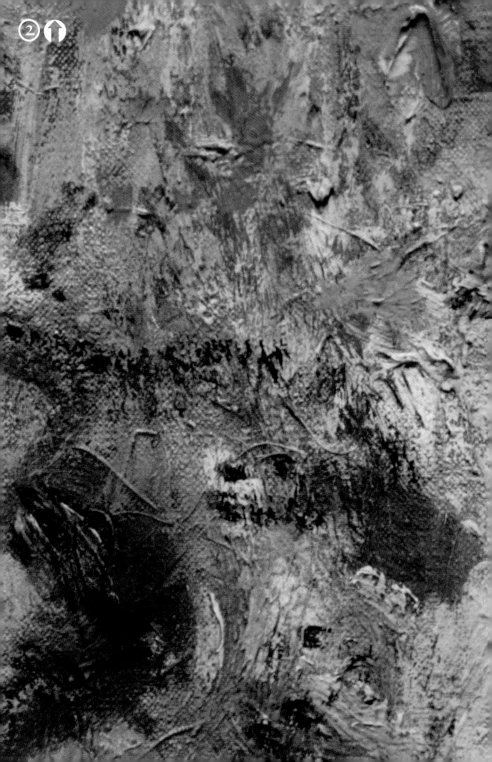

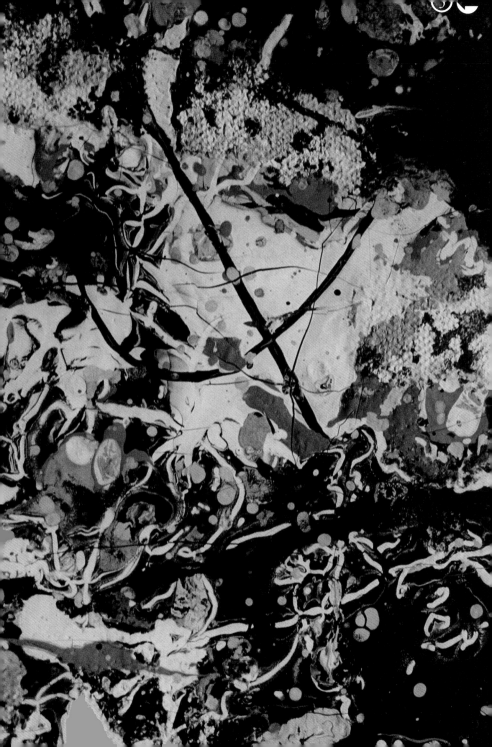

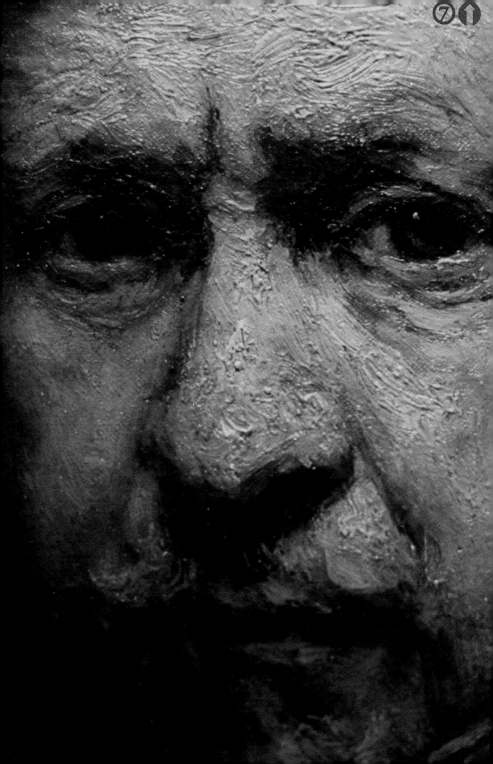

"provisional, doubtful, and insufficiently characterized forms of sulfur." These elusive allotropes are named after their even more eccentric-sounding discoverers: the Four Sulfurs of Korinth; the Twelve Crystalline Fields of Vezzoli, Dachille, and Roy; the Sixteen Sulfurs of Erämetsä; the Violet Sulfur of Meyer; the Purple Sulfur of Rice; the Black Sulfur of Skjerven; the Cubic Sulfur of Bååk. Even science has its backwaters, its unverified results, its encyclopedias of things that are seldom seen. People like Erämetsä spent years waiting, watching their test tubes and evaporation dishes, hoping for a certain red, green, violet, purple, or black.[35]

When nothing is known, anything is possible. An alchemist who added "aqua regia" to "luna" might not have had any idea what could happen. An artist who mixes salt into a lithograph, or beats water into oil paint, is taking the same kind of chance. If there is no way to predict the outcome, or to confidently name the substance, or to describe the process accurately enough so it can be repeated by someone else, then the experimenter has to watch as carefully as possible and take note of every change. That close observation is sometimes lost today, when we think we know what substances are. In a chemistry experiment, the chemist might watch for just one thing: a certain temperature, or a pressure, or the signs of boiling. But artists and alchemists have to keep their eye on everything, because they do not know what to expect. Monet paid strict attention to the motions of his wrist and arm, and the varying pressure of his brush against the canvas. He must have spent hours at a time getting his media just right, testing it again and again by dipping a brush into it, or tilting the palette to see how fast it ran. All of it was done without words, but with intense concentration.

There might be a world of difference between a greasy oil and an oily grease, or a reddish white and a whitish red. Nothing can be ruled out and anything might be meaningful. From a welter of poorly understood substances, artists and alchemists make their choices more or less at random. In part they know what they want, and in part they are just watching to see what will emerge.

2

How to count in oil and stone

THESE ARE GLIMPSES of what it's like to struggle with materials without knowing their proper names or their chemical properties. Alchemical and artistic thinking take place outside modern chemistry, but that is not all there is to the difference between studio art and the science of materials. Painting also takes place off to one side of counting and basic math, in a realm where numbers don't behave the way we were told they do in elementary school. To move farther into the alchemical state of mind, we have to move farther back down our own educations: first forgetting what little of college or high school chemistry we might remember, and then going back to elementary school and erasing the ground-level memory of classes in addition and subtraction. Alchemy and studio art exist, you might say, on the first-grade level: they depend on intuition and naiveté, and they are ruined by secure knowledge. This has nothing to do with the supposed split between the right brain and the left brain, and it does not mean that interesting painting cannot also have a high scientific content (though that is unusual).[1] What it means is that painting depends on a sense of materials and numbers that could not survive even the simplest question from a second-grade teacher. In painting, one plus one is not necessarily two.

It makes sense that artists should count differently than scientists, because painting itself does not have much to do with counting.[2] If

paintings could count, they would just say the number one over and over: each painting would insist on its own uniqueness, because no mark can be like any other, and no picture can duplicate another. Photographs, xeroxes, and prints inhabit a different world, where images come in "editions," "copies," or "multiples." A painting or drawing, on the other hand, always counts the number one. It is unique, and so is every mark on it. As every artist knows, a single brushmark can never be retrieved: if it is painted over, it is gone, and no matter how many times the same hand passes over the same inch of canvas, the mark can never be reproduced. Every mark is a different beginning: one, one, one . . . and so on forever.

Still, there is a sense in which counting happens in painting. It has to do with the way that marks exist together, so that they make sets and groups. If an artist paints a Cadmium Yellow streak, and then a Chromium Green blotch next to it, the two marks exist together on the canvas and make a set. There is no way to tell in advance how they might relate to one another: the green might balance the yellow, or harmonize with it, or pull away from it, or overwhelm it. But whatever relation they have, it is not the relation that one number has to another. Each mark is unique: the yellow is not one and the green is not two, and they do not add to make two or any other number. Looking at them, you would not be tempted to count "one, two." So even though it's possible to look at the canvas and count two marks, that goes against everything that paint does. Instead they form a set or a group or a composition that consists of two unique elements, two ones, existing together and making something new, which is another one. Paint adds like this:

$$1 + 1 = 1.$$

The three ones are not exactly the same, since the first is a yellow, the second a green, and the third something unnamable and new. So really the equation would have to look more like this:

$$1 + 1 = \text{\scriptsize I}.$$

Obviously the math we learn in school isn't going to help in thinking about painting. But there is a mathematics that can describe what happens here: it is the ancient art of numerology, and it begins—significantly enough—at the same moment that Western mathematics begins, with Pythagoras in the sixth century B.C. From there it finds its way through alchemical and mystical texts up to the present day. We still feel the last shudders of it whenever we think twice about the number 13, or wonder if 666 might not have special meaning after all. To a rationally minded modernist, numerology is nothing more than a pastime or a silly leftover of medieval—or rather, preclassical—superstition. But a tremendous amount waits to be written about numerology, because even the greatest mathematicians have had hunches and feelings about numbers. It is a commonplace among academic number theorists that as the properties of different numbers become more familiar, they take on personalities of their own. Once Srinivasa Ramanujan Aiyangar, perhaps the most important mathematician of the century, was visited by a friend who remarked that the day was not especially propitious since the license plate of the taxi that had brought him to Ramanujan's house had the number 1729—"Not a particularly interesting number." Ramanujan's face lit up, and he said, "On the contrary! 1729 is the smallest number that is the sum of two different cubes two different ways: $1729 = 12^3 + 1^3$ and $1729 = 10^3 + 9^3$." Ramanujan "knew" the number, and that kind of acquaintance is not irrelevant for mathematics, because it will lead a mathematician to make other discoveries. Ramanujan could have added, for instance, that 1729 is also the sum of 865 and 864 and the difference of their squares 748,225 and 746,496. Numbers unfold their peculiarities to people who think about them as individuals, instead of as anonymous markers on a notched line leading to infinity. Numerology can also be found in philosophy and the humanities, with their nearly mystical interest in twos and threes. The philosopher Hegel started that obsession by insisting that nature counts by adding a thesis to its antithesis, and subsuming both in a synthesis; and even today postmodern theorists shy away from "reductive dualities" and search for ideas that call for larger congregations of num-

bers. They tend to mistrust any idea that comes packaged as a "dual-istic" choice, or a "Hegelian" triad. In all cultures, numerology has had little to say about larger numbers: except for the important ones (666, 1000), numerologists are mostly interested in numbers under twenty or so. There is a certain truth to the habit of sticking to smaller numbers, since the unaided human mind can rarely hold more than three or four ideas at once. (According to the psychoana-lyst Jacques Lacan, the numbers zero to six are a special key to the psyche because the unconscious can't count beyond six.[3]) The basic idea of this book is a duality (painting and alchemy), and as I write I might be able to keep a half-dozen of its themes in my head at once. But no one except the odd number genius has theories that depend on 1000 or 1729 ideas. Numerologists are right to remain faithful to the normal capacities of the mind. Dualities may be reductive, but they are entirely reasonable quantities for understanding the world.

 In the case of the two dabs of color, the combination is not two, exactly, but it is a new object that has the feel of the number two: it is what the numerologists called a dyad. Numerologists do not count "1, 2, 3, 4" but "monad, dyad, triad, tetrad" or "oneness, twoness, threeness, fourness" or "singleness, doubleness, tripleness, quadru-pleness," or "unary, binary, ternary, quaternary"; and they do so because it helps preserve a sense of the uniqueness of each "number." In the end, a quaternity is still four—but it is a much richer four than the ordinary number four, because it has within itself much of the meaning of oneness, twoness, and threeness. This kind of numerol-ogy is not antiscientific (I am not speaking about superstitious or astrological numerologies), but it is extra-scientific: it exists along-side mathematics, neither contradicting it nor helping it in any easily describable fashion. And it is hardly an unimportant or marginal way of thinking: everything is counted according to numerological mean-ings *except* the abstract numbers of mathematics. It is trivially true that a mother, father, and daughter make three people, but it is much more important, and more profound, that they make a family—that is, they are a triad that is another unity. Paint mimics people in that way.

•

Alchemists cherished individual numbers, lavishing them with alle-
gorical meaning and searching for their intrinsic significance. Each
number was treated separately and differently than the others, so that
the endless number line was transmuted into a collection of different
kinds of objects rather than a sequence in the mathematical sense.[4]
Alchemical numerology ascribes personalities to numbers, and some-
times it goes farther and even gives them weight and body as if they
were physical substances. The Renaissance mystic John Dee, spiritual
alchemist and personal astrologer to Queen Elizabeth I, alludes to
this in his willfully strange book *The Hieroglyphical Monad*. Math-
ematicians, he says, treat numbers as if they are "abstracted from
things corporeal, and ... remote from sensual perception." They
would be astonished to see that "in our work" numbers are "concrete
and corporeal ... and that their souls and formal lives [*animas, for-
malesque vitas*] are departed from them so as to enter our service."[5]
Dee's numbers are nearly living beings: they have hidden meanings,
personalities, and even bodies, and their bodies have incorporeal
souls. This is why alchemical numerology is suited to painting: it
does not stop short at the vague intuition that numbers have charac-
ters, but it tries to bring them to life. Like the substances that the
alchemists studied, these numbers have spirits and souls. Only the
thinnest veil separates them from clay and gold and fire.

There is a word, *hypostasis,* that describes what happens when flu-
ids and stones seem to have inner meaning, and when numbers come
alive. Properly speaking, it is a religious concept: Jesus was the hypo-
static incarnation of the Word of God into the ordinary substance of
a human body, meaning that he was spirit that became flesh.[6] A
hypostasis is a descent from an incorporeal state into ordinary mat-
ter, or in general an infusion of spirit into something inert. It can
describe the feeling that numbers have "souls and formal lives," and
it can explain the notion that two fluids, mingling in a bottle or on a
canvas, are somehow expressing a state of mind.

Hypostasis is the feeling that something as dead as paint might

also be deeply alive, full of thought and expressive meaning. One moment paint is nearly nothing, an excuse for some historian to write about the influence of Florence on Siena, or the difficulties of realistic painting—and then suddenly it is also there in all its stubborn weight and thickness, clinging to the canvas, gathering dust, wrinkling with age. Ordinarily paint is a window onto something else, a transparent thing that shimmers in our awareness as we look *through* it to see what the painter has depicted: but it is also a sludge, a hard scab clinging to the canvas. The art historian Hubert Damisch said it best when he titled one of his books *The Cadmium Yellow Window*.[7] A painted window can be brilliant with light—think of Matisse's open windows, with their curtains blowing in the warm ocean air—but it is always also a closed plaque, a heavy mineral deposit that is stubbornly and absolutely opaque. And when it is merely paint, it begins to speak in an uncanny way, telling us things that we cannot quite understand. It seems to be infused with moods, with obscure thoughts, and ultimately—in the language of alchemy and religion— with soul, spirit, and "formal life." From that moment on, it never stops speaking. Like alchemists, painters are bound up in hypostatic contemplation: paint seems irresistibly to *mean,* as if the littlest dab must signify something. It never speaks clearly because—as any sober scientist or humanist will tell you—every meaning is a projection of the viewer's inarticulate moods. Substances are like mirrors that let us see things about ourselves that we cannot quite understand. And in painting there is another element in the equation, which suddenly makes the feeling of meaning tremendously interesting: the paint was laid down by an artist who also had hypostatic feelings about paint, and so it is also possible to interpret those feelings in pictures instead of just imagining them. The most reliable way to do that—if anything this tenuous and personal can be called reliable—is to look at the marks as evidence of the motions of the painter's body, as I have done with Monet. It is also possible for paint itself to have meaning as it works against itself, over and under itself, on the canvas—as it does in Dubuffet's portrait. All of this is speculative, and most of it is

useless to cold art history, but it is the fertile hallucination that makes paint so compelling. Paint is like the numerologist's numbers, always counting but never adding up, always speaking but never saying anything rational, always playing at being abstract but never leaving the clotted body.

I

To begin counting, it is best to start with one. The Bible opens with a primal unity: In the beginning all elements were a single chaos. Alchemists often speak about the world around them as if it were still that ancient chaos "without form," and they imagine their purpose to be the regathering of the fallen parts of the world into a new unity. The "All in all" (*omnia in omnibus*), a favorite alchemical invocation, is an attempt to compensate for the bewildering variety of the world, by swirling every conceivable object into the first undifferentiated unity. *Omnia in omnibus* also gestures toward the interconnection of all things, as if to say, Even though there are two marks, or an infinity of marks, they are only a single mark.[8] The perfectly fused substance is the unwavering goal of alchemy, and it is also alchemy's starting point: just as the world began in a single chaos, so it will end in an impeccable perfection.

The best name for this congealed perfection is the monad. To Dee, the number one known to arithmetic is only an example—an "outward sign"—of the fundamental carrier of "unary" meaning, the monad. Its special unity is the property of the philosopher's stone, goal of the entire alchemical *opus*. In that sense the monad is neither one nor any other number. It is a quality (*virtus*) that engenders the whole of Nature. Pythagoras was interested in harmonies between numbers, and some of the discoveries ascribed to him are at the foundation of mathematics; but he also apparently thought the first ten numbers were a kind of cipher for the universe, all beginning and culminating in the number one. He is credited with inventing the *tetraktys,* a pyramidal arrangement of points:

```
        .
      .   .
    .   .   .
  .   .   .   .
```

The monad at the vertex is followed by a dyad, a triad, and a tetrad, all adding to ten. This schema was taken to have fundamental affinities with the structure of the world, the harmonies of music, and the basic properties of numbers. It does not so much add to ten as culminate in the "denary," which repeats the monad again on a higher level. Alchemical thought moves up and down this sequence: one thing becomes two, which becomes three, and four, and then the four coalesces and shrinks back into the three, the two, and the one. The idea that the monad is a fundamental source rather than a number is probably due to Johannes Trithemius, who is credited with the proverb "Unity is not a number, but it gives rise to all numbers."[9]

The monad is dark because it cannot be clearly understood. It is inhuman, or rather, it is prehuman. Even sexuality is undefined before the number two. Pythagoreans identified odd numbers with maleness, since they are "hard to divide," and even numbers with femaleness, since they are "easy to separate."[10] The number one was considered to be "both male and female at once," because "it alone is both even and odd": that is, it can be added to an odd number to make an even number, or to an even number to make an odd number. In contemporary mathematics, this does not make sense, since any odd number, added to an odd or even number, will produce an even or odd number. But the idea is that one is itself not a number. Pythagoreans defined an odd number as one that can only be divided into two unequal parts, one even and the other odd. Hence one is not yet a number, but a source of numbers. For the same reason an even number is one that can be divided into two equal parts and also two unequal parts, so that two is also not yet a number, but a source of numbers. So the number one is chaos, "formless and void," undivided, before sexuality itself.

If there is a monad in painting, it is the shapeless, formless masses of oils, waiting to be distilled and separated into grades, or the endless rocks in the earth, waiting to be exhumed, purified, and ground into pigments. The monad is all paint, before it is separated into individual paints, and long before it is injected into tubes, squeezed onto palettes, separated into piles of colors, regimented along the color wheel, and teased into figures and landscapes. Those are all divisions, moving down the *tetraktys* toward infinite variety. In poetic terms, the paint monad is the perpetual implacable enemy of every painter, because it is the meaningless formless mindless raw stuff out of which something must be made. The paint has to be divided from itself to be useful. There has to be distance between parts of the paint: between yellow and red, and then between yellow and orange, and then between yellow and yellowish orange. There have to be distinctions of mass and medium: between sticky and runny, sticky and smooth, sticky and tacky. Those divisions are not infinite, as they are in mathematics, but they go by twos, threes, and fours. The most colors that any artist has on the palette is twenty or thirty: after that, they begin to resorb into a grey continuum, and the battle against the monad is lost. (A few painters had more intricately subdivided palettes. Seurat's was a gridwork of tints and hues, made in strict compliance with his pseudoscientific color theory. But those cases belong in the archives of pathology, and few painters have felt compelled to take such artificial steps.) After the paint has been divided from itself, and its primal mass has been splayed into the colors of the spectrum, then it needs to be recombined, placed together with itself on the canvas. In the end, the paint is once again a single mass. The monad splits into the dyad, and the bifurcations continue, and then gradually slow, and fuse, until the last gaps are closed and the paint returns to itself, reunified and perfected.

The best emblem of the monad is the famous alchemical *ouroboros,* the snake with its tail in its mouth. One of its many names is "Unity of Matter," and another is *Omnia in Omnibus.* It was first illustrated in a Greek alchemical treatise, and it flourished

during the renascence of alchemy in the seventeenth century.[11] In popular mythology, the snake clenches its tail in its fangs in order to roll quickly downhill, but the original ouroboros has a more violent purpose. One seventeenth-century writer put it this way, comparing the ouroboros to the mythical Polyps who cannibalized themselves:

> An atrocious hunger forced the famished Polyps to gnaw at their
> own legs,
> And it taught men to feed on human flesh.
> The dragon bites its tail and swallows it,
> Taking most of itself for food.
> Subdue the dragon by hunger, prison, and the sword, until
> It eats itself, vomits, dies, and is born again.[12]

In this poem the ouroboros not only bites itself but eats "most of itself," decaying in the alchemical vessel until it dissolves into "vomit." Taming the ouroboros by "hunger, prison, and the sword" means destroying it by sealing it up and heating it (the sword is a symbol of fire) until it ingests itself—in other words, putting it in a pot and cooking it until it is mush. Some alchemists tried to give exact interpretations: one thought the dragon is the blackness that remains at the bottom of a vessel when everything else has been boiled away, and the last thickened water around it was its tail, so that the two could be coagulated together into something new.[13] Another said that the dragon is mercury, and the tail is salt, and when they are heated they become "the ash that is within the ash" (*cinis qui est in cinere*), capable of sending out a life-giving rain and coming alive once more.[14] But no matter how it is glossed, the ouroboros that eats itself is an unforgettable image of the continuous recirculation of the monad: it begins as one thing, attacks itself, falls into its own mouth, and then—when nothing is left except the bloody mouth, and the intestines are inverted in an impossible topology—it vomits out its own chewed insides. That pool of flesh is the monad again, even more rigorously single. The ouroboros is the relentless

search for perfect self-coincidence that dogs alchemical thinking.

These thoughts of horrible destruction and partial sexuality are threads that run through alchemy. They are the inescapable result of giving bodies and souls to numbers: after all, what could be more monstrous, more formidably inhuman, than the number one itself, the birthplace of the universe and the moment of its destruction?

2

After one comes two. Two is really all painting needs: a color or a texture, and something that can stand opposite to it. The history of painting is full of pictures that take their energy from the primordial contrast of light and dark: a brilliant angel bursts in on a saint who studies in the darkness; a woman sits alone in a dim room, looking at her reflection by the light of a guttering candle. Just as many pictures make use of the less fundamental contrasts between warm and cool, above and below, smooth and rough. The twentieth-century painter Adolf Gottlieb finally reduced all those possibilities to the elementary contrast of two shapes. Above, a smooth and glowing reddish sphere; below, a hacked and splintered black tangle of paint.[15]

The dyad is universal, and rarely achieves such a pitch of drama. In everyday occurrence it is just one mark to the side of another, or a green near a yellow. Any two marks are a dyad. From the Venetian Renaissance onward, painters have made use of a convenient contrast between warm and cool in order to paint as efficiently as possible. A Venetian painter might begin by laying down a thin reddish-brown undercoating, the *imprimatura,* over the whole surface of the canvas. Then, to paint a sky, he would cover the imprimatura with translucent layers of cool paint—say Ultramarine Blue, mixed with Lead White. The hills would be warm by contrast—say a tan Ochre. The object was never to let the two clash into a child's version of sky and ground, but to keep the reddish-brown imprimatura visible so that it could soften and blend them into a common background. The miracle of the method is that it is so simple: even a few careless marks will make a convincing landscape if the viewer steps back far enough to let the

colors soften and merge. COLOR PLATE 4 is a small detail from a seascape.[16] The artist, Alessandro Magnasco, is a wonderful and eccentric painter from the time of the alchemists. He was captivated by scenes of failing light and engulfing darkness, and his paintings often have spectral lights flashing in deep twilight. This is the crucial portion of one painting, where a warm sky meets a cool, windy sea. Everything above this passage is scudding clouds and sunset glow, and everything beneath is dark turmoil. The earth is in tumultuous disarray: waves are whipped up, trees lash back and forth, the weather is changing. Originally the painting would have been even wilder, but like so many paintings it was relined (the canvas was removed and a fresh one put in its place), so much of the paint has been pressed flat.[17] (Relining is a very common procedure, and it is a fair guess that most major paintings done before the twentieth century have been relined. Ask the staff in the museums you visit which are which, and you will be able to see how much damage was done. In the case of Magnasco's painting, it helps to imagine a more corrugated and less glossy surface.) Underneath the layers of paint is a light tan imprimatura, visible just to the left of the boat among the flecks of white foam. It's important to see the imprimatura first: when artists set out to copy paintings, they search for the places where the imprimatura is most obvious, so they can match its original color. Here it is clearest to the left of the rudder, where there is an especially strong line of white seaspray. Just underneath the spindrift is the neutral brown of the imprimatura, left entirely uncovered. Once you have seen it, the color of the imprimatura shines through everywhere: it tints the entire middle third of this detail, softening the colors into a mirage of mists and vapors. For the sky Magnasco used a warm tone—Lead White, with touches of Naples Yellow, blue, Vermilion, and browns—and for the sea, a cool tone—Ultramarine, with touches of browns. (Magnasco was not one of the painters who used only a few colors. This is real polychromy: within the small compass of this detail, there is purple on the hill, and an orange just above the boat; the painting has perhaps a dozen pigments in all.)

The warm sky descends onto the horizon, and the cool sea rises up toward it. They do not meet in a line but in a blur, and they cross and overlap. There is some blue-green underneath the rose paint of the sky, and also blue-green over the sky color: at the left, closer to the horizon, are five or six hairstreaks of blue lying on the rose. In the ocean, the two basic tones are much more tangled, and sky colors come flooding down over the roughened horizon, as if the air could dilute the ocean, or the ocean could evaporate into the sky. Near the center of this detail, there are two very thick, short horizontal strokes, one a fingerbreadth above the other: the upper one is rose, and the lower one blue. Even at the bottom where the darkness is swallowing the light, Magnasco has put faint swirls of sky-color into the wet ocean-color. When painters work this way, they tend to have two brushes in their painting hand at once, one for each color. That way they can switch back and forth with the speed of a thought, alternating until the two colors are perfectly mingled. One of Magnasco's biographers called this method painting "by dabbing" (*dipingere di tocco*), and there are quick touches and streaks throughout the picture.[18]

Even in this little extract from one painting, there is an uncountable complexity of marks—a diaphanous conversation between light and darkness, one that can never end because the two are as inextricably woven as waves of light. At the same time the painting is beautifully simple, because it is easy to say what the paint is about. In a single phrase: it is light, talking to darkness—a dyad.[19]

Because the dyad is one thing with another thing, side by side, it has also been called the "source of distance and inequality." Before there were two things, nothing could be separate from anything else, and nothing could be unequal. With the dyad, all that changes. "Distance and inequality" are the words of Iamblichus, an author credited with the best treatise on numerology, the fourth century A.D. *Theology of Arithmetic.* Iamblichus also thinks that the dyad has no shape: it is not yet quite an object in its own right, as three, four,

and the other numbers are. The reason has to do with the way the Greeks arranged numbers into grids and piles of dots, which they called "triangular numbers," "square numbers," and so forth. Sixteen, for example, is a square number:

```
•  •  •  •
•  •  •  •
•  •  •  •
•  •  •  •
```

By that logic, the dyad has no shape, since it is only a dotted line with two dots:

```
•  •
```

Because the dyad does not command an area of any sort Iamblichus calls it "indefinite and formless."[20] Like the monad, it is a singleness, but it appears also as a doubleness. The alchemists, always looking for sexual parallels, saw in that halfway condition an incomplete sexual fusion: what is double is either on the way to becoming one, or on the point of dividing into numberless pieces.

This is the discourse that lies behind the founding alchemical pair of sulfur and mercury. At least from the time of Arabic alchemy, and in the West from the twelfth century, sulfur was paired with mercury as the two fundamental constituents of matter.[21] The beginnings of that idea are lost, just as the origins of trichotomy and tetratomy.[22] In most Western alchemy sulfur and mercury are known by long lists of synonyms that at first make the treatises bewildering to read. The two are called—in a list made by a modern scholar—"Osiris and Isis, sun and moon, Sol and Luna, brother and sister, masculine and feminine, active and passive, giver and receiver, seal and wax, fixed and volatile, wingless lion and winged lioness, lion and eagle," sun-tree and moon-tree, yellow and blue.[23] Sulfur is also oil, crocus, soul,

and "all-nature," and mercury is phlegm (meaning distilled liquid).[24] In Indian alchemy the list of synonyms is just as large, and it is called the Twilight Language (*sandhya bhasya*).[25] Learning those undependable names is part of the novice's initiation into alchemy, and it quickly becomes clear that no meaning is the single best one.

The dyad is fundamentally male and female, but it is also every conceivable opposite that belongs together: knowledge and ignorance, good and evil, Gnostic light and darkness.[26] The key is that the opposites are true to the principle of opposition: they are not some arbitrary pair like salt and pepper, set up by convention, but the concept of pairing itself: sulfur is to mercury as husband is to wife. One flies (meaning it can be boiled off), and the other sits (heat does not move it). One burns, the other does not. One is porous, the other is not. One can be smashed, the other cannot. In each case the qualities of sulfur and mercury complement one another and make a perfect union, so that the dyad is never an arbitrary pair. It can represent anything in the world, but it is always the universal underlying principle of opposition.

Two marks, side by side on a canvas, make a dyad. Something about them is closed or finished, and they seem to create a universe between them. This is true of any two marks, whether they are painted on paper or etched into a rock face. Any two marks, seen together and without any distractions, will appear complete in themselves, as if they were a whole language in two words. "Male" and "female" may be the deepest names we can give to them, but any will do. And as Iamblichus says, the dyad will also appear unequal or unstable. Merely because the marks are different they will conjure the thoughts of separation, difference, and singleness, as if they were two unique individuals who could never be exactly equal. Unless they are mechanically balanced, two marks will suggest inequality, and all the dynamics of relations that go into being human.

It may seem that I am reading too much into a pair of marks, but that is only so if we decline to look closely and think openly about

what we see. The beginnings of pathos, domination, loneliness, insta-
bility, and love are all present in the most careless and accidental pair
of marks—say the two minuscule bars of blue and rose in Magnasco's
sea. The blue tilts slightly upward, and has a little curve to it, and the
rose is lenticular, and has a tiny echo to its left. They are a perfect
pair and a whole, and yet they can never be balanced: that is the
dyadic relation in miniature. It contains the seeds of any human rela-
tion. The dyad is a new unit but it is also formless incipience and
incompletion—as if it must divide, because anything that is two must
become one or three.

3

From here the doctrines multiply. The monad and dyad are wonder-
ful starting places for meditating on the relation of substances, and
on relation in general, but it was never easy for the alchemists to
explain how all substances are comprised of just sulfur and mercury.
The sixteenth-century visionary Paracelsus is conventionally, but
unjustly, credited with introducing a third principle to help bring sul-
fur and mercury together: salt, the "double saline mediator," which is
sometimes written as **Y**, as if to imply that two things fuse into a
third. In the Renaissance sulfur, mercury, and salt became the *tria
prima,* the three first principles. In books they are represented as the
alchemical triangle, sometimes constructed from three serpents. With
three principles instead of two, the associations at once become
much more dense. Alchemists who were interested in spiritual and
religious meanings quickly baptized them the "three hypostatical
principles" (*principia*; in Arabic, *arkān*) of body, soul, and spirit,
bringing them perilously close to the Christian Trinity. Other
alchemists found ways of squeezing the four Greek elements of
water, air, fire, and earth, so they would fit the new Trinity. As in all
number symbolism, schemata were trimmed as best they could be to
match the new regime:[27]

Mercury	Sulfur	Salt
metallicity, liquidity	inflammability	uninflammability
volatile, unchanged in fire	volatile, changed	found in the ashes
Holy Spirit	God the Father	Jesus Christ
spirit	soul	body
water	air and fire	earth
phlegm	fat	ash

The rearrangements and substitutions among the triads produce an almost uncontrollable plethora of meanings, and alchemists never stopped rearranging them.[28] The triad has a burgeoning usefulness, as opposed to the empty monad and the irresolute dyad. Once there are three, there is structure: there can be pictorial compositions made of triangles, families made of more than just husband and wife, Christian theologies, and whole natural histories, each more interesting than the simple dichotomy of opposites.

In post-Renaissance alchemy substances were often thought to be made of sulfur, mercury, and salt, or of the three principles together with the metals copper, iron, tin, lead, and gold. The Renaissance alchemist called Basil Valentine classifies gemstones this way: diamond, he says, is made of "fixed coagulated mercury," while rock crystal is only made of ordinary mercury (*Mercurio vulgi*). Ruby is composed of the "tincture of mars" (*Tinctura Martis*) or "sulfur of iron," emerald is the sulfur of Venus, granite the "soul of Saturn" (*Anima Saturni*), and sapphire is composed of sulfur and the "tincture of the moon" (*Tinctur Lunæ*).[29] These are all beautiful ways of thinking about gemstones, and they have their share of truth. Leonhardt Thurneysser von Thurn, a disciple of Paracelsus, wrote a monstrously long treatise classifying varieties of parsley and other garden plants by noting the exact proportion of sulfur, mercury, and salt that produce each one.[30] He goes in exhaustive detail through every possible medicinal use and property that they might possess, and explains them all in terms of the three principles. The plant in Figure 1 is called *oppopanacis,* and it has six parts of sulfur, two of salt, and four of mer-

cury (as Leonhardt notes at the top right). Using sulfur, salt, and mercury, the whole wide world could be built out of three common parts.

4

The quaternary relation, or tetrad, can spring from any of the sets of three. John Dee imagines fourfoldness as something that "flows" from the monad, in the way that the point at the center of the cross can be extended into its four arms. He calls this kind of addition and subtraction "mechanics": just as "geometricians teach that a line is produced by the flowing of a point [*LINEAM, EX PVNCTI FLVXV*]," so "our lines signifying the elements are produced by the continuous fall of drops that become a flow [*quasi FLVXV*]."[31] We are to imagine the corporeal numbers, pouring themselves into new shapes, and it could also be an image of the liquidity of paint, smearing a point into a line, pushing a line into a cross. A tetrad can also be made of two dyads, or a triad and a monad, and any such combination will reverberate—an alchemical term—with the qualities of its constituents. One tetrad, therefore, may be utterly unlike another.

To alchemists, the four elements are everywhere. The medieval writer Marius analyzes milk in order to show that even fluids can contain all four of the classical Greek elements earth, air, fire, and water.[32] If milk is whipped, cream appears at the top, and if the remainder is put in a jar, it will separate into whey and water. Then if the whey is burned, ashes will remain. The experiment yields the four constituent products of milk: butter from the cream, water, fire, and ashes from the whey, and they translate into air, water, fire, and earth. The butter is air, Marius insists, because it can nourish fire. Milk contains a little fire, both because it warms the body and because the whey burns. Eggs have also been subjected to this quadrature. The shell is the earth, the white water, and the yolk fire, for three different reasons: the shell is chalky, so it must be earth; the white is fluid, so it is water; and the yolk is fire, since it's yellow. That leaves air unaccounted for, and according to one alchemical text it can be found in the two membranes that separate the other three parts of the egg.[33] The inner membrane between the yolk and white

Jul.6.die.
⊙ 26♋
☽ 12.♍

צְרִיעֶשֶׁב : פֶּנֶג

Sulph. vj
Saltz ij.
Mer. iiij.

Ein Oel.
Magiste.
Ein Saltz

πάνακες.

Wermbt.
Weichet.
Vn offnet.

Iß gewechs hat ein zimliche Lange/ vnd
mit vil Beyzeserlein bewachssene/ starcke
vnd fingers dicke/ auch treffenlich starck

is more tenuous, in keeping with its closeness to fire, and the outer membrane between the white and the shell is farther from fire and closer to earth. Hence an egg contains earth, water, fire, "upper air" and "lower air." Although many creatures lack one or another of the elements—according to where and how they live—humans are usually said to be made of all four.[34]

Another example, more neatly worked out than eggs or milk, explains why a log has all four elements. When a log burns in the fireplace, the flame seems to grow from the wood itself, like fiery leaves. (Some writers noticed that if fire is the child of wood, then it is an ungrateful progeny, since it also eats away at the wood until nothing remains save piles of white ash.) Green wood also hisses, and weeps tears of water and sap. Smoke rises and dissolves into air, and sometimes steam can be seen escaping or condensing on nearby windowpanes. There is a great quantity of this unseen spirit: Van-Helmont noted that "sixty-two pounds of oak charcoal yield one pound of cinders," so the rest must be "woody spirit."

In modern chemistry, we could say that the hydrocarbons in the wood decompose, with the hydrogen combining with oxygen to yield water and the carbon remaining behind. But that description would have been too simple for the alchemists, because it goes against the richness of experience. In alchemical thinking there are four substances working together to destroy the log: fire, earth (as the wood itself), water, and air. It is also possible to evade the Greek quaternity and think of the burning log as three things instead of four: a combustible element in wood, an element that can be vaporized, and an element that can neither be burned nor vaporized. Paracelsus thought that those were sulfur, mercury, and salt respectively, so that wood is composed of a certain mixture of three elements instead of four.[35]

FIG. 1 *Oppopanacis*. From Leonhardt Thurnheysser von Thurn, *Historia Unnd Beschreibung Influentischer, Elementischer und Natürlicher Wirckunger* (Berlin: Michael Hentsken, 1578), p. 10. All black and white photos are courtesy of University of Wisconsin, Madison.

This kind of reasoning is rooted in the human imagination, and it continued right up to the brink of modern chemistry. According to proponents of the disproved "phlogiston theory," fire exists in an invisible combined state (*phlogiston*) and a visible uncombined state (common fire). Burning a log is liberating phlogiston, and revealing both the fire and the remaining substance. Hence the phlogiston theory, which stands at the threshold of chemistry, can be understood as a further reduction of the number of elements in the log. At first it was four, in the system used by the Greek and Arabic writers, then it was three, in some treatises of Renaissance alchemy, and finally two, in the eighteenth-century phlogiston theory.

It seems as if the quaternion, as it was called, is an especially sturdy number. Jung proposed four colors as the standard alchemical sequence: black, white, yellow, and red. In Greek natural philosophy, the four elements—earth, air, fire, and water—have four associated qualities—moist, dry, hot, and cold. (The alchemists call them *qualitates*.[36]) The four elements do not correspond exactly to the four qualities, so the arrangement is sometimes imagined as a square of elements with sides that are qualities:

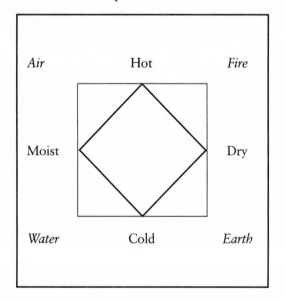

Air	Hot	Fire
Moist		Dry
Water	Cold	Earth

Many things make sense with the help of this diagram. Fire is hot and dry, water is cold and moist. When earth (meaning anything in and on the earth) is heated, it becomes dry and catches fire. When air becomes too moist, it rains as water. The inscribed square shows that grease is cold, since it is a little more like earth, and oil is moist, since it is nearer to air. To the English mystic Robert Fludd, air is "dense and crass" fire, water is dense air, and earth is dense water, giving the square a circulating motion.[37] The Greek way of thinking is comforting and circular. The quaternion corresponds to the four elements, the four qualities, and to many other sets of four:

the four seasons

the four Evangelists (Mark, John, Matthew, Luke)

the four sacred animals (lion, eagle, man, and cow)

the four kinds of substance (animals, plants, metals, and stones)

the four kinds of animals (those that walk, swim, crawl, and fly)

the four sorts of stones (precious, light, hard, opaque)

the four ages of man (*infantia, adolescentia, maturitas, senectus*)

the four winds (Eurus, Zephirus, Aquilo, Auster)

the four humors (sanguine, melancholic, phlegmatic, choleric)

the four temperaments or "complexions" (vivacity, gaiety, nonchalance, and slowness)

the four movements of nature (ascendant, descendent, horizontal, and circular)

the four terms of mathematics (point, line, plane, space)

the four terms of metaphysics (being, essence, potential, and action)

the four moral virtues (prudence, justice, temperance, and power)

the four rivers of Eden (Physon, Gihon, Hiddekel, Euphrates)[38]

The problem, of course, is that the same kind of list can be made for two, three, four, five, six, seven, and twelve. The Christian Trinity is resilient, but the Greek system of four elements is almost designed to be disassembled, especially when it has to accommodate somehow

the three principles.[39] Simpler accounts solve the discrepancy by fiat: thus an anonymous eighteenth-century treatise on the "powder of projection" declares that salt is dry, sulfur hot, and mercury both cold and humid, so that the four Greek qualities hot, dry, cold, and humid are squeezed into the primary trinity.[40] But even though sleight of hand can solve the problem by erasing one system or another, the choice between four Greek elements and three principles was a serious one.

The diagram of elements and qualities is also vulnerable when it comes to unusual substances. Anyone who has had mercury in their hands, and felt its curious weight, has been drawn to reflect on the nature of liquids. Mercury is like water, and yet it is like metal. Mercury poses severe problems for the stability of the square, since it is both moist and dry, both water and earth. On the square, that translates into a torsion that breaks the diagram entirely. Mercury's many names reflect the alchemists' bewilderment: it was called quicksilver (meaning "living silver"), dry water, living water.[41] "Living water" (*aqua vitae*) also meant alcohol, a most wonderful water since it burns. A glass of alcohol is indistinguishable from a glass of water, but it burns with a cold flame, as befits something cold and moist. Aqua vitæ therefore collapses the square of elements into a triangle, by pulling together the opposite vertices of fire and water.

All of these strange substances tear at the neat diagram, dismantling it in favor of a simpler form—say a triangle, or a straight line. In that way, the alchemists worked backwards from tetrads to triads and dyads, to the unary Stone itself:

Because sulfur, salt, and mercury are a mystic reflection of the Trinity, they are also one. "In the profound depths of the nature of

mercury is sulfur" is a saying attributed to Ǧābir.[42] Basil Valentine's *Triumphal Chariot of Antimony* sings the praises of antimony in such a way that it begins to appear as if it is the Stone itself. Antimony "combines the virtues" of all precious stones, he writes, and it can be prepared so it becomes "a true Stone."[43] Just as the theology of arithmetic can become monotheistic, alchemy can become monolithic—in the literal sense of that word, "one stone." Paracelsus helped along these confusions by claiming that earth, air, fire, and water are each composed of the three principles of sulfur, mercury, and salt, but that each principle is different in each element (air's sulfur is not the same as water's sulfur). A little math suggests that there are twelve principles, or perhaps an infinite number, if they change in every substance.[44]

Jung supported his sequence of four color stages by reducing more complicated texts to their "fundamental" four stages black, white, yellow, and red (*nigredo, albedo, citrinitas, rubedo*). Many alchemical texts do not keep to the four-step sequence, and it is also common to find black, white, red, or black, white, green (*viriditas*), red, or an indefinite number of cycles, or no color identifications at all.[45] Even the 4-3-2-1 sequence is often only wishful thinking on the part of readers and alchemists. A modern work, John Read's *Prelude to Chemistry*, proposes such a sequence:[46]

Four elements	Three principles	Two opposites	One stone
Earth			
	Spirit		
Air		Moon	
	Body		Tincture
Fire		Sun	
	Soul		
Water			

This tempting simplification, first proposed by Michał Sędziwój in 1604, has been repeated in several texts.[47] But such a simple reduction is rare. The alchemists are usually much more deeply confused

or uncertain. Four is close to the limit of what the imagination can hold, and quadripartite schemata tend to become unstable and collapse.

∞

The alchemists also had stories about the numbers seven (the metals) and twelve (the months of the year), but the trail becomes fainter after the quaternity. The periodic table that clogs our imagination of substances is the end of these exfoliating fantasies. Its very length makes it immune to allegory, since it is impossible to concoct personal stories for *all* the elements.[48] Primo Levi's poetic novel *The Periodic Table* achieves a partial imaginative rethinking of the elements, including several alchemical episodes. He has stories to tell about most of the common elements, but he cannot bring the entire periodic table into the life of the imagination, and he says nothing about the awkward polysyllabic elements that crowd the end of the table.[49] Perhaps a precondition for modern science is a robust autoimmunity to all forms of allegorical meaning.[50]

To a modern reader, the forest of alchemical substances and symbols seems more difficult to learn than the periodic table, but in practice it is somewhat easier. Though alchemists also worked with a large number of substances, they did not have words or symbols for all of them.[51] The obscure synonyms and symbols that make it so difficult to understand books of alchemy are not endless, and a few common ones are used most of the time.[52] Some of the basic alchemical symbols have been in use since earliest antiquity. The elegant Greek elemental symbols (which may have an Egyptian origin) are the most universal: fire △ and air ▵ tend upward, and water ▽ and earth ▿ downward. They can be superimposed into a kind of star of David, with a horizontal line across the middle ✡ meaning all the elements in balance. The symbols for the planets are also ancient, and like the astrological signs they may have begun in Egypt. Some may be pictographs: according to tradition Saturn's scythe, which he used to castrate his father Cronos, is visible in his sign ♄.[53] Mars's sign

may be a picture of his shield and spear ♂, and Venus's looking-glass is supposedly depicted in her sign ♀. It seems that four of the seven planets had metallic associations from earliest antiquity (Sun = gold, Moon = silver, Saturn = lead, Mars = iron), but Jupiter's identification with tin, Venus's with copper, and Mercury's with quicksilver were undecided until relatively late.[54] Those are the indispensable symbols, and there are about two dozen others that are common in the texts.

Some are simple pictures. Sand, for example, is written as a pyramid of dots ∴ and ⊂⊂ means hart's horns. Others are made of the initials of names, such as a fused 𝄢 for balneum Mariæ (the double boiler), QE for "quintessence," three long 𝕾𝕾 for substances that have layers (*stratum super stratum*), and 𝕰 for extract of coral. The commonest signs give rise to many related ones. Thus Venus ♀ provides the model for the sign of mercury ☿ (with two arcs atop the circle), and also for cinnabar ♂ (the mirror inverted), sulfur ♁ (with a triangle instead of a circle), tartar ♁ (with a square instead of a circle), potash ♁ (with the top of the square deleted), and a dozen others. The dotted circle of gold ☉ becomes salt ⊖ when a line is put through it. Some alchemists saw that as a symbol of the earth that is in salt. Further alterations give saltpeter ⊕ (salt on its side), verdigris ⊕, white vitriol ⊕-, blue vitriol ⊕+, green vitriol ⊕∿, lye ⊖∿, ammonia ⊖⊢⊖, soda ⊖⊥⊥ and a host of others. In this way both the number of symbols is kept within bounds that can be easily memorized, and each one can have a personality and not just a set of sterile statistics like our modern chemicals. A glance at one of the huge catalogues put out by modern chemical suppliers—one that I receive lists 33,000 chemicals—shows how impossible it is to have even fleeting acquaintance with the number of substances that are commercially available. Alchemists preserved themselves from conceptual infinity by limiting names and symbols.

Oil paints are also a limited domain whose names must be slowly be learned.[55] Given enough time, each color gets its own personality, and the sum total of all pigments acquires a kind of familial feel.

Payne's Grey is the cold, undependable grey that tints everything with the color of blue steel. Malachite and Emerald Green are also cold, but even they are friendly in comparison with the sour stain of Viridian, which leaches its bitter tone into every color it touches. Among the blues, Cobalt and Cerulean Blue are light and airy, and Ultramarine is watery and lush. Azurite is the rich blue-green that makes a limpid summer sky when it's mixed with white. Few people beside artists know about oil colors. Even art historians and critics do not recognize them when they encounter them in pictures. They call them "red," "blue," or "yellow," and they invent adjectives to describe them—"rust colored," "tangerine," "cream-colored." That is a little like going to a party and not remembering anyone's name. For painters, the colors are old friends. If you're a German painter, Vermilion is *Zinnober*: it can never be anything else, just as your friends and relatives cannot have arbitrary names. It's not difficult to learn the basic pigments; I have given a number of them in this book, and a few visits to a painter's studio can help. They are the family whose conversations echo back and forth in paintings of all centuries. (Normally their names are not capitalized. I have capitalized them in this book to emphasize their individuality: to a painter they are not generic terms, but very particular characters.)

It is similar in chemistry, where chemists will recognize the typical colors of burning copper or zinc (its flame is greenish-white), and the rainbow colors of the sulfides and ferrocyanides. But it is not possible to go too far with colors in chemistry or alchemy, because they are infinite and infinitely deceptive. Alchemists sometimes used the four colors Jung names, especially to talk about ideas like purity, perfection, and death; but much more often they worked with a continuous rainbow of hues, and they delighted in whatever colors the substances could yield. The peacock's tail (*cauda pavonis*) was a good sign, and seeing all the colors of the rainbow at once is not unusual in alchemical experiments.

The twilight of lesser-known pigments (Manganese Violet, Scarlet Vermilion, Egyptian Blue, Ultramarine Ash, Woad) is a perennial siren

to painters who feel they need to explore the dim outlying parts of the spectrum. Generally, though, painters settle for favorite groups of colors, and work with them to the exclusion of many others. They become faithful to certain combinations, and to certain manufacturers, and most painters can talk at length about their accustomed pigments. Usually only salesmen know the entire range of any company, and only conservators and restorers know the even wider domain of historical pigments. The infinity of paints, like the infinity of substances, is limited by what the imagination can populate with personality. Each paint needs to have its particular feel, its quirks and idiosyncrasies, or it cannot take its place in the mixtures and blendings that lead from the dyad through the triad and the quaterniad, and then back to the one.

3

The mouldy *materia prima*

IT IS POSSIBLE to grow a golden slug in a bath of acid. The nine-teenth-century alchemist Stephen Emmens describes the method in his book *Argentaurana:* it begins with a few drops of tannic acid, $C_{11}H_{10}O_9$, in a big bottle of water.[1] (In the seventeenth century, alchemists would have gotten tannic acid by sawing the galls off oak trees, drying them, pulverizing them, and mixing the powder with water. Emmens probably got his tannic acid from a chemical sup-plier.) The diluted liquid tastes faintly astringent, like soured water left standing in a rainbarrel. Into it the alchemist drops a solution of gold chloride.

> The effect produced is magical. Threads and skeins of amethyst grow and steal and creep through the liquid, and gradually deepen into the most magnificent purple.
>
> By stirring, the fluid becomes uniformly colored; and if a quantity is prepared and kept for a considerable time, a black substance makes its appearance in the form of a shining slimy mass, which when lifted out on a glass rod hangs pendant and looks remarkably like a slug. It is a metal and is soluble in water and ammonia; but when heated in the flame of a spirit lamp it assumes the aspect and takes on the properties of ordinary gold.

A black slug, made of gold? The recipe seemed unlikely to several modern chemists, and they tried to reproduce it. According to their experiments, the slug is nothing but a pile of mould:

For our experiments we used one drop of a 1% gold chloride solution prepared by dilution of a commercial 75% $HAuCl_4 \cdot 3H_2O$ solution and 10 ml of a series of tannic acid solutions varying in concentration from 1–0.025%. With the more dilute solutions, the suspended threadlike precipitate and purple color were observed, but the amount of precipitate was insufficient to cling to a stirring rod. With the more concentrated solutions, enough precipitate was obtained to cling to a stirring rod, but it was brown or black and quickly deposited on the bottom of the test tube.

In all cases the tubes must be allowed to stand for several weeks for development of the "slug," which is apparently a mold impregnated with colloidal metallic gold. We have had the fungus, which also grew in the tannic acid stock solution, tentatively identified as either *Penicillium frequentans* (*P. tannophilium*) or *Penicillium spinulosum* (*P. tannophagum*), both of which are reported to decompose tannin and tannin liquors and from which the enzyme tannase has been produced.

It is a disappointing result, this golden creature that turns out to be nothing but a clot of mould. But it is also entirely in the spirit of alchemical and artistic experiment. The alchemists were drawn to slag and refuse: they loved the suspicious skins that thickened over their stews. They rooted in cinders and picked at ashy heaps. They let their waters rot, and then rummaged in the soft granular sludges that sank to the bottom. More often than not, it is the crust or the ash that fascinates them, and not the pellucid colors and volatile oils that comprise the stew itself. Putrefaction, with its Latin name *putrefactio,* is a nearly universal step in the alchemical work. The clean substance has to degenerate into brackish mould before it produces anything worth examining.

Academic painting had a natural affinity with mud and excrement, because of the common use of brown hues and thick varnishes that yellowed and darkened with age. The Impressionists laughed at the

academics' "brown sauce," but William Blake had already put it best when he said Rubens used "a filthy brown, somewhat the color of excrement." From the mid-sixteenth to the mid-nineteenth century, paintings were routinely founded in "earth tones," and it was only a step to go from speaking about "muted colors" to acknowledging what the paint was really like: sluices of mud, running diarrhea. (Another name for the *materia prima* was *terra fœtida,* "fetid earth."[2]) Impressionist and Postimpressionist canvases are acts of repression: they pretend that a high enough chroma takes paint out of the sewer and puts it in the fresh open air. Painters who work in browner and more traditional styles cannot acknowledge those facts, except as jokes: but their reluctance, or blindness, about what they do is better than the obliviousness of most painters, who think they are saved by bright colors and hardly give their excremental medium a second thought.

The alchemists' interest in *putrefactio* is shared by contemporary artists, many of whom see something beautiful in natural decay. The rotting fruit, blooming at the back of the refrigerator, is also outlandishly beautiful with its crown of bluish hair spreading over a glowing orange skull. So is the throat ravaged with bronchitis, blossoming in smooth white flowers. And the bloated deer half-swamped in the lakeshore is also beautiful, with its gorgeous smooth hide stretched into a lucent bubble. There are hundreds of examples in fine art, each more nauseating and compelling than the last. The installation artist Ann Hamilton soaked a hundred thousand pennies in honey, and then let them gather a film of dust; Andres Serrano made stagnant infusions of piss, semen, and milk; Frances Whitehead works with fabrics soaked in water, mud, oils, resins, and perfumes. In the time I have been teaching artists—a little less than a decade—I have seen rows of moulding slices of bread, desiccating open jars of baby food, bottles half-filled with fetid tomatoes, rotting fish dampened with a sprinkler system, and condoms stuffed with swollen putrescent tapioca.[3] Beginning in the early 1970s, there have also

been artworks made of old turds, dried blood, and sanitary napkins. If anything, contemporary artists are more inventive than their alchemical forbears in the search for the conjunction of the repulsive and the compelling.[4]

But it was alchemy that made that compulsion into a principle. For alchemists, one of the great puzzles was how to begin the work. Their purpose was nothing less than to make perfection itself—and what artist imagines anything different?—and so they needed to think carefully about their raw ingredients. Some chose to begin with sulfur, mercury, and salt, but to others that seemed too simpleminded, and doomed to failure. How could the perfect Stone be made with such universally known substances? And so they set out in search of the proper object from which to begin—something not as obvious as sulfur or mercury, something that would never occur to a literal mind, or a superficial thinker. That cloudy object was called the First Substance, *materia prima*.

Since everyone would expect the *materia prima* to be as esoteric as the rest of alchemy, the trick was to fool the vulgar crowd and look instead for the most ordinary object imaginable. Alchemists wrote poems and told stories about the fabulous *materia prima* that could be found anywhere in the world, if people only had the eyes to see it. Travelers would trip over it, thinking it was a stone dislodged on the roadway. Farmers would plow it up, taking it to be a stubborn root. Fishermen would sit down next to it and fish the whole day through, without even recognizing what was inches from their feet. This *materia prima* could the commonest lump of clay, or the most ordinary nondescript pebble. What is more, it could be actually repulsive: it could be a poor plant in a sump, reeking of swamp gas, or a turd in a compost pile, slowly returning to the earth. The one object that anyone in the world would overlook, the one that would attract no one's attention, the one that would be instantly cast away like a mouldy orange: that alone would be the key to eternity, spiritual consummation, riches, and everlasting health. The *Secret Figures*

of the Rosicrucians calls *materia prima* the "greasy fat dew of the ground," the "womb of the earth," the "salt of nature," and finally "the one good thing God has created in this visible world."[5]

The *materia prima* is exquisitely, brilliantly beautiful to the person who can understand it for what it is. In the midst of its rotting pile, it shines at the "true philosopher" with a secret light. The idea that everything begins in squalor and refuse is an old one. Yeats said it well when he wrote about giving up his fancy mythological creatures and the airy inventions that had kept his poetry alive, and beginning again from scratch, "in the foul rag-and-bone shop of the heart." What makes the alchemical notion stand out is that the *materia prima* is not only a metaphor for the desperate impoverishment and loneliness of the first moments before creation, but it is also a literal embodiment of them. Alchemists actually dug in swamps, and tried to brew turds and urine.

Visual art is the same, and that is one of its strengths. Artists cannot begin in antiseptic abstraction, like philosophers with their notepads, or theoretical physicists at their blackboards. They have to begin *in medias res,* literally in the middle of things: oil, canvas, squalor. So it is the artist's task to discern somehow what is worth saving, and what can be transformed, and finally to crawl out of the morass.

Following the model of Jesus's hypostasis—His incarnation into flesh—and His resurrection, some alchemists conceived their purpose as the rehearsal of their own resurrection at the Second Coming. They studied the revelation of divinity in ordinary matter, and especially in the most earthy things, those farthest from heaven and most like themselves. They looked at purulent infusions and saw their own dying spirits. Turbid waters mirrored leaden thoughts. A dusky flask suggested a dark mind, and a foaming crucible implied inner turmoil. They saw the endless *labor,* with the recipes calling for a year's worth of work to accomplish a single step, as painful allegories for their own lives, and their chances of redemption. But the Stone was a hope

to be cherished, since it promised that their bodies could finally be balanced and preserved, and their souls made calm and clear.

In academic language, these are hypostatic allegories. They are a general truth about alchemy, but it is easy to overstate them, as I think Jung did. Most of the time it is implicit that whatever happens in the flask is of pressing religious importance, but it is rare to find alchemists drawing parallels between each experiment and a particular state of their immortal soul. Even so, most alchemy is theoalchemy: it is about questions of eternal life, soul and spirit, resurrection, and incarnation. Alchemists knew they were rehearsing, and often speeding up, processes that the earth does naturally by brewing metals underground. That work was God's, and it was the ongoing perfection of the world. As the universe drew near to the millennium, human souls as well as stony spirits were slowly being purified and brought closer to God. So in a fundamental sense, the alchemists did see their souls in the retorts and crucibles, but they rarely spoke about their experiences in the terms that Jung implies: certainly they never mentioned the psyche, the unconscious, and the archetypes, which Jung proffers as the actual mechanisms driving alchemy. Even devoted theoalchemists who wrote about revelation, spirit, and redemption did not make explicit connections between laboratory recipes and their own souls. They implied as much by talking about the relation between alchemy and prayer, but they did not have the modern penchant for confessional self-analysis. The act of making, *labor,* was the prayer, *ora.* What counted in the laboratory was the wordless work. The theoalchemists such as Georg von Welling, the ecstatic prophets like Heinrich Khunrath, the philosophic mystics like Michael Maier, and even the "scientific" psychologists like Jung all came afterward, with their heavy interpretations in tow. It is essential to remember that no matter how crucial religious meanings were to the alchemists, there are no books *written in the laboratory* that speak about them. At the moment of making, the act is everything. Afterward, there is plenty of time—even centuries—to try to figure out what it all meant.

The exact same silence is the essential trait of the studio. There is a wonderful liquid complexity of thoughts that accompany painting, but they are all in, and of, and through the paint. (That is not to say an artist might not think about anything, from Wall Street to Jung: but what is engrossing about painting is the act itself, and everything else is a distraction, or a way of not thinking too directly about the unnerving importance of the very next brushstroke.) The love of the studio is an unreflective, visceral love, and for that reason the ideas I am setting out in this book risk being *too* explicit, too much dissected, too open to conscious thought. When I was working on these opening chapters, I sent copies to a number of people—painters, chemists, alchemists, historians of art and chemistry. Among the responses was a very thoughtful letter from Frank Auerbach. He says he feels the book is right, and yet "there is something else, something much rarer":

> An Irish woman attending church and a sermon on "Family Life" was heard to say, on leaving the church, "I wish I knew as little about it as he does." I feel what you say does not betray or offend my experience of painting. *Everything* you say is true to my experience.
>
> But—the whole subject makes me extremely nervous. As soon as I become consciously aware of what the paint is doing my involvement with the painting is weakened. Paint is at its most eloquent when it is a by-product of some corporeal, spatial, developing imaginative concept, a creative identification with the subject. I could no more fix *my* mind on the character of the paint than—it may be—an alchemist could fix his on mechanical chemistry. I have put this clumsily—but I am certain that you understand.[6]

It's very beautifully put, this warning about thinking too much. It seems to me that there are only a few self-reflective texts in practical alchemy because when substances are at work, they can't also be the

objects of intellectual speculation. Jung couldn't think about the laboratory partly because he only saw substances as psychic allegories. The same failure haunts this book, because every notion, every concept and allegory, pushes me a little away from the subject I am trying to describe. My book makes Auerbach "extremely nervous" because it threatens the alchemy—in the usual, loosely allegorical sense of that word—of his work. It makes me less nervous, because I am no longer a practicing painter: but I still want to stay close enough to the "foul rag-and-bone shop" to put at least some of it into words. The analysis of paint is a danger for any painter: those who get too analytic about paint—who get involved in picking just the right exotic oil, or finding the latest Nepalese drawing paper—risk drifting away from what Auerbach calls, with unavoidable awkwardness, the "creative identification with the subject." Fundamentally, thought about paint comes after paint. Jung's psychology could only get underway when the laboratory doors closed; this book began for me about ten years after I left the studio.

Things only get harder to articulate when the religious meanings come into focus, and it begins to appear that the studio work—the *labor*—really is about redemption. In my experience it is rarely apposite to talk directly with an artist about the underlying spiritual meaning of his or her work. For any number of reasons, religion is no longer an easy subject, and many artists do not link it directly with themselves or their work. The buried spiritual content of modern and postmodern art may be the great unexplored subject in contemporary art history. Still, any book devoted to the subject is bound to fail because it would have to spell out so many things that the artists do not even tell themselves. Such a book would mercilessly transgress the boundary between the experience of paint and its meanings. It is the same with alchemy: in both cases the underlying act is spiritual—and especially redemptive—but the public language is only inconsistently and weakly so. The advantage of alchemy over theology, Jungian psychology, or art criticism for exploring spiritual meaning in art is that it is a sister discipline. Alchemy is also shy, and it also

keeps to substances and lets them silently fill with meaning rather than blurting out what seems most precious.

Yet redemption is a root idea of this book, and it is a principal reason why the starting-point of alchemy or painting must be perceived as more than a brute lump of matter. In artistic terms, it has to seem potentially expressive, and in alchemical terms, it must have the spark that signals an incipient spirit. Because those requirements are both crucial and vague, it is no surprise that the *materia prima* goes under many names. Often the alchemists call it lead, meaning not so much the chemical substance lead as the heaviness and darkness of lead. Lead is like compacted waste, dull and blunt and poisonous. Even pure lead grows a crust of lead carbonate, sullying itself with a whitish mould. Both gold and lead are heavy, both shine—one with light, and the other with darkness—and both can be nicked with a few taps of a hammer. Since lead is heavy (eleven times heavier than water, so that a bucket of it can weigh hundreds of pounds) some alchemists thought it was a degraded form of gold, a "sick" or "leprous" gold. Others supposed it was young gold, immature and "green."[7] The mission of alchemy was to administer to the lead and cure it into gold, or to nourish it until it grew into mature gold. (There were also opposing voices: Ğābir is supposed to have said only "idiots" think lead and gold are linked.[8]) An artist who thinks of starting from lead is experiencing raw paint as a kind of sickness, and painting as its convalescence: a common enough feeling. A whole chain of associations bind artists to lead: lead (along with tin) was said to be Saturn's metal, and Saturn was the sign of melancholy, and melancholy was the traditional artists' affliction. Those ideas have faded from consciousness (except in popular books like *Born Under Saturn*[9]), but the sadness, darkness, and heaviness of lead are still very much entangled with depression. For some artists the studio is a blight until the work is well underway. The sight of the paints is disheartening, and it brings on a leaden sadness. That is the monstrous heaviness of the *materia prima*.

Aside from muck and lead, the *materia prima* went under a bewil-

dering number of aliases. In pictures, it is often an egg—a natural symbol for a starting point. Another common symbol is a toad, for three surprisingly different reasons: first because they live in murky undergrowth, second because they were thought to be poisonous (common medical opinion had it that great poisons could draw out poisons from other materials, so that a poisonous toad could suck the leprosy from lead and remake it into gold), and third because there were legends that toads lived deep underground, even inside rocks, and that they sometimes grew lumps of gold inside their heads. Often, too, dragons stand for the *materia prima,* because they are associated with chasms, mountains, and caves.

Other alchemists chose to be more specific about the *materia prima.* Robert Fludd took water as his *materia prima,* though he did not mean the Greek element water, but the primary waters that light brought forth out of chaos in the book of Genesis.[10] In the same vein the alchemist who called himself Cleidophorus Mystagogus thought the universal spirit must be a mist, a vapor, a chaos, "or rather an unctuous and viscous water, which is the true matter of all the ancient philosophers."[11] Fludd and "Cleidophorus" both believed *materia prima* must be like the nebulous silent waters that felt the shadow of God's spirit floating overhead—"and the spirit of God moved upon the face of the waters," as it says in Genesis 1:2: "The earth was without form, and void; and darkness was upon the face of the deep." Alchemists loved those words, "without form and void," and many of them knew just enough Hebrew to quote the opening verses of Genesis, including the words *tohu wa bohu,* תֹהוּ וָבֹהוּ One sign for *materia prima* captures this perfectly: ° ⦂ ° a few tentative bubbles or droplets, almost forming a cross.[12]

When painters think this way, they are experiencing the *materia prima* as a moment of silence before the work begins: the colors on the palette are empty, "without form and void." Before creation the waters are still, colorless, odorless, lightless, motionless: they are pure potential, waiting for the movements and light that will disperse them across the canvas. From this perspective, the *materia prima* is

the gloom that envelops the starting moment of any enterprise. It is a feeling that artists know very well. When the work is about to commence, there has to be some tenuous notion of what will happen, but it is usually wrapped and hidden even from the person who will be doing the creating. An artist has a delicate sense of the work to come, and how it might become the perfect thing in the imagination, but historians and critics are wrong when they assume that it can be clearly seen in advance. No painter knows what the picture will look like, and those painters who try too hard to use paint to realize an idea are typically disappointed. Like poetry or any other creative enterprise, painting is something that is worked out in the making, and the work and its maker exchange ideas and change one another. The ideal image of the work is blurred and hard to picture, as if it weren't quite there, or as if it were something seen out of the corner of the eye. If the artist tries to turn and look at it directly, it vanishes. The only way to capture it is to do the work, and remake the idea through the paint. The state of mind at the beginning of the creation of a work of art is nearly inaccessible. What an artist knows is principally what will happen in the next second, not the next hour or month. Thoughts at the moment of beginning are only guideposts, and the actual substance of the work is entirely inchoate. This is the common ground of artistic process, which begins in an odd inarticulate place that is neither well known nor unknown, neither substantial nor entirely invisible.

The *materia prima* was also imagined as a way-station between utter chaos and perfection. It held every substance, but in an occluded form. One of the most compressed alchemical symbols is John Dee's "hieroglyphic monad," which he advertises as a monogram that includes all seven metals:

Some of them are very distorted, but at least mercury ☿ and copper ♀ are easy to see.[13] The ♄ of tin, for instance, is hiding on its side at the bottom of the monad. In Dee's theory, the monad has the universe of substances within itself: it is both the dishevelled *materia prima* and the glyph of perfection.

The most elaborate single alchemical sign appears in an anonymous book called *The Golden Chain of Homer, or a Description of the Origin of Nature and Natural Things*.[14] The chain links heaven and earth, with heaven this time at the bottom. Reading from the top, first comes chaos itself, and then three versions of the "spirit of the world," each one improving over the last, and then the *materia prima:*

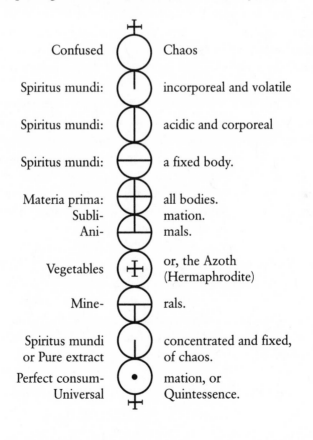

Confused	Chaos
Spiritus mundi:	incorporeal and volatile
Spiritus mundi:	acidic and corporeal
Spiritus mundi:	a fixed body.
Materia prima: Subli- Ani-	all bodies. mation. mals.
Vegetables	or, the Azoth (Hermaphrodite)
Mine-	rals.
Spiritus mundi or Pure extract	concentrated and fixed, of chaos.
Perfect consum- Universal	mation, or Quintessence.

After the *materia prima* there are animals, vegetables, and minerals, each more perfect than the last, until finally the spirit of the world is "concentrated and fixed," made into "a Pure extract of chaos." The chain ends with the quintessence, in the form of a sign combining mercury \textvarmercury and gold \odot. The whole symbol is a map, detailing the descent from unrelieved chaos to rude *materia prima,* through the familiar spheres of animal, plant, and mineral, and onward into heavenly perfection. The sign of the cross appears three times, at the top, on the bottom, and in the middle, as reminders that God has set everything in place. God has already made *materia prima,* and it is up to alchemists to accelerate and complete His work. Occasionally alchemists talk about a *secunda materia,* and they mean this half-formed *materia prima.*[15] On this diagram, the "true" *materia prima* would be the original chaos, forever hidden from out eyes, and the *secunda materia* would be the one that this author proposes as the hinge between spiritual existence and the visible world.

The anonymous author of this book might have agreed with Dee that the *materia prima* would have to contain all substances, or at least all metals, in an inchoate mass. From an artist's point of view, this is the feeling that paint has every form already within it, but in a confused state. The paint is like a bird's nest, with the threads all tangled and interwoven, and the painter's job is to tease them apart and lay them out for everyone to see. It is a very different frame of mind from the queasy awareness of rot and excrement, the heavy despondency of lead, or the delicate incipience of water. Here painting is more of an operation, or a technique, and the paint is already poised halfway between chaos and completed painting.

And the list is not finished yet, since there are dozens more identifications of the *materia prima.* The medieval Spanish polymath Ramon Llull is credited with a manuscript claming the first principle is not mercury but love, which is a binding agent (*amoris foedere*) for all substances.[16] Love was the favorite choice of alchemists who thought that alchemy should begin and end in a monadic principle.

In the frontispieces of books by the French clergyman François Béroalde de Verville, love takes the form of a trellis of ivy that entwines all the operations of alchemy.[17] There is another tradition in alchemy that holds that mercury is the single matter required in the alchemical work: another manuscript attributed to Llull speaks of the world as a polarity of forms of mercury—the hot, dry calcinated mercury and the cold, moist sublimated mercury.[18] Titus Burckhardt, a twentieth-century Arabist and mystic, blends modern psychology with older traditions by suggesting that "in the last analysis," quicksilver is "the most direct psychic manifestation" of *materia prima*.[19] Later in the history of alchemy, salt became the primary principle and *materia prima* of the universe.[20] Johann Rudolph Glauber (his name means "believer") waxed eloquent about salt: "everything lives and grows and is sustained and increased in salt," he wrote, "salt is the beginning and ending of every thing."[21] Georg von Welling's massive pansophic *Magic-Kabbalistic and Theosophic Work on the Origin, Nature, Property and Use of Salt, Sulfur and Mercury* is a religious and philosophic rhapsody on salt. Welling says that the three principles sulfur, salt, and mercury are the Heavens that existed at the beginning of creation (the Hebrew *shamayim* שָׁמַיִם, another favorite alchemical word from the opening of the book of Genesis). To Welling, the *shamayim* are nothing other than fire and water, and fire and water are nothing other than the "secret salt."[22]

The Renaissance scholar Martin Ruland lists fifty synonyms for *materia prima* in his *Alchemical Lexicon,* and his nineteenth-century translator A.E. Waite adds another eighty-four.[23] The *materia prima,* Ruland says, is the "greatly admired Creature of God," and it is the microcosmos because it contains every substance in creation. In a typical alchemical paradox, it can even be the philosopher's stone itself, especially if it is the "one thing" that comprises the Stone. And the *materia prima* is the water of life, "for it causes the King, who is dead, to awake into a better mode of being and life." It is shade, because it makes darkness, and dew, because it "falls from the air and

stimulates the soil." It is also lye, "for it washes and cleans the metals, and the body of the King"; bath, "for it washes and cleanses the King and the metals, and causes them to perspire"; vinegar, "for it macerates, makes spicy, pickles, renders savoury, strengthens, preserves, corrodes, and yields a tincture"; and also shit, "for it manures the earth, which it renders moist, fat, and fruitful." And Ruland goes on, in the manner that Rabelais parodies in his fanciful lists. The *materia prima* is also:

Eagle Stone.	Spirit.	Nebula.
Venom.	Medicine.	Fog.
Poison.	Heaven.	Moon.
Cinnabar.	Clouds.	Stella signata.
Lucifer.	Tin.	Magnet.
Permanent Water.	Sulfur of Nature.	A White Moisture.
Metallic Water of Life.	Lime.	White Smoke.
Leafy Water.	Alum.	Metallic Entity.
Fiery Water.	Spittle of the Moon.	Virtue of
Salt of Nitre.	Incombustible Saliva.	Mineral Mercury.
Saltpeter.	Burnt Copper.	Soul of the Elements.
Bride.	Black Copper.	Matter of all Forms.
Spouse.	Flower of Copper.	Tartar of the
Mother.	Ore of Hermes.	Philosophers.
Eve.	The Serpent.	Dissolved Refuse.
Pure Virgin.	The Dragon.	The Rainbow.
Milk of the Virgin.	Marble.	Indian Gold.
Fig Milk.	Crystal.	Heart of the Sun.
Boiling Milk.	Glass.	Shade of the Sun.
Honey.	Scottish Gem.	Heart and Shade of
Spiritual Blood.	Urine of Boys.	Gold.
Syrup.	Urine of the White Calf.	Chaos.
	White Magnesia.	Venus.

There are also eighty-four Arabic, allegorical, and chemical names for it, among them:

A Drop.	Chyle.	The Bull.
Asrob.	Cock.	The Sea.
Almisada.	Ebisemeth.	The West.
Aludel.	Embryo.	Animal Stone.
Alun.	Euphrates.	Vegetable Liquor.
Abzernad.	Eve.	The Woman.
Anathron.	Hyle.	The Belly of the
Androgyne.	Infinite.	Ostrich.
Antimony.	Isis.	Anger.
Aremaros.	Kibrish.	Butter.
Arnec.	Laton.	May Blossom.
Arsenic.	Mars.	Golden Wood.
Asmarcech.	Menstruum.	The Tree.
Azoth.	Mother.	Silver.
Borax.	Orient.	Whiteness.
Caduceus.	Salamander.	Soul of Saturn.
Cain.	Vapor.	The Lamb.
	Lord of the Stones.	

And still Ruland is not satisfied, since the *materia prima* is also the Aristotelian quintessence, "the matter of which the Heavens are composed," "the bird of Hermes, which descends continually from heaven to earth, and as continually ascends and goes back from earth to heaven," "the mysterious ladder of the vision of Jacob," "the seeds of bodies," the "seminal life of all things," and finally, sperm.

On the other hand, if the *materia prima* has so many names, and *is* so many things, then it cannot be any one of them. Other alchemists make lists of things that the *materia prima* isn't, in order to show us that it has to be all of them a once. Otto Tachenius, a seventeenth-

century adept, says that "it is not with the soft gums, nor with the hard excrements, it is not with green raisins nor with herbal quinetessences, strong waters, corrosive salts, nor with Roman vitriol, not with acid talcum, nor impure antimony, not with sulfur or mercury, not even with the vulgar metals themselves that an able artist will work at our Great Work."[24]

No one can name the *materia prima* because it has to be both nothing (nothing *yet,* nothing that has been formed) and everything (everything *in potentia,* all the things that wait to exist). Like the formative chaos of Creation, masses of undivided paint can become anything in the world. A spot of reddish pigment might end up as the little red at the corner of a painted eye, and a touch of dirty white might become the gleam on a pearl. *Materia prima* is a name for the state of mind that sees everything in nothing. By logical inversion, the choices are more vast when the raw materials are more restricted. If the starting point is a neat palette laid out with the canonical Roy G. Biv spectrum, then many kinds of paintings will be out of bounds. If the starting point is a formless repulsive slug—or a drop of semen—then anything is possible.

In the end there are two basic choices for the *materia prima,* and either might be the best path into the work. On the one hand, it might be a boiling mixture of all the elements of the world, tangled and corrupted and half-formed, melted and burnt and uselessly fused. The task then would be to complete the work by purifying and extracting the pure Stone from its matrix. On the other hand, the starting place might be empty, like the calm sublime waters of the second verse of Genesis, slowly swirling with everything uncreated, *in potentia* as theologians say—or the blank canvas before the work has begun. In that case what matters is the pureness of the void, and the challenge is to reproduce creation from nothing, *ex nihilo.* That is Fludd's watery first principle: a silent pregnancy, infused with substances waiting to be born.[25] It is also the solid lightless mass of lead,

and the occluded lump of swamp mud. In painting it is emptiness, and also darkness. (The blank white canvas is a modern convention; in the past, the starting point was the dark imprimatura.) In the beginning is the dull pile of earth tones, the dark greys or blacks at the bottom of the value scale. This *materia prima* is silent, cold, and strange. Tachenius says that in the beginning, God created a chaos, which emerged "as a confused mass from the depth of Nothing." This *massa confusa* did not look holy. "One would have said," he continues, "that disorder made it, and that it could not be the work of God."[26] Yet even this uncanny substance can be molded. Slowly and carefully, God built out of the darkness, making light, and then water, and then land, and plants and animals.... Most painters before the twentieth century began from formlessness. They progressed by orderly and systematic steps in the creation of their pictures, like architects building from the cleared ground to the cornice. In modern art, the silence of the blank canvas is broken more violently, but it is still the place to begin.

In the other option the *materia prima* is a roiling sea of impurities. This is not the still waters of Genesis, but the noisy churning of the Flood. It is a dangerous condition, with substances and ideas tossing violently about, and thoughts and experiments out of control. Nothing is fixed: everything is volatile, explosive, half-formed. Ideas flash by like the obscure names on Ruland's lists. In painting, the canvas is a flurry, suggesting shapes but not spelling anything out. Especially in the past century, many painters have preferred to begin this way; and even before modernism, painters invented shapes by looking at stained walls or throwing painted rags and sponges at the canvas. Stories like that are told of Leonardo da Vinci, Botticelli, and others. Rubens instructed his assistants to put on the imprimatura with large brushes so the stray marks would inspire him, and the wild brown streaks can still be seen in many of his paintings. This first kind of *materia prima* is rich in possibilities, but also hard to control. Thinking of the danger, some alchemists pictured them-

Nu wil ik my tot de Soutbergen begeven,
die tusschen het Oosten en het Zuiden gelegen
zijn, en daer in is de heerlyke Stad van
Hermes met drie schoone rivieren begaeft,
waer van de eene is graeuw, de andere rood,
de derde wit. Dese komen uit het Oosten,
strekkende na't Zuiden, en sy hebben haren
uitgank na't Westen, dit zijn de drie
Wateren van onse Zee; ♄, ☿, ♃.

Wanneer ik met myne oogen sag op de
Werkken Godts, en mijn insicht nam
op het Boek der Natuur, te weten, Hemel en
Aerde, allesins met des Heeren wonder-daden
ver-

selves as Noah, floating on the ocean of turbulent metals and trying to preserve some token order on board the alchemical ark (Figure 2).

One reason Ruland's lists are faintly sinister is that the *materia prima* shares an important trait with the devil: they both have a thousand names. The turbulent *materia prima* is also a kind of hell, a seething lifeless place where only God (or his surrogate, the alchemist) can make something beautiful. Some of the earliest Western alchemical texts, attributed to Zosimos of Panopolis, are visions of that sulfury hell. In one manuscript Zosimos recounts his fascination with a pool of burning yellow, where souls pop to the surface and scream before they sink again into the burning depths. It all happens in a dream, where Zosimos finds himself looking into a cauldron set on an altar:

> I fell asleep ... and I saw ... a bowl and at the top the water bubbling, and many people in it endlessly. And there was no one near the altar whom I could ask. I then went up towards the altar to view the spectacle. And I saw a little man, a barber, whitened by years, who said to me, "What are you looking at?" I answered him that I marveled at the boiling of the water and the men, burnt yet living.[27]

In chemical terms, his vision was probably a bubbling cauldron of sulfur powder and quicklime.[28] It is easy to recreate the yellow hell in a laboratory, by mixing two cups of quicklime (calcium oxide, CaO) with one cup of sulfur powder and five cups of water.[29] When the vessel begins to heat, the yellow sulfur and quicklime sink to the bottom, and a clear "sky" of water forms above them. As it comes to the boil, sulfur bubbles ooze upward like the greasy streamers in a lava lamp, rising and bursting on the surface, and slow-motion showers of sulfur rain back down. Eventually a reddish layer forms on top (the

FIG. 2 Noah's ark. *From Goossen van Vreeswuk, De goude Leeuw of den Asijn der Wysen* (Amsterdam: the author, 1671), p. 100.

supernatant, calcium polysulfide), casting a bloody light over the landscape. If the heat is moderate, the sulfur and quicklime never entirely dissolve: instead they undulate like the quaking ground of hell that Milton describes at the beginning of *Paradise Lost*.

The hellish smell and churning belches of Zosimos's liquid are an apt metaphor for the wasteland of the beginning of the work, and it turns out that the mixture has unexpected links to visual art: it has been used to tint and color fabrics and metals. If a strip of polished copper is held above the surface, the hydrogen sulfide fumes will stain it into a darkened metallic rainbow of silver, purple, and black. After a while the clear "sky" in Zosimos's liquid will take on a greenish gold color, lit from above by the deepening Vermilion of the floating calcium polysulfide. Different metals can be submerged in the greenish half-light and emerge with their colors changed. A piece of clean grey cadmium (Cd), dipped into the liquid, will eventually turn yellowish or golden, and tin (Sn) will blanch, taking on the look of white gold (called *asem*).[30] People who work in bronze casting know the stomach-turning fumes of liver of sulfur, which tints bronze in the same way. Even the most unpromising jar of industrial waste can yield beautiful results.

In painting, this *materia prima* is the full chromatic spectrum of the palette in all its force and incoherence. Kandinsky described it most eloquently when he remembered the first box of paints he got as a child. The paints flowed from the tubes, he said,

> jubilant, sumptuous, reflective, dreamy, absorbed in themselves,
> with deep seriousness or a mischievous sparkle ... those strange
> beings we call colors came out one after another, living in and
> for themselves, autonomous, endowed with all the qualities
> needed for their future autonomous life ... At times it seemed
> to me that whenever the paintbrush ... tore away part of that
> living being which is a color, it gave birth to a musical sound.

For Kandinsky colors were the chaos itself, the original source of energy and life. He loved

the strife of colors, the sense of balance we have lost, tottering
principles, unexpected assaults, great questions, apparently use-
less striving, storm and tempest, broken chains, antitheses and
contradictions, these make up our harmony ... Legitimate and
illegitimate combinations of colors, the shock of contrasting col-
ors, the silencing of one color by another, the checking of fluid
color spots by contours of design, the overflowing of these con-
tours, the mingling and the sharp separation of surfaces, all
these open great vistas of purely pictorial possibility.[31]

This is the churning, engrossing flux that Zosimos envisioned, full of
sharp detail and mutating possibilities. In art, colors and pigments
can also be a deep, poisonous addiction. Kandinsky probably felt
them too intensely, and it led him into a wandering mysticism. No
one sees Kandinsky's paintings the way he insisted they should be
seen: no one reads the occult personality of each color—the yellow
that is "brash and importunate," that "stabs and upsets people," and
has a "painful shrillness," or the delicate balance of orange, "like a
man convinced of his own powers"—because if they did, there would
simply be too much to attend to in any painting. Instead, we back
away from his fanatical private symbolism and enjoy the paintings in
other ways. The turmoil of colors is hypnotic, but it is a dangerous
fascination. Most artists keep the "inner life" of colors at arm's
length, in order to be able to control colors, to use them and navigate
among them rather than bobbing helplessly in Zosimos's pot.

Kandinsky spun elaborate stories, both for himself and his public,
to explain what his pictures were doing with color and shape. But he
always claimed to be producing order: to be making colors express
certain ideas, or arranging shapes so they could communicate forces
and motions. Other artists have not tried to improve on the *materia
prima,* but to display it in all its wildness. There are several reasons
why Jackson Pollock started putting his canvases on the floor instead
of tacking them to a wall.[32] It was an act of rebellion against acade-
mic painting and easel painting of all kinds, and it helped squelch the
ingrained desire to see the picture as a window, as if it only existed to

produce an illusion of depth. It also gave him a different vantage on the canvas: instead of standing in front of it, or sitting on a studio chair, he had to bend over, sometimes so far that he had to put his hand down to steady himself. (In some paintings there are painted hand prints as evidence.) On occasion he stumbled, and left a smear where his foot slipped. Things fell onto the paint and stayed there until he noticed them: the paintings preserve negative impressions of brushes, cigarettes, and paper; and they are littered with tiny scraps, ash, dust, and hair.[33] (The white wisp at the lower right of COLOR PLATE 5, hanging into the darkness, is a piece of cotton swab left by a conservator. Tufts of cotton are very common in paintings, and it is a sign of how few people bother to look closely that they remain in place year after year. They can be found in virtually any painting that has been cleaned in the last fifty years, and some canvases have dozens of them.) For people who see Pollock's works for the first time, they can seem to be complete chaos, with no differentiation or order. But the same horizontal position that helped Pollock cover them also determined the kinds of gestures he could make, and therefore the shapes of the marks on the canvas.

Standing just at the edge of the canvas, with his toes tensed, he leaned forward, letting the paint drool off a long-handed house-painter's brush and fall in curlicues and broken strings. To make larger marks, he braced himself with one leg back and the other just touching the canvas, held a can of paint in his left hand and a three- or four-inch brush in his right, and let the paint fall in thick ropes and sudden gushes. There is a film of him painting, and watching it care- fully, it's possible to discern several kinds of marks. The most relaxed are the dribbling gestures, where the paint falls in a steady stream as if it were being poured. If he holds the brush almost still, he produces flowers and knots of paint, and if he moves his arm in gentle loops, the paint falls into swags and wide curls. A typical gesture is a grace- ful turn of the arm, the wrist flexing slowly back, slowing at the end so the paint could fall all in one place. Often he lifts the brush verti- cal at the end, to stop it from splattering. The film shows clearly

what so may people who have doubted Pollock's skill could not bring themselves to believe: he *was* drawing, and the slower marks are well under control. The loops thread their way between other marks, if he wants them to; and the dark blobs fall just where they should. At the same time, other portions of the gestures are not controlled. He sometimes takes paint from the open can, and then moves the brush quickly to the spot where he intends to paint, without caring that it is laying down a trail. Often at the end of a mark, he is impatient to get more paint, and he turns the brush hard back toward the can, spraying the canvas with droplets.

Pollock had several families of gestures he used habitually. Another is a more violent kind of marking where he flicks the brush at the canvas, beginning with the hand curled in toward his chest, and turning it down and out like the obscene gesture Italians make by flicking their chin. Sometimes, the hand is curled down and it turns quickly up and out, like someone impatiently turning the pages of a book. Those movements create explosive splatters, with curled tails that drop an instant afterward, from paint that has arced through the air and fallen more slowly. With an empty hand, not carrying a brush, the gesture would have been like a punch at the canvas, or like the gesture children use to flick water at each other, bunching the fingers under the thumb and then springing them free. There are other marks, as well: the film also shows a third family of gestures, where the hand sweeps slowly back and forth—once right, then left—and then he steps to the side, takes more paint, and sweeps again. The movement is quick and efficient but repetitive, like sowing grain, and it makes U shapes that overlap into trails of W's.

None of the three—the gentle arc, the violent splatter, and the pendulum swing—are separate from one another. Often a harsh movement will suddenly soften into a graceful fillip. In other scenes, the violence is unabated and the paint begins to lose its control. The canvases have evidence of all these gestures. Looking at his paintings and thinking about the motions one by one, the pictures become exhausting. The long continuous strings, carefully placed as if they

were drawn in charcoal, mean he must have been leaning far over the canvas, carefully keeping a constant speed and inclination to the brush or the can. In that position, the back muscles begin to burn, and the legs get stiff. The huge bursts of paint mean he was holding heavy paint cans out over the canvas, and then reaching out to spill the paint at just the right place: a gesture that reminds me of aching forearms and shoulders. Worst are the small-scale swirls and dribbles, like the ones in COLOR PLATE 5—they must have been made by balancing close to the canvas, perhaps by propping himself on one or two fingers, and leaning down close enough to drop just a few fluid ounces of paint. It is in the microcosm that Pollock's allover technique becomes most random, because he begins to lose control over the little bubbles and splatters. The tiny rivulets spin down from his brushes like threads of molasses stretching from the jar to the plate, making unpredictable scribbles on the canvas. This detail is crossed by some larger-scale phenomena: there is a wide trail of black leading up the left-hand third of the passage; it is part of a network of violently propelled black streaks, which comprise the main structure of the painting. The black bands begin in oceanic spills, as at the right, and then thin into long whips that cross half the width of the painting. Here a finer filigree of black makes two loops across a stretch of nearly unpainted canvas. These are the kinds of curves that were "drawn," that is placed in position rather than flung without looking. This painting, *Lavender Mist,* has four scales of marks. The first three account for the structure that can be seen from an arm's length away: there are large blurry patches of beige or flesh tone and white (none are present in this detail), linear black streamers with their bulbous ends, and finer strands and loops. Closer in there is a fourth level of detail, made of fine spray and uncontrolled drippings. In this detail there is a passage of very thin snaking white threads, like overcooked angel's hair pasta, and droplets of beige, part of a widely dispersed spray. The smallest droplets went down last, so they lie on top of every other mark—notice the beige drop that sits squarely in the middle of the straight black diagonal, splaying it slightly where it hit.

In Pollock's paintings, pigments have to be called "flesh" or "beige" instead of, say, Ochre or Sienna, because he used commercially mixed colors. The actual names would have been more like "Fawn Beige" or "Caravan." In this sample there are five colors: black, beige, a darker greyish brown, white, blue-green, and aluminum. The aluminum is the most unusual, since it is a shiny metal-based pigment; it is visible toward the bottom, just right of center.

Thinking of the painting as a layered sequence, it may seem as if Pollock was actually working toward a kind of order, so that the painting would reveal its creation, step-by-step, to a careful investigator. But Pollock was desperately interested in avoiding the normal structure of drawing and painting. It is rarely possible to follow a stream of paint as it winds its way across the canvas (as museum docents often advise visitors to do). Wherever such a layer became too obvious, he obfuscated it, tangling it back into the pattern as if he were stitching a stray thread. Where marks threatened to become too clear, Pollock let a messy beige drip fall just on top of them, or he held the brush still while it spun a thread of paint, piling up like syrup on a pancake. Here the white paint has been dropped that way into the wet black, falling on top of itself and sinking in. I imagine Pollock taking special pleasure in details like the broken squiggles of white at the lower left. Just left of the vertical white ribbons, there are several disjointed white pieces: a Z shape, a dot just above it, and two C's, one of them backwards. They do not add to a comprehensible human gesture: they are effectively cut off, floating inside faint halos of white.

It may be that what Pollock feared, and wanted most to destroy, was the long continuous contour that would imply a human figure. Art historians have written about Pollock's desire to efface the signs of figural elements in his earlier work, and the artist Frank Stella has said that he still senses draped figures "underneath" Pollock's canvases.[34] It's certainly true that Pollock's actions can be explained in that way, but since this is a book about paint, and not representation, I do not want to say more about it. What matters is what happens in this one tiny extract from *Lavender Mist:* even here, in these four

or five square inches, there is an astonishing amount of *work,* a tremendous labor devoted to making a chaos. The allover paintings are like battles fought against whatever might unexpectedly produce a continuous, figural outline. The struggle is clear enough on the whole canvas, but it is waged just as strongly in marks that are not much larger than the weave of the canvas (which is also visible in this detail). This is what Pollock spent his time doing, working to create a convincing and utter disarray.

Yet no chaos is complete. There is no such thing as absolute absence of structure, or pure randomness: if there were, we would be unable to perceive it at all, because it would have no form or color to understand.[35] Everyday randomness usually harbors some secret order. The random-dot stereograms that are popular in books and calendars are actually strongly ordered, and computers that produce lists of random numbers sometimes do so by following instructions designed to produce the effect of randomness. Even here, where the destruction is nearly complete, there are a few marks that still preserve the sense of gesture. There's the graceful curve of black at the center, and especially a tiny white loop that's nearly lost, just right of the black vertical that comes up the left third of the painting, a fingerbreadth below the dark green smudge at its top. It's tiny, but it is clearly a loop, and the white strands that fall from either side are clear signs of the hand that made them: you can picture Pollock's hand, making curlicues in the air. It is the beginning of form, the first step out of chaos.

These stories about the *materia prima* are only a few out of many. The place where painting begins, and the moment before it begins, is almost unreachable by poetry or prose. Alchemy's benefit is that it is full of stories—almost too full, almost neurotically overstuffed with competing accounts and endless synonyms. I compared the lists to the devil's many names, but they are also like a neurotic's compulsive counting and naming. In an obvious sense, alchemists were concerned that they begin with the correct substance: otherwise they would risk losing years of work. But more subtly, they worried about

the idea of beginning, of needing to start somewhere. After all, the first verses of Genesis are not exactly comforting: they are as deeply mysterious as the Western mind can stand, and they are hardly good models for a poor alchemist's experiments. None of the other options are that soothing, either: beginning in dung heaps could not be counted as a promising idea, and starting from lead—the sickest of the metals, the one farthest from redemption—must have seemed a desperate measure.

It is beginning itself that is fraught. In the original Hebrew, the first verse of Genesis begins obliquely, as if it were trying to sneak into the creation story. In English we have it: "In the beginning, God created . . ." but the Hebrew is "In the beginning of God's creating of the heavens and earth . . ." It is never easy to begin, and the English misses that subtlety. Artists of all kinds have difficulties beginning. Physically, it is hard to pick up the brush. Mentally, it is hard to decide what to do first. What kind of beginning should it be? One that builds rationally from canvas to varnish? One that starts wildly, with big inspiring gestures? In his early days as a literary critic, Edward Said wrote a book called *Beginnings,* unraveling poets' strategies.[36] If there is one subject that is treated in every one of the thousand-odd artist's manuals, it is starting a painting. Along with knowing how to finish a painting, starting may be the most common topic of conversation between artists.

But in all that talking and all those books, there is very little said about what it means to begin in different ways. Artists tend to trade confidences and tricks: how to make yourself start, how to start easily or quickly. The how-to manuals are all recipes for avoiding interesting beginnings in favor of pre-tested ones. Paint is especially difficult to start with: as you can imagine if you're a non-painter, the lifeless lumps on the palette and the pristine canvas can be horrible specters, or implacable enemies. The alchemists thought longest and most freely about how to begin with substances, and it is their myths that I invoke when I think of starting.

4

How do substances occupy the mind?

HOW DO SUBSTANCES occupy the mind? How is it that looking at a Monet painting I begin to sense a certain tenseness, feel an itchy dissatisfaction with the body? Why does Magnasco give me a little vertigo, and set up a swirling, diaphanous motion in my eyes? How does Pollock exhaust me with his vacillation between violence and gracefulness? Before I go farther into the alchemical work, and talk about what happens after the *prima materia,* it is best to think a while about the way that mere paint—mere chemicals—can work so strongly on people's imaginations.

The sensations I get from paint come from attending to specific marks and the way they were made. I am using very small details of paintings in this book to make the point that meaning does not depend on what the paintings are about: it is there at a lower level, in every inch of a canvas. Substances occupy the mind by invading it with thoughts of the artist's body at work. A brushstroke is an exquisite record of the speed and force of the hand that made it, and if I think of the hand moving across the canvas—or better, if I just retrace it, without thinking—I learn a great deal about what I see. Painting is scratching, scraping, waving, jabbing, pushing, and dragging. At times the hand moves as if it were writing, but in paint; and other times it moves as if the linen canvas were a linen shirt, and the paint was a stain that had to be rubbed under running water. Some

96

painting motions are like conversations, where the hands keep turning in the air to make a point. Others are slow careful gestures, like touching someone's eye to remove a fleck of dirt.

Painters feel these things as they look at pictures, and they may re–enact the motions that went into the paintings by moving their hands along in front of the canvas as if they were painting the pictures at that moment. In a museum, it is often possible to tell an experienced painter from an historian because the painter will step up to a picture and make gestures, or trace outlines. Those movements are not always done in any deliberate way—they are second nature, a kind of automatic response like waving to a friend. An historian or a critic will freeze in front of a painting, or adopt a solid teacherly pose. A painter will walk right up to the painting, and move a finger or an arm along with the original artist's gestures; an historian will either stand at a respectful distance (it often equals the distance between a speaker's podium and the screen behind it), or suddenly move up close to the painting and point at it. The painter moves with the painting, the historian against it.

Moods are all tangled up in this as well. Any motion my body makes throws me into a certain frame of mind: hard exercise is a joy for the mind as much as the body, and finicky work like threading a needle exasperates the mind as much as it frustrates the fingers. Not all art historians ignore this: some do write about the body, and the imagined body of the painter. But they never take the extra step I am taking here and start talking about the associated moods or frames of mind. It seems somehow unreliable or too personal. Yet I wonder if there is a way *not* to fall into a mood as I rehearse a painter's gestures. Since this is a personal book, and my academic laces are untied, I don't mind saying Monet makes me feel anxious. You may not agree that some of Monet's marks imply the tension I sense in them, but you cannot disagree that the marks themselves are tense: they are made with a half-controlled jitter that I experience as a mood of tension. First my hand tenses, and then I feel tense, and it is almost irresistible to say that Monet must have felt something

similar. Emotions cannot be excluded from our responses to paint: these thoughts all happen too far from words to be something we can control. Substances occupy the body and the mind, inextricably.

Further, each medium has its own language of moods, its own way of reporting what the artist did and felt. A lithograph bears the memory of its stone: it has the heaviness of the lithographic press, and the wash and grease of the lithographic chemicals. The stone—or the ghost of it, when modern zinc plates are used instead of marble slabs—conjures the body at work, bent over the massive wood tables, hauling the stones from their cabinets, turning the polished crank to move the press. Lithographs speak about the crayon's crumbly grip, the water pooling across the plate, the furious polishing of gum arabic and acid. Each lithograph has something different to say about the body that made it. Some are careful drawings, done with slow gestures. "Chalk lithographs" pretend they are dry pastel drawings. Others are inundations of fluids. Toulouse-Lautrec spattered ink across his plates by flicking a small brush with his fingernail. Memories of stones and waters and moving bodies mingle with the thoughts that went into the making. Gentle movements mean calmness. Heavier stones and wilder gestures imply a more turbulent mind. The meaning seems to travel like an electric current, sparking from the artist's body to the chemicals, and from there to the eye of the viewer.

An engraving is a story of the tiny hard scratches that made it, the squinting eye that peered to follow them, the pinched movements of the hand, and the back bent over the work. From there it is only a short gap—the electricity of meaning arcs across it—to the feelings that accompany those bodily configurations. No matter what they depict, engravings are about having the patience to sit in one position for hours, letting the wrist or the fingers turn white with the pressure of the plate or its lead-filled cushion. An engraving is a monument to a certain act of determination, in the same way as a bank of burning votive candles is evidence of devotion. Each engraving speaks a little differently about its making. But we can hear the subtle voices

because it is *our* fingers that curl around the small round handle of the burin, and our arms that begin to burn from the constant pressure against the plate.

In photography the factual distance of a photograph echoes the steel and plastic camera that was manipulated to make it. A photographer can infer the settings of the camera from the photograph, and sometimes also guess the kind of camera. The grain of the print tells what kind of film it was, and how it was developed, and the tones of the print tell about the paper and the developing process. The constant heaviness of the camera, its smooth surfaces lightly greased by the fingers, the feeling of the knurled aperture ring, the grainy ground-glass in the finder, the corrosive chemicals of the darkroom, and the flashing searchlight of the enlarger, all mingle in the viewer's mind together with the photograph. My experience of any photograph is blurred together with my thoughts about clutching the camera, and the peculiar tunnel view through the viewfinder. A photograph that has been heavily manipulated in the darkroom, such as one by Ansel Adams or Edward Weston, brings with it the long hours bending over the enlarger. The clean snow and cold air of Adams's photographs of Yellowstone in the winter are mixed with the acrid odor of the stop bath; their pure whiteness mingles with the red darkroom light; and their open distances are closed again by the memory of peering into a magnifier, focusing the grain of the negative onto the test paper. Many photographs are made as if it were possible to ignore those physical meanings, but they cannot be erased and any full reaction to a photograph has to admit them.

By the same logic, marble sculpture often seems to be about marble: that is, the sculptors try to work up to the limits of what the marble will allow. Long thin objects are the most difficult: Gianlorenzo Bernini, one of the most skillful sculptors, managed to shape marble into branching twigs and leaves. Michelangelo carved five perfectly curled fingers on the Rome *Pietà* that have long been famous among sculptors. It is probably not coincidental that they are the fingers that were the target of the attack by an angry spectator in the 1970s. (He

broke them off, and ever since the sculpture has been kept behind a Plexiglas screen.) There are techniques for deceiving the stone into those unstonelike shapes: Michelangelo would have left small marble bridges between the Madonna's fingers, and cut them away at the last moment. Such tricks are common knowledge, but they are superficial, because they tell us very little about what compels sculptors to work so with such devotion on marble—instead of wood, for instance, which is easier to carve, or clay, which is easier to mold. To sense the meanings that marble gives to any sculpture, a viewer needs to know how the work of pushing, chipping, dusting, and gouging can occupy the mind. Marble is something that sculptors work on, but it is also something they think about. Marble has a specific kind of hardness. It is woody, meaning it can sometimes be pushed back or "peeled" in slivers. A chisel can dig down, curve, and come back out like a sharp knife in wood. But marble is also dry and friable, and it powders like chalk. Sculptors are constantly preoccupied with the feeling that marble is like wood, perhaps because it is seldom true: it is more like a dream, a kind of half-way version of the Pygmalion story where the artist dreams that the marble turns into wood instead of flesh. People also say that marble is like skin, but that is also a bit of a dream since marble outshines skin: it is glossier and smoother than any skin could be. It is notions like these, and not stories about technical excellence, that make marble an absorbing subject for a life's work. It is cold stone that dreams of being wood, and even skin. A sculpture might conjure thoughts of hard chiseling with a heavy mallet, or whittling, as if it were wood, or caressing, as if it were skin. Any viewer can appreciate the accomplishment of making stone into fingers and leaves, but in a more important, bodily way, marble is about the different motions and emotions that go with stone, wood, and skin.

It would be possible to write more along these lines, but they are only generalizations. What makes artworks interesting is the precise unnamable sensation particular to a single image. The moods and meanings I have been sketching creep into our experience without

our noticing, sparking directly from the eye to the mood without touching language at all. How do substances speak eloquently to me without using a single word? How do my eye and my finger know how to read paint? Partly, it is a matter of studio experience: the more time you spend painting (or sculpting or taking photographs) the more acutely you will be aware of the meanings of substances. But it is also independent of that experience. Anyone can walk up to a painting in a museum, look at the brushstrokes, and begin to relive them in imagination. Something about paints and colors must work on us without consciousness being much involved. Painting and art history do not have much more to say on the subject. Better answers to the question, How do substances occupy the mind?, are to be found in the old science of substances.

Alchemical substances have meanings very different from their modern chemical counterparts, so it would not make sense to study alchemical lead in order to understand painter's Lead White. The alchemists knew hundreds of substances, but chose just a few and made them fundamental. Sulfur, salt, mercury, and a few others are the building blocks of much more complicated methods. The alchemists would not have been able to believe in such a gross simplification if it did not answer to compelling differences between basic qualities such as wetness, dryness, or fieriness. The bodily response to substances may be about the same: it probably understands only very simple notions, and probably stumbles over the more complex compounds. So alchemy can help answer our question about artists' substances by showing what the body knows, as opposed to what the mind memorizes.

Taking mercury first, as the alchemists nearly always did: its sign ☿ is very like the sign for Venus or copper ♀ —they are both feminine

and "volatile." Mercury is apt to move around, and show a lively desire to combine with other metals.[1] It is also called quicksilver because it looks like cold liquid silver, and the alchemists thought it could dissolve gold, silver, and other metals. It is a penetrating liquid, they said: it can seep into stones and find precious metals. If a sample of powdered rock is heated with mercury, the mercury will attach itself to whatever gold there might be and draw it out.[2] Quicksilver is associated with fluids, especially semen, blood, and the humid breath: it is "primordial humidity" (*humiditas radicalis*). Mircea Eliade reports that Hindu alchemists call it the "semen of Shiva."[3] For Andreas Libavius, a late sixteenth century alchemist, mercury is the "material, vaporous principle" of water itself, as if mercury were what made water wet.[4] More sober metallurgists like the medieval Marius report that mercury has "an abundance of water" in it, so that "it is very similar to cold water and ice and is readily congealed"—that is, made into amalgams. It has only a small portion of fire in it, since it does not burn easily, nor scorch the tongue like fiery substances. Its high water content, he observes, also "forces it to scatter if it is thrown into a fire."[5]

The sources paint a picture of mercury as a principle of wateriness, a kind of liquid more fundamental than water itself. It washes itself into crevices, ferrets out hidden things, melts and dissolves whatever appears solid. In painting, therefore, mercury is the very principle of the solvent—the turpentine, turpenoid, benzene, or mineral oil. Its liquidity has no limits: the more powerful the solvent, the thinner the paint layer can be. Benzene can make very thin matte layers of paint that dry almost immediately and can be put down one over another. Other volatile oils like turpentine are less strident and carry the gloss of the linseed oil with them as they spread over the canvas, forming shiny glazes instead of dull sheets. The strong solvent is also a penetrator: if the brush bears down too hard, it might begin to dissolve the dried paint underneath it. Especially in tempera, painters have to go delicately over the layers of paint that have already set, or else their solvents will begin eating into their own

paintings. It is disconcertingly easy to wipe through carefully laid layers of tempera, right down to the white gesso underneath. There is no way to patch such a hole: it leaves a permanent scar in the painting. To a painter, the solvent is a kind of anti-paint, because it is what pigment must be balanced against in order to make it possible to paint at all. Like mercury, the solvent is volatile, unable to remain fixed in place, or to take on color. The principle of fluidity, liquidity, or solubility is a universal requirement in paint, and one-half of the two fundamental ingredients of paint (water and stone).

$$\text{\Large ♀}$$

Sulfur is quicksilver's opposite, complement, and "consort." Its masculinity is shown by its "fieriness"—its affinity to fire, smoke, and stench. Paracelsus simply called it Fire.[6] It can turn mercury into a solid, and even give it color. The result of the union of mercury and sulfur is cinnabar (HgS), whose brilliant red color is said to come from the male sulfur. The ability to color is masculine, because sulfur "impresses" itself into more flighty, changeable substances. Sulfur is also called the "balsam of nature," since it is the "formative" power and life in substances.[7] As the giver of form (*informator*), sulfur is masculine, the seed *par excellence*.

"In a certain sense," writes Titus Burckhardt, "'rigid' Sulphur is theoretical understanding," containing "the gold of the Spirit in unfruitful form."[8] Certainly the idea that sulfur is infertile without mercury is rooted deep in the alchemical tradition, though the explicit equation between sulfur's bodily nature and theoretical reasoning is new to this century. Considered as a principle, sulfur can be anything that does not evaporate or turn liquid, just as mercury can be whatever is volatile or easily liquefies. Ordinarily, alchemists thought raw sulfur was impure (an odd mistake by contemporary standards, since sulfur is one of the few elements the alchemists

possessed in a reasonably pure state). They tried to get at the secret heart of it by extracting whatever was not dry and flammable. One text says sulfur is double (*sulfur duplex*), consisting of a heavy non-flammable corporeal sulfur and a fraction that is fiery, stonelike, and spiritual.[9] Raw sulfur could be fixed—made even more stonelike—by distilling it with linseed oil. The calcined residue was sometimes identified with the essence or "seed" of sulfur, and a few alchemists even called it the Secret Fixed Sulfur of the Philosophers.

In painting, sulfur is the pigment, the color itself, and its fiery nature is reflected in the dryness of the colored powders that go into oil paints. Some of the most intense colors are commercially ground dry pigments: they are even higher in chroma than fluorescing sales tags or boxes of laundry detergent. Earth artists have scattered powdered pigments over stones and sand, producing almost hallucinatory effects: the blues and reds can be so powerful they look like optical illusions. When a powdered pigment is mixed with only a tiny amount of binder, it remains dry and fiery: it needs the liquid solvent to temper its color so it can harmonize with normal colors.

Painters know paints by their bodies: "body" is a standard painter's term for the heft of the paint, its resilience and sturdiness. Paint that has no body is "thin" or "lean," and apt to disappear into the crevices of the weave. It is insubstantial, well suited to fool the eye into seeing through it to whatever seems to be beyond. Other paint is called "fat," and it adheres to the canvas in lumps and pats, reminding even the most absentminded viewer that the object is a painting, and not a landscape, a face, or a disembodied abstraction. The principles of solution and solidity, mercury and sulfur, articulate that choice.

Third of the alchemical trinity is salt. Until the middle of the eighteenth century, salt was any solid, soluble, nonflammable substance

with a salty taste.[10] A few alchemists, such as Blaise de Vigenère, thought hard about salt, and wrote treatises dedicated to it. Vigenère says salt is "biting, acrid, acidic, incisive, subtle, penetrating, pure and clean, fragrant, incombustible, incorruptible ... crystalline, and as transparent as air."[11] In a more prosaic sense, salt was said to be whatever remains after evaporation, or forms crystals. Salt crusts can be made by evaporating salt water or tears, and saltpeter or nitre (sodium or potassium nitrate, $NaNO_3$ and KNO_3) appear as a salty crusts on the surface of rocks—hence its name *salpetra,* meaning rock salt. Salt is an "earthly principle," with power to coagulate and preserve.[12] It is a bounder, a delimiter (*terminator*) of substances, since it is itself the sterile end product of many reactions. Salt is the embalmer, the agent that assures corporeal stability.[13]

For painting, salt is the finished product: the dried crust of paint on the canvas, the inert product of the reactions that created the painting. Paint on an old painting is as petrified as the salt that ends alchemical experiments. It is the place where the strife of liquid and solid, inflammable and nonflammable, colorless and colored, female and male, come to their resolution.

The two antithetical principles of solvent and pigment are commonplaces in the studio, and artists are aware of the need to balance them. In my own experience at least, it rarely makes sense to think of the components of paint as male and female the way the alchemists pictured sulfur and mercury, though it does help to think of them as antagonists or partners. Artists have to negotiate between pigments and their solvents, and they are often conceived as opposites. But the idea that there may be a third term, and that it is the dried paint itself, is entirely new to painting—as it was to alchemy when Paracelsus promoted salt and invented the alchemical Trinity. The alchemical triad suggests that painting works toward a balance between color, fluid, and "salt," or—to put it in studio terms—between the powdered color, the colorless solvent, and the final dried product on the canvas.

In practice, these generalities resolve into sharply different cases depending on what substances are being used. A passage done with

stand oil and Burnt Sienna—that is, a rich reddish brown in a sticky gloss medium—will dry into a deep shadow. Another passage painted in benzene and cold grey, will produce a shallow, brittle-looking surface. At its most watery and colorless, paint is like a glass of water spilled onto the canvas, sinking into its threads and evaporating into a faint stain. At its driest and most fiery, paint is an opaque obstruction to light, a hunk of rock or oil crusted to the canvas surface. Monet's series of façades of the Rouen Cathedral are cases in point: it is as if the paint were limestone, and Monet had rebuilt the cathedral on the canvas itself (COLOR PLATE 6). The colors are dry and bright, like stones baked in the sun until they glow with a palpable heat. Sun beats down in the painting, and also in the paint itself, since the medium is sun-thickened oil. The projecting paint casts harsh shadows as if it were real carved stone: toward the bottom of this detail, a ledge of paint stands in for a cornice on the actual cathedral. But oil paint can never behave like masonry, and the thickened remnants of the medium resist the transmutation into rock and pull the paint into torturous shapes, bringing it forward into sharp spikes, tearing it into troughs and ridges. The round form in the middle is an old clock that no longer hangs on the cathedral.[14] It had a flat, unornamented face, but Monet has molded it in the same spikes that model the cornice. What appears to be a flat façade around the clock, made solid by the granular weft of the canvas, is meant to represent open-work—stone carved in three dimensions, like a perforated screen that opens onto the rose window several feet behind it. The paint here is strongly unnatural, but it is obdurate and it conjures stone. Monet painted in a pale Ochre, and then dabbed his masonry with a fucus—a surface layer—of yellowish Sienna, and Emerald Green, and Naples Yellow. There are even Cerulean Blue echoes of the sky and perhaps the nearby ocean. It is as if he were building in stone, and then painting in color. The clock itself is as clotted as paint can be and not revert to rock: it is almost pure pigment, worked into a grumous paste of solvent and medium. Paint like that is annoying to handle, because it wants to be slavered with a palette

knife instead of pushed with a brush. Like half-set glue, it clings to the brush as much as to itself. The clock was made by herding the paint into a circle, and then jabbing at it to dig out troughs and raise spikes. The rest of the façade was painted hard, almost scraped the way a mason would rough out a flat stone with a rasp. Over that foundation, the few seared colors went on easily, more like normal paint than glue or stone.

That, as the alchemists would say, is the imbalance of Monet's technique: it is as far toward pure fire or pure color as oil paint can go. The oil and solvent in it are almost strangled by the powdered pigment—but not quite, and their last struggles are violent. It is unpleasant painting, because it is so unbalanced, so tilted in the direction of flammable sulfur—as if the hot stones of the church would burst into fire. The result is a biting, acrid, hard crust: a salt. The great majority of oil painting makes a truce between the liquid and solid principles, between water and stone, and the painting mirrors their negotiation. Here one principle has overwhelmed the other, and the product is sterile. In other paintings Monet swings the other way, and the solvents liquefy everything, turning the world into a soft mist.[15] In those paintings, the canvas tends to be a watery, with very little salty residue. This is the problem with paint: if it is going to have a full range of meanings, it must work between water and stone, and not let itself dry up and burn, or evaporate into a colorless steam.

It was a consistent alchemical ambition to make an alloy of all the seven metals: gold, silver, mercury, copper, iron, tin, and lead. If it could be done, the amalgam would have wondrous properties—not least because it would be a little model of the solar system. In the Renaissance, the seven planets were the Sun, Moon, Mercury, Venus,

Mars, Jupiter, and Saturn. The Sun counted as a planet because it revolves in the sky just as the other planets do; and, of course, the Earth was not a planet, but the center of the universe. Since the planets from Uranus outward are not visible to the eye, they were not known. Alchemy continued this ancient tradition, which is based on common sense, long after Copernicus and the invention of the telescope. Because each planet corresponded to a metal (the Sun to gold, Mercury to mercury, Moon to silver, Venus to copper, Mars to iron, Jupiter to tin, Saturn to lead), an amalgam of the metals would bring the universe into the laboratory. It would be a model of perfect balance between opposites.

The Ethiopian alchemist Abtala Jurain, who also called himself Aklila Warckadamison, "Crown of the Gold Seekers," composed a recipe for a substance made of all seven metals. First the alchemist makes medallions out of six of the metals, and stamps each one with its symbol. (Mercury is excepted.) Then they are all put in a crucible in a darkened room, and seven drops of the "blessed Stone" are added one by one. As the seventh drop falls,

> a flame of fire will come out of the crucible and spread itself over the whole chamber (fear no harm), and will light up the whole room more brightly than the sun and moon, and over your head you shall behold the whole firmament as it is in the starry heavens above, and the planets shall hold to their appointed courses as in the sky. It will stop by itself, in a quarter of an hour everything will be in its place.[16]

Paracelsus also wrote a chapter on the possibility of making a single substance out of the seven metals. He called it electrum (normally electrum is an alloy of gold and silver), and he thought that a goblet made of it would defend against illness and poisons.[17]

In painting, this dream is the ideal of perfect consonance among all colors and media, and not just between the principles of water and

stone. But harmony is not possible, as painters know, because some ingredients are inherently inimical to others. There are inharmonious textures and dissonant colors, and in the end it is the personalities of each substance, and not the temperament of the whole, that prevents the kind of cosmic harmony that Jurain and Paracelsus imagined. Some alchemists sensed that more difficult relation. Constantine of Pisa was among the first, and he captured it in a poem about the elements. Since he was a medieval writer, he couldn't admit that his free verse was a poem: he calls it a "table," as if he were just listing properties.[18] But it is a poem, and it has a startlingly beautiful last line:

> Saturn can be bound
> Lead is fetid, and it can be fused
> Jupiter can be disjoined
> Copper is leprous
> Mars might be fluid but never melts
> Iron is squalid and falls apart
> The sun is soluble
> Gold gleams, it glitters, it is pure and perpetual
> Venus is corruptible and meretricious
> Tin is shrieking and inconvertible
> Mercury exhales vapors
> Quicksilver is the mother
> The moon is silver, eternal and stable
> In silver there is a provision for everything:
> This is the burning people

There is no hope of pure balance, no electrum with miraculous powers. A painting is a conversation between its substances, and it will always be a little imbalanced. Oils and colors are not co-equals, but "burning people," unable to converge on a single purpose. Some colors will be more strident than others; some parts will liquefy while others congeal; some marks will be harsh and others flaccid. It is the

conversation itself that makes paint eloquent, the "thinking in paint" as Damisch says. A perfect electrum would be dead.

So far I have been using the word "substance" whenever I can, and avoiding "element" unless I mean modern chemistry or the four Greek elements. Alchemists talk about substances and elements, and they also talk about "principles"—mercury, sulfur, salt. All of them (substances, elements, principles) are fundamentally chemicals. But why should a substance, in the sense that I mean it here, be only a chemical? The Greek elements also have "qualities"—hot, moist, dry, cold—and artists also care about oiliness, runniness, and powderiness. Couldn't they be "substances" in an artist's mind, just like linseed oil or Burnt Sienna?

There is a difficult and even profound question lurking here. Is a substance going to be restricted to something that could be on Ğābir's list—a metal, a stone, a salt, and so forth? Can a mixture, like an alloy of all the metals, also be a substance? If water can be a substance, then what about phlogiston, or even solubility, or liquidity? Isn't "cold" substantial enough to be a substance? And most important: do our intuitive responses to the world care about these kinds of distinctions? Perhaps in my uncognized reactions to the world (I hesitate to say my unconscious reactions, since I don't mean anything so doctrinaire), "cold" and "oil" are equals, instead of one being an adjective and the other a noun.

It's important again not to rush to give an answer based on modern chemistry, but to keep in mind how the world seems to the naked and naive eye. According to the phlogiston theory, for example, things that burn easily such as charcoal, phosphorus, sulfur, oils, and fats are rich in phlogiston, and they can even lend it to neighboring substances.[19] Therefore kindling transfers flame to logs. Inflammability becomes a substance that can be traded, rather than an insubstantial quality. According to Georg Ernst Stahl, originator of the phlogiston theory, what remains after burning wood is not ash but two things, a colored substance (*substantia colorans*) and a raw

substance (*substantia crudior*), so that, counting phlogiston, a log has three substances in all—unless one is just a quality.[20] The separation of substances and qualities has always been a vexed question, and it was seldom resolved in a rigorous way. And the subject is even more complicated than that, since substances and qualities are not the only properties that have been ascribed to things. Marcelin Berthelot, an historian of Greek alchemy, points out that there are at least four ways to understand fire: it can be a material element (*la matière particulière*), a state of things (*l'état actuel*), an action (*l'acte dynamique*), or a hypothetical element (*l'élément supposé*). That is to say, fire can be a substance, a property, a process, or the "hypothetical element whose union with bodies" causes them to burn, more or less as the phlogiston theory had it. Jean-Paul Marat, most famous as a martyr of the French Revolution, wrote a book of alchemy in which he claimed to make fire visible—meaning not the material element, but the hypothetical one.[21]

It is easier to think of fire in the first sense, as a material element, the particular "matter of a burning body." That is what we mean when we say, "Don't touch the fire," as if fire were a substance just as the candle wick or the candle wax are substances. The "material element" is compatible with modern science, since the bright yellow of a candle flame is incandescent carbon atoms, which have been liberated from the wax—and so in that sense, fire *is* a substance and not at all an evanescent spirit or quality.

In the second sense, fire can be the state or condition of a substance that is "undergoing combustion," as in the phrase, "The house is on fire." In that case fire is a property, and not a substance. And in the third meaning, fire can be the act of combustion in general, as when we say, "Fire up the engine."[22] Then it is again intangible, but in a different way. Together, the four meanings Berthelot lists give a sense of how difficult these questions were before modern chemistry. In the first sense fire is a tangible and perceptible (fire has a color and a smell, and it hurts), but it can also be taken as the single essential definition of fire; and fire can also be a state (the second definition);

an act (the third definition); or an intangible, imperceptible quality (the fourth definition).

This is a conceptual swamp where qualities are tangled with substances, and properties with states. The alchemists debated the nature of qualities; sometimes they thought of them as clothes that could be taken off, leaving the pure "body" of the object, and other times they thought qualities were the body itself. The historian of science Pattison Muir divided his *History of Chemical Theories* into two sections, the first titled "The History of the Attempts to Answer the Question, What is a Homogeneous Substance?" and the second "The History of the Attempts to Answer the Question, What Happens when Homogeneous Substances Interact?" To him alchemical substances are "qualities . . . of classes of substances," implying that no alchemist ever knew a true substance (that is, a pure molecule, or an element with a certain atomic number and weight), though some of the alchemist's "qualities" are very close to contemporary chemical descriptions of elements.[23] The question, "What is a homogeneous substance?," was solved for modern chemistry by a series of texts beginning with Joachim Jungius and Robert Boyle.[24] As soon as there was a stable definition of element, the question of substance ceased to exist. Searches for substances became searches for elements. The Slovakian historian of chemistry Vladimír Karpenko has made a study of the mistaken claims chemists have made to have discovered new elements. He lists over a hundred forgotten "elements." (Often they have wonderful names: anglohelvetium, crodunium, dubium, eurosamarium, glaucodidymium, hydrosiderum, incognitum, neokosmium, nipponium, oceaneum, wodanium, and even jargonium.[25]) But he begins his study in the mid-eighteenth century because before that time, there was not yet agreement on the nature of a substance or element.

The moral I draw from these debates, which fill volumes in the history of chemistry, is that where alchemy and painting are concerned, there is no good reason to distinguish substances, qualities, principles, and even elements. What matters in any specific instance

is *what* is occupying the mind: a certain oil varnish may be engaging because it is unusually viscous, in which case a quality counts as a substance. A particular stone might be of interest because it is powdery, so that the principle of sulfur or the property of inflammability comes to the forefront. There is no reason to put qualities or principles on a different footing from substances, just as there is no reason to refer substances back to elements and chemical formulae. For the same reason I am skeptical about distinguishing between what philosophers call ideas and observables. If the purpose is to understand paint, then there is no utility in making a sharp line between concepts and chemicals: a concept can be a substance in the mind just as a chemical is a substance in the world. Substances occupy the mind as concepts, and concepts occupy the world as substances. Linseed oil on the palette is indistinguishable from linseed oil in my mind. Philosophically, there are many good reasons to say otherwise; but in terms of experience, substances settle in the mind and act on the thoughts exactly as if they were principles of thinking, and the ways I think migrate outward and settle in the oils and paints exactly as if they were solid things. Thinking *in* painting is thinking *as* paint.

Alchemists do distinguish substances from processes, but even that basic distinction is never quite secure. The ecstatic Heinrich Khunrath confuses ideas, spirits, and substances continuously. In one book, talking about the spirit of God, he says it must be a "spiritually fired water, or a watery fiery spirit, or a fiery spiritous water" (*Geistfewrigem Wasser / wässerigem fewrigem' Geiste / oder fewrigem GeistWasser*).[26] There is no way to tell, and no reason to try. Since Heraclitus, it's been a commonplace that things are in continuous flux, but alchemical thinking opens a much more radical possibility: that flux itself may be a thing. The historian Conrad Hermann Josten is probably right when he says that in some contexts, a paired eagle and serpent in an alchemical picture may "represent the Philosopher's Mercury as well as its sublimation and the Stone itself,—the matter, the method, and the result."[27] Dee's "hieroglyphic monad" can be "hieroglyphically considered" in different ways so it is at once a sign

for substances, their transmutations, and the stone.[28] Artistic proc-
esses are arrangements and transmutations of substances: but some-
times they also *are* substances.

Here it is in paint: a Rembrandt self-portrait of 1659, which I have
photographed in slightly raking light (COLOR PLATE 7). Rembrandt
is well-known for the buttery dab of paint that he sometimes puts on
the ends of the noses of his portraits, and this nose is certainly greasy
and has its little spot of white. But touches like that do not stand
alone: when Rembrandt was interested in what he was doing, as he
was here, he coated entire faces in a glossy, shining mud-pack of vis-
cid paint. The skin is damp with perspiration, as if he were painting
himself in a hot room, and he slowly accumulated a slick sheen of
sweat. It is impossible to ignore the strangeness of the paint. If I
looked at my face in the mirror and saw this, I would be horrified. The
texture is much rougher than skin, as if it is all scar tissue. As a painter
works, the shanks of the brushes become repositories for dried paint,
and flecks of that paint become dislodged and mix with fresh paint,
rolling around on the canvas like sodden tumbleweeds. They are all
over this face, forming little pimples or warts wherever they end up.
(There is a large one halfway up the nose.) Among contemporary
artists, Lucien Freud has made an entire technique out of these rolling
flakes and balls, and he lets them congregate in his figures' armpits
and in their crotches.[29] In short, the face is a wreck, much more dis-
turbing than the unnaturally smooth faces that most painters prefer.

Although historians tend to see Rembrandt's method as an
attempt at naturalism, it goes much farther than portrait conventions
have ever gone, then or since. Consider what is happening in the
paint, aside from the fact that it is supposed to be skin. Paint is a vis-
cous substance, already kin to sweat and fat, and here it represents
itself: skin as paint or paint as skin, either way. It's a self-portrait of
the painter, but it is also a self-portrait of paint. The oils are out in
force, like the uliginous oozing waters of a swamp bottom. The paint
is oily, greasy, and waxy all at once—even though modern chemistry

would say that is impossible. It sticks: it is tacky and viscid like fly-paper. It has the pull and suction of pine sap. Over the far cheek, it spreads like the mucilage schoolchildren use to glue paper, resisting and rolling back. On the nose—it's rude, but appropriate—the paint is semi-solid, as if the nose were smeared with phlegm or mucus. On the forehead, it looks curdled, like gelatin that is broken up with a spoon as it is about to set. There is drier paint around the eyes, and the bags under the eyes are inspissated hunks of paint, troweled over thin, greyish underpainting. The grey, which is left naked at the corner of the eye and in the folds between the bags, is the imprimatura, and the skin over it is heavy, thick, and clammy. The same technique served for the wings of the nose, where dribbles of paint come down to meet the nostril but stop short, leaving a gap where the grey shows through. Of course, the nostril is not a hole, but a plug of Burnt Sienna with Lamp Black, and it also lies on top of the grey imprimatura. Rembrandt's thin moustache is painted with wiggles of buttery paint, almost like milk clinging to a real moustache. Over the eyes and eyelids there are thick strips of burned earth pigments—Lamp Black and Burnt Sienna—covering everything underneath. The tar spreads up and inward, and then falls into the hollows between the eyes and the nose in dense pools like duplicate pupils.

There is no limit to this kind of description, because Rembrandt's paint covers the full range of organic substances. It is more fully paint, more completely an inventory of what can happen between water and stone, than the other examples in this book. And that means it is also more directly expressive of qualities and properties: it is warm, greasy, oily, waxy, earthy, watery, inspissate. It is not dried rock, like Monet's cathedral, nor water, like his marine paintings. The thoughts that crowd in on me when I look this paint have very little to do with the underlying triad, or with the named pigments or oils. They are thoughts about *qualities*: I feel viscid. My body is snared in the glues and emulsions, and I feel the pull of them on my thoughts. I want to wash my face.

This is how substances occupy the mind: they congeal it into their own image. The painter's face becomes a portrait of the substances that filled his mind.

For the alchemists all this was usually terribly literal. They often wanted to eat what they had made, as if the ingestion would transport the qualities into their bodies where meditation would not. Edible gold was a common goal. Some recipes are genuinely edible, even if they wouldn't be good for you (there are mixtures of gold and honey, and gold and salt). Others are poisonous. Joseph Du Chesne, a late sixteenth century physician and alchemist, tells how to make edible gold by pouring blue vitriol (copper sulfate pentahydrate) over tin powder, resulting in "the most beautiful yellow water in the world."[30] It is left overnight, and then the next day the alchemist pours it over gold leaves and adds "very fine brandy" (*tres-excellente eau de vie*). If it is heated long enough, the gold will turn to oil, and can be taken internally for "all diseases of the lungs, the stomach, and the heart, in short, for all kinds of illnesses and infirmities . . . It is also excellent for the prolongation of life and the prevention of all kinds of diseases." This is the quackery that eventually hurt the alchemists, but it also has its deeper truths. There is something beneficial about seeing gold turn to yellow water, and then to oil, just as there is something eloquent and unanswerable about Rembrandt's pastes. It could even be said this way: substances not only occupy the mind, they become the mind.

5

Coagulating, cohobating, macerating, reverberating

EMIL NOLDE, the original German Expressionist, had a wild way with paint. Where an academic painter would have begun cautiously with a smooth thin underpainting, Nolde started right off with opaque paint at full strength. Instead of planning where each color would go, he worked impulsively, changing his mind in midstream, piling color on color in thick impastos, or scraping the brush back and forth on the dry canvas long after it had given up its pigment. If the paint became too thick and wet and yet was still all wrong, he did not swab off the excess with a cloth, or put the canvas aside to let it dry. Usually he just kept painting, until the thin paste became an unmanageable oily sea. Some of his pictures look like cracked molds for bas-reliefs, and others are haggard where the dry brush has scratched and rubbed to get the last morsel of pigment. Even though he knew the academic protocols, Nolde didn't care about fat and thin paint, or the slow patient building-up from dark toward light, or even the proven logic of color combinations. He covered greens with oranges, and violets with yellows, and he tried over and over to do something every beginning painter knows is hopeless—he shoveled brushloads of white into wet blues and blacks, hoping to lighten them. (Blues can't be lightened that way: the white disappears endlessly into the dark.)

Nolde's process was unruly, but the results are sometimes wonderful beyond anything the later Expressionists managed. Deep orange suns, embedded in thick magenta clouds, shine darkly on brackish waters. Cool forests, shot through with bluish green treetrunks, shimmer with streaks of dirty yellow and heavy brown. Shining sunflowers hang their plastered faces in gardens filled with dense Viridian and purple, shadowed under bluish skies. Spooks and specters—Nolde believed naturally and impassively in ghosts of all kinds—fluoresce in red and blue against predawn mountain skies. In Nolde's pictures, paint is macerated rock, dried onto the surfaces of things. It is a residue, a stain, or a smear on the raw canvas. Paint is paint, much more solidly and truly than in the "self-referential" gestures of postmodern painting. It has a ponderous luminescence that the filmy glazes of academic painters never achieved, as if the entire world were encrusted in gleaming volcanic rock.

Unlike some works by his Expressionist followers, Nolde's paintings have no method in their madness. They were never planned to be wild: they grew wild naturally, without any thought on his part. More often than not they went wrong somewhere en route and were either abandoned or destroyed. Some he turned over, and painted on the back, and others he cut up, or tore in pieces, or just crossed out in chalk. The proof that Nolde had no method can be found in the new multivolume edition of his collected works. There it becomes apparent that only one in twenty paintings is a success, and the other nineteen are ruined by overwork. If a wet thick orange is overlaid with a thick green, the result might still be beautiful—streamers of orange, grey, and green twined together—but if that mixture is overlaid again with blue, and then with red, and then with purple, and then with brown, the paint will finally succumb to the laws of optics and become a colorless grey mess. Many of Nolde's paintings ended up inexpressive because he tried to make them too expressive. The golds and magentas gave way to slushes and sluices of muddy neutral browns, and finally the paintings congealed into cold grey soups. Still, Nolde was genuine in his love of paint, and he even cherished

some of those last moments before the paintings extinguished themselves. He made the best of the suffocating tones by painting pictures of stormy seas (he even painted on the deck of a ship sailing in midwinter), and there are entrancing scenes of muddy streams and sodden houses. If the paint insisted on becoming mud, he followed it as far as he could by painting pictures of mud. But most of the time, his ecstatic thoughts led him on without stopping, and the paint suffered so many transformations that it finally died.

The seascape in COLOR PLATE 8 is one of a long series where the subject is just the waves thrashing over each other, and the paint thrashing over itself. In the best of them, Nolde manages to stop just before the colors blend into a neutral greyish greenish brown. Here he has been painting straight from the tube with gobs of creamy Viridian, Lead White, Chromium Green, Lamp Black, purple, and brown. The seas must have been racing, because he paints up and down, and then slurs the colors by dashing the brush across sideways. Already the bottom and the top of the scene are lost to heavy impastos of impenetrable opaque color, and the horizon—the key to whatever space there is left in the picture—is in danger: it is overburdened by incompatible hues, and with one or two more brushstrokes it would lose its focus and fall into a flat curtain of static grey.

Painting is the art of metamorphosis, and Nolde is its wildest student—never thinking, never planning, never pausing long enough to formulate a strategy. He is the opposite of the careful didactic plotters in the French Academy, who made painting into a professional activity by giving it a sophisticated nomenclature and a battery of methods. In the French practice, which was generalized throughout Europe in the eighteenth century, painting proceeds according to a plan, beginning with drawing and progressing through sketches and studies and underpaintings and layers and glazes, and culminating with delicately concocted varnishes. It was an apotheosis of systematic learning. The French Academy tried to revive and preserve earlier methods that were thought to have been used in the Renaissance, and they were right in many ways: Renaissance paintings generally

did demand some advance planning, and they did proceed step by step. A tempera painting, for instance, begins with the figures all in green. When the green dries the painter goes over it again in translucent red, and a flesh tone is miraculously produced where the green shines weakly through the red. Having done that myself I can testify to how unexpected it is, and how difficult it can be to have to look at a greenish cast of characters, and try to think ahead to what the colors of the finished painting will be. Many old tempera paintings have been over-cleaned, so the figures are greenish or bluish instead of rosy. Sassetta's madonna, COLOR PLATE I, is an example: her face may have been slightly cool, to indicate her heavenly status, but it has been made somewhat cold, like a polished emerald, by restorers who dabbed away the finishing layer of red. The depth of the underlying green can be judged by the dark bluish cracks that have opened in the madonna's skin. In past centuries painters routinely had to exercise a force of imagination as they worked, because their transformations went by slow stages. An unfinished painting would never look like the final product until the last moment; it would be deliberately too light, or too warm, or too green. At the beginning, Sassetta's painting would have had a blank where the figures are, and a mat of red clay all around. The clay, called bole, supports the gold leaf, and takes the impressions made by the artist's punches when he decorates the halos. In this painting, the punches have held up well— one set serves as decoration in her collar—but the gold is abraded and the red bole shows through. Clothes would have been done separately, often in multiple layers to build up their density. That kind of planning has long since vanished. From the Impressionists onward paint has been allowed to transform more rapidly, and from the Expressionists onward, there have been virtually no rules or restraints. Now anything is possible, and a picture might become suddenly beautiful or be ruined in a moment.

These two possibilities—the slowly worked-out plan, and the impetuous rush—are different ways of managing metamorphosis. Conservative painters and teachers mourn the loss of "real" technique,

but the two are just opposite ends of the same spectrum of transformation. As painters say, the paint seems to have a mind of its own—it "wants" to do certain things, and it "resists" the painter. Some artists have tried to discipline paint, to learn its inner rules, and to control it from a position of knowledge. Others have learned to let paint do what it wants, so that painting becomes a collaboration between the artist's desire and the unpredictable tendencies of the paint. In the first category belong the majority of premodern painters, the academicians, conservators and chemists, technically-minded artists, color theorists and chemical engineers. In the second belong the Expressionists and Neo-Expressionists, and the majority of contemporary painters. They are agreed on one principle: painting is metamorphosis. When people say art is alchemy, they usually mean it involves metamorphoses that can only be partly understood. Chemistry can only go so far, and then intuition, creation, skill, genius, imagination, luck, or some other intangible has to take over. Alchemy is the generic name for those unaccountable changes: it is whatever happens in the foggy place where science weakens and gives way to ineffable changes.

Normally there isn't much that can be said about the exact ways in which paint changes, or what it "wants." The "creative process" is vague, and so is the metaphor of metamorphosis. Once again, alchemy is the clearest path into these questions because alchemists nearly always understood that their art demanded a mixture of rational control and intuitive freedom. The alchemical substances could be partly understood, but they also changed in unexpected ways. Some literal-minded alchemists wrote exact formulas for their everyday elixirs and oils, but in most cases those recipes are either trivial or well-known. The important recipes are always clouded or incomplete, and though there are many reasons for that (some alchemists were intentionally fraudulent, and others were hopelessly confused), the incompletion was necessary so that the substances could remain alluring and unpredictable. Alchemical metamorphosis is not so much pre-scientific as para-scientific: it works alongside science (from

para-, meaning "beside") by taking some laws from the rational world of experimental procedure, and fusing them to irrational methods designed to expose the unpredictable properties of half-known substances.

The literature on painting is relatively mute about metamorphosis. If you go in search of it, you will find it is entirely taken over by largely uninteresting books on chemical composition, artist's techniques, and restoration. There is not much to say about Nolde's methods because there are so few words to describe what happens when one color struggles with another until they both weaken. The same is true of the older methods: there is no critical language to describe the greenish tempera painting, waiting for the red to cover and restore it. Those are important meanings and states of mind, and they need words.

The principal alchemical terms for metamorphoses are names for changes that also happen in painting. For the alchemists as for the painters, they are partly reasonable procedures that can be taught and learned, and partly intuitive, mystical methods that describe something a rational analysis cannot grasp.

CONGELATION

To the alchemists, there were two fundamentally opposed states of matter: the fixed and the volatile. They were symbolized elegantly with two little pictures: \vee for fixed and \wedge for volatile. The sign for fixed suggests a spot of matter, sitting in a crucible. The other suggests a dot of vapor, rising to the top of a closed vessel. Volatile is also written \curlywedge as if it were a puff of smoke, drifting and eddying in the air.

All matter, the alchemists thought, is one or the other. Water is volatile, since it can be boiled out of a pot, leaving a white skin of dried minerals. Honey can be boiled, leaving ash. But gold is fixed: it is difficult to change gold, and it can seem that gold survives all mixtures intact. It can be melted, but it cannot be boiled away (or so the

alchemists thought). It can be dissolved, but only with some diffi-
culty, and if it is hidden in a mixture it will never form chemical com-
binations—the mixture can always be heated, and the gold will be
there at the bottom (or so the alchemists thought). One of the aims
of alchemy, and one of its most basic metamorphoses, is to make the
volatile fixed: to cut the limbs from the lion, or clip the wings from
the dragon, or shear the feathers from the phoenix. The alchemists
thought of fixation as hobbling, chaining, and mutilation. Chop off a
man's feet, and he will not walk far. (In other texts, by typical
alchemical paradox, amputations make more mobile, and so more
volatile.) Alchemists also symbolized fixation as �929—that is, mercury
ϙ shorn of its head. In one alchemical frontispiece a lion sits de-
murely beside its four paws, hacked off by the alchemist's sword. The
paws are in two neat piles.

Fixation is certainly the primary metamorphosis of painting as well,
since the liquid paints are siccative: they desiccate and become solid.
Congelation is a name for the act of fixing or congealing, both in
painting and in alchemy. Whatever else painting is, it is the patient
supervision of oil as it dries, and that is why painters have always been
so concerned about how different media dry: whether poppyseed oil
dries better than linseed oil, whether pine oils or sunflower oils might
be used instead. It can take an expert eye to judge the differences: I
have been told hazelnut oil is the best for tempera paint, but so far I
have failed to see its distinctive properties. The endless combinations
of balsams and turpentines, soft resins such as mastic, dammar, shel-
lac, and sandarac, hard resins such as copal and amber, waxes, tal-
lows, oils (of cloves, lavender, rosemary, elemi, cajaput, camphor):
they are all meant to fine-tune the manner in which the oil paint dries.
Ideally it should not wrinkle, shrink, or discolor, and it should remain
viscid long enough to be worked but not so long that the painting
cannot be packaged and sold. Acrylics could only be successful in the
twentieth century, when painters are more likely to be impatient. In
past centuries, acrylic would have seemed to dry far too quickly.

And alchemists were right to imagine fixation as a violent process. Imagination is fluid, or it wants to be, and the very act of painting is an act of violence against the liquidity of our thoughts. A painting is frozen, and its permanence is very much unlike our evanescent ideas. That is one of painting's powers, since the stillness of a painting can set the mind free in a remarkable way—paintings give us license to reflect in ways that volatile arts, such as movies and plays, cannot. A film bombards the senses with new configurations, while a painting remains still, waiting for us to dream the changes it might possess. But for the painter, the continuous partial freezing of each day's work is also something unpleasant, like a necrosis creeping through healthy tissue.

A fixed element in a work, such as a dried passage where the painting is effectively finished, can be a cornerstone around which the work is constructed. It is necessary, but it also hurts. It is often possible to look at a painting and guess which passage was fixed early in the process. It may be a face, or a beautiful passage of drapery, or a brilliant gestural mark: usually it is whatever is so obviously successful that the painter could not bear to efface it even when the whole painting changed around it until its very existence became a luxury. At first the perfect place in the image is a happy discovery, what in French is called a *trouvaille,* and then as the painting gathers around it, it wears out its welcome and becomes an annoyance. Often, too, it is possible to see paintings where the perfect place, prematurely fixed, has outlived its value and continues to exist only as a fossil of some earlier notion of what the picture might have been. Paintings tell the story of their creation that way. The paint gathers around the one fixed spot like the nacre of a pearl around a piece of grit. Anything permanent in the imagination is also an obstruction, an ossification of the freedom of thought. Like a bursa in a shoulder joint or a sand grain in a clam, it attracts accretions that try to smooth it out and make it less painful. The painting swirls around the fixed spot, protecting and enclosing it like a bandage. But thoughts rub against it, and it aches.

DISTILLATION

The second most important metamorphosis is distillation, where substances rise as vapors into the tops of vessels, and then condense as dewy sweat and run down the sides of a tube into a cool glass. The symbols for distillation express the beautiful simplicity of the idea. In one symbol, ♌, derived from an astrological sign, the fluid boils in an egglike flask and the vapor rises up into a curved tube and trickles down the tail toward a collecting vessel.

In alchemy, distillation is when the substance gives up its mundane body and becomes spirit, and in painting, it is when the paint ceases to be paint and turns into colored light. Although the Christian metaphors run deep and thick here, the fundamental concept is religious in a more general sense. On an empty canvas, a blob of yellow paint is a wet sculpture, a hanging adhesion on the linen threads, coated in a slowly thickening elastic skin. But if I step back far enough, it may become a yellow sun, shining in a white sky. In that moment the paint distills into light: it moves without my noticing from its base oily self into an ethereal abstraction. Every painting distills and condenses over and over as I look at it: I see first the dirty threads and yellow stains, and then the open sky and sun. Even the most stubbornly postmodern paintings rely on that idea—even Sherrie Levine's copies of Piet Mondrian's paintings are faint reminders of the old transcendence—and it is not much of an exaggeration to say the entire history of Western art is a set of variations on this underlying theme. Distillation, as I am calling it, is what made medieval religious painting possible by allowing worshippers to see *through* the thinly painted panels to the heavenly sphere beyond. Distillation is what made romantic painting so effective as a servant of the sublime, and it is the dying idea that keeps the play of postmodernism going. But this book has nothing to do with all that, since I want to keep to the paint itself, up to the moment when it changes from blob into sun, and not beyond.

In alchemy, distillation is transparently a metaphor for resurrection. It means cleansing, purification, and renewal. Alchemists

lavished their attention on the transcendent meanings of their craft, but they never lost sight of the necessity of working in the dark stench of the laboratory. Art history does not have as good a track record. Art history is concerned almost entirely with the suns and other things paint represents once it is sublimated, and very little with the unpleasantness of the machinery that creates the miracle. From the vantage point of heaven, or of traditional art history, the studio is only the staging area, and what is important happens from the moment the paint becomes a sun. But from the point of view of earth, distillation is not that easy. After the fact, it seems like effortless trans-substantiation, where the spirit rises like breath from the body. But before the fact, in the vessel itself, distillation feels like a churning cauldron. As any artist knows, there is no such thing as effortless mimesis: it takes work to make paint look like anything at all.

The alchemists tell the fable of King Duenech, who had a bad case of constipation: he was "swollen by bile," and "horrible in his behavior." His wise doctor Pharut sealed him in a glass steam house. The heat freed him of his "black bile," and he returned to his people, wet with dew.[1] If this were a medical legend, there would have been a toilet in the steam house, and perhaps Pharut would have offered the King his best laxative and a good diaphoretic to make him sweat. But this is alchemy, and things are never that easy. The alchemist Michael Maier explains there are three kinds of bodily discharge. One is the "thick" and "fat" bile—that is, feces—that are discharged by purgatives. Second is the "liquid, thin, bilious, and salt" secretion that appears as urine. Third is "still finer," and is carried off as sweat. The King suffered from all three kinds of corporeal stoppage, and he had to be relieved in a more radical manner. Another alchemist tells the full story: Duenech sweated so strongly that his sheets were stained, because the black bile had squeezed out of his intestines and suffused his entire body. Pharut had to cure him three times: once by letting him sweat, then by putting him in an airtight bed and rubbing "evil-smelling oil" into his feet until the remaining bile retreated to his head, and finally by rubbing him with a mixture of water, oil, and

sulfur.[2] And Duenech had it easy. Other constipated kings had to be hacked in pieces and boiled into a mush, or drowned.

As far as the gross substance is concerned, there is nothing elegant or beautiful about distillation. Nor is it simple.[3] In alchemy, distillation is sometimes the easy laboratory procedure that makes wine into spirits, but more often it is an almost mystical pursuit designed to capture ever-so-slightly different species of vapors as they rise from the boiling sample. All that is required to make a sharp, evil-smelling moonshine from table wine is a distilling vessel, a cooling tube, and a collection vessel (Figure 3). The main vessel, called an alembic, has a swollen belly—the matrass or cucurbit—and a rounded condensing head, leading to the "snake" and eventually the collection vessel. In this case, the tube is curved and it passes through a barrel of cold water, but those are unnecessary elaborations. (In modern chemistry the barrel would be called a "cold-water jacket.") Artists can make their own turpentine by distilling it from pine pitch, leaving a residuum called colophony.[4] In modern chemistry, fractional distillation is the name of a method for extracting several volatile substances from one sample by arranging tubes and collecting vessels at different heights above the sample, as in Figure 4. When crude oil is boiled in a covered flask, the first substances to evaporate are benzene, gasoline, kerosene, and naphtha; as the temperature rises, progressively heavier oils will evaporate until there is nothing left in the flask except the buttery petroleum derivatives such as vaseline and paraffin. It is possible to catch different volatile oils in different collection vessels by arranging them at various heights above the crude oil. The higher the collection vessel, the hotter the substance that will be caught, so that a single heating of a sample of oil might yield a half-dozen different substances. If a plant is boiled to extract its oils, the first to evaporate are the essential oils that smell the same as the plant itself; they appear even before the water has come to a boil. Later, as the water is boiling furiously the fatty oils will appear in the collection vessel. They are often odorless: when it is first extracted linseed oil has no odor. After the water has nearly boiled away and

the plants are reduced to a mush, the still will extract the empyreumatic oils, which are heavier and smell burnt. The heaviest oils will remain in the alembic.[5] Oil of Dippel is the name for the especially viscous oil that remains after repeated attempts to putrefy, dissolve, and distill animal parts.

The alchemists understood some of that, but they also confused fractional distillation with an illogical kind of distillation where tubes and collection vessels all separate from a common point like the spokes of a wheel. According to modern theory, the same substances would have to be collected in each. Alchemists also mixed the scientific and unscientific methods in all sorts of twilight combinations, like this one where the collection vessels are lined up like piglets suckling at their mother's teats (Figure 5). A modern chemist might say that only the most infinitesimal differences between compounds could ever be separated this way, and even so it would be too unreliable to ever produce dependable results. The alchemists also distilled their substances over and over, hoping to discover different forms of the same substance. They called that process *cohobation,* and they had a beautiful symbol for it: ♉♉ showing two cycles, with a zig-zag suggesting more to follow. (It's also possible to think of Fig. 5 as a symbolic diagram, and not an actual piece of laboratory equipment, in which case it hints at how many times the distillation must be repeated.)

Illogical apparatuses made distillation into a mystery. It was fitting that distillation should be at least partly unknowable, as long as it was a metaphor for transcendence. The English Renaissance alchemist George Ripley describes an experiment in which a thickened, crystallized mixture of lead oxide and glacial acetic acid—he calls it his Green Lion—is put in a flask and distilled. When it is heated, the Green Lion gives off white fumes which condense into a clear liquid, just the way steam would fill a glass container and condense back

FIG. 3 Simple still with cold-water jacket. From Fra Donato d'Eremita, *Dell'elixir vitæ* (Naples: Secondino Rontagliolo, 1624), n.p.

FORNO ET ISTROMENTI D' ACQVA VITA

FORNO. ET IN STRVMENTI D'AQVA VITA

A. forno alto due buoni palmi G. serpentina di piombo.
B. fenestra del pedamento da H. Aqua fredda nel botticello.
 cauar le ceneri. I. botticello di legno.
C. fenestra da far il fuoco sopra K. pertuggio doue passa.

into clear liquid. But then all of a sudden there is an ustulation: the remaining mixture puffs up to three times its height and solidifies into a brittle white mass, like a glass sponge. It is a startling effect, and it happens with no warning. If the sponge is heated further, the collection vessel will fill with a strong-smelling liquid that Ripley calls his Blessed Liquor. The sponge can be broken down, and if powdered remnants of it are heated again, they will turn black. Then, when they are taken out of the still and touched by a match, a beautiful rainbow of colors glides across their surface and is fixed in place. I have a sample I made several years ago; even now, it glows with burnt-out reds and oranges.[6] It's the kind of beautiful and utterly unexpected chain of transformation that painters also know: the moments when it seems one thing is absolutely certain, and then something entirely unexpected happens instead. Even the most unpromising leftovers, like Ripley's black powder, can be ignited into gorgeous displays.

For people who care only about what paint can depict, distillation is the rudimentary step that all painters make in order to represent anything. It's the business of painting, and what counts is that the paint can be arranged in the shape of a sun (or a figure or a landscape). But from the artist's vantage, the moment when paint suddenly forms itself into something is always at stake—always vexed, always sudden and mysterious. From that point of view, distillation is the unpredictable, dangerous agitation that immediately precedes transcendence.

SUBLIMATION

From here the metamorphoses become subtler, and many are variations of the basic two. Sublimation is a kind of distillation of solids: a rock, placed on a heating plate, may give off a vapor without melting, and the vapor can be collected where it rises to the top of the vessel. The Greeks knew this method, which they used to tint jewelry, and

FIG. 4 Apparatus for fractional distillation. From *Dell'elixir vitæ.*

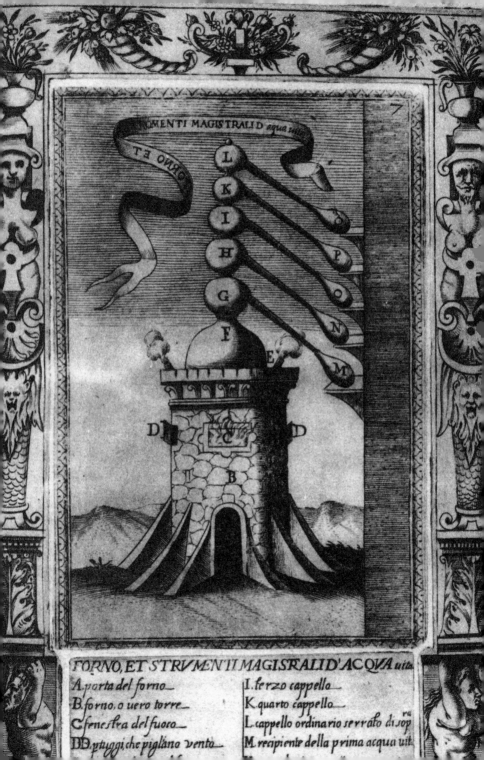

FORNO, ET STRVMENTI MAGISTRALI D'ACQVA vita.

A porta del forno.

B forno, o uero torre.

C fenestra del fuoco.

DD piuggi che pigliano vento.

I ferzo cappello.

K quarto cappello.

L cappello ordinario serrato di sopra.

M recipiente della prima acqua vit.

they named the vessel with two platforms (one high, one low) the *kerotakis*.[7] At the bottom near the fire there might be a piece of sulfur, and at the top on a little shelf a copper earring. As the yellow sulfur disappears, it reappears as a purple coating on the earring. Yellow to purple: a typical alchemical leap.

In art, sublimation is metempsychosis. A work jumps suddenly from a place where everyone can understand it to somewhere new, where it is lost to sight. An artist labors up a succession of steps, one following the other. Like an alchemist plodding along the great work, an artist can think and produce slowly, so that each piece is exactly one step from the last. That's the goal of academic painting: pure control, nothing unexpected. Sublimation is rapid, fiery, and decisive, and therefore it is also divine. That which was solid rock is now a swirling fume, or an invisible spirit. Sublimation is unexpected transformation, a sudden impulsive change.

(The *kerotakis,* incidentally, is another link between painting and alchemy. Originally it denoted a special palette that was used by encaustic painters.[8] Since encaustic is based on wax and not oil, it is necessary to keep the pigments warm so the wax does not set until it is in place. The *kerotakis* was a metal palette that rested on a bed of coals. The alchemists borrowed it from the painters, adding a platform and a hood to trap the fumes. In doing so they transformed one kind of sublimation into another.)

CIRCULATION

In circulation, the collection tube curves down and re-enters the vessel itself, pouring its condensate back into the boiling mixture (Figure 6). The vessel is filled with whatever substance needs to be circulated, and then the glass is sealed so there is no way for the pressure to vent. The airtight seal is very dangerous, and it is the main reason explosions were so common in alchemical laboratories. Even so, the alchemists often felt it was necessary seal their vessels—perhaps they

FIG. 5 Alchemical still. From *Dell'elixir vitæ.*

FORNO ET STRVMENTI D'ACQVA VITA

A fornello di creta sottili spiriti et questa é di sei paſſa
B. boccia di uetro lutata I. canale di uetro con suoi pizzi.
C. recipiente della prima acqua. che entrano nelli sopra detti
D. recipiente della second'acqua. recipienti ben oſturati, quale
E. recipiente della terz' acqua. sara' lungo da tre palmi
recipiente della quart'acqua. K uaſo pieno d'acqua freſca

were thinking of the closed womb, or the underground cavities where nature transmutes metals. The act of sealing was done specially under the protection of the god Hermes, who was the alchemists' guiding deity—or as we still say, the vessels were hermetically sealed.

The alchemists called such vessels pelicans, since that bird was supposed to nourish its young by pecking at its own breast and letting the blood spurt into the open mouths of its chicks. In the alchemical treatises, birds fly up and down in arcs to demonstrate the graceful, ritual violence of circulation. It is an especially attractive variation on distillation and cohobation (repeated distillation), since it conjures the cycles of birth and death as the substance evaporates, condenses, and returns to itself; and it is reminiscent of gestation, since it takes place out of the reach of the alchemist's intervention. (In an actual pelican, the sides may become coated with opaque residue, so that the entire process will be invisible, as if it were a real womb.) The boiling substance dies, and gives up its spirit, and then receives it back, and lives again. Or, in the pregnancy metaphor, it is slowly nourished with the juices extracted from its own body, until— often after a suitable period of time such as nine days, or nine months—the pelican is broken and its contents poured out.

Circulation is all too familiar a feeling in painting: it creeps in whenever the studio and the work seem to be hermetically sealed, so that the only nourishment must come from the refuse of the painting itself. Nothing new enters the studio, and nothing is wasted: everything goes into the work, and comes back out again. Usually that is a state of mind, a kind of stifling end-of-the-road feeling, but it can also leave its marks in the painting. Francis Bacon sometimes scraped up the layers of dried paint and dust from the floor of his studio and mashed them into pigments. It is possible to see the results in some of his paintings, in the form of dirty clots of fur and grit mixed with oil. COLOR PLATE 9 is a detail from one of his triptychs. Bacon was dabbing and blotting the paint with a rag, and some of the lint tore

FIG. 6 Alchemical pelican. From *Dell'elixir vitæ.*

VASO CIRCVLATORIO

A. Pellicano.
B. Caldara piena d'acqua.
CC. Spiracoli del fumo.
D. Fornello.

off and got mixed in with the colors. At the same time the paint was drying, so that each time he came back to it, the rag lost more fibers and the paint became hairier and harder to manage. After a week or so, his rag was uprooting paint skins and dragging them along, until they built into this massive violet grey clot. It's like a wave moving across the canvas from left to right, trailing a mouldy froth of fibers, each tinted in its own color—white, grey, red, and dark purple. The wave crests toward the right, and throws off streamers of spume: at the top is a cone of lint wrapped around a single human hair; and at the bottom (at the lower center of this detail) a winding rope of dried hair hangs out in space like a waxed and twirled moustache. On the right, the steep face of the wave is a barber-pole of wet colors alternating with drier ones: a bright magenta that was already half-hardened, a runny white, and red. The whole surrealist object could just as well have been scraped off the floor and glued to the canvas, and in its place—at the center of a bloodied figure, surrounded by fragments of torn meat—it is nodule of pain, torn from a painted body, just as it was torn from the studio.

As the *materia prima* reminds us, paint is very much like waste. That is so in both senses of the word "waste": some paint is like the refuse of the studio, and some is like human waste. In the studio it can feel as if paint is not just reminiscent of shit, but it *is* shit. The alchemists realized that excrement cannot be denied, that it has to be used. It is hopeless to pretend that oil painting does not continuously recall the worst miscarriages of digestion. Circulation is the esoteric discipline of recycling substances, especially the body's products, but also whatever is despised and overlooked, including the dusty waste material of the studio. Circulation is a metaphor, as well, for recycling the waste products of the mind, and somehow going on when nothing new can be found. Old discarded thoughts become new ones, and the work starts again. The sludge that has sunk to the bottom of the pelican is boiled to the surface, forced upward, and purified, and when it comes back into the work it is somehow—perhaps incrementally, perhaps infinitesimally—stronger. Circulation is also a

good name for one of Samuel Beckett's unnamable ideas: what it means to inhabit a life lived in absolute stasis and isolation that somehow also muddles forward. In a typical scenario in Beckett, nothing new has happened in years: there have been no new events, no inspirations, nothing unexpected or even entertaining. Yet somehow it is necessary to keep working, and find some use for the awful leftovers of the life that has been lived so many times over in the same room. *The Unnamable* ends: "... you must say words, as long as there are any ... I don't know, I'll never know, in the silence you don't know, you must go on, I can't go on, I'll go on."[9]

Shit is not the only excretion that paint recalls, and the alchemists were right to stress that ultimately it is blood—and since blood carries the spirit, paint becomes a trope for life. An artist who is mired in a suffocating cycle of unsuccessful strategies is in the pelican. But it is the virtue of alchemy to point out that self-immolation is also self-nourishment, and the alchemists valued circulation as a strengthening agent: each time the substance is boiled away, it is returned to itself in a purer state. They thought that the very act of distillation would enhance the substance—never mind that modern science would say nothing changes in the pelican. In the same way, wonderful things can be accomplished in the studio when it is shut off from the outside world. Working again and again with the same wretched pigments, the same frowzy brushes, the same paint-stained walls, can be exactly what is needed to bring something worthwhile to life. The British painter Frank Auerbach has worked in a single room for decades, for the most part without dusting or rearranging anything. Imagine the resonance that every stain and particle must finally accrue. Critics who say that artists need experience of the world do not know about the pelican, and the springs of strength that come from the body and lead back into it.

DIGESTION

The alchemists took digestion literally, and tried for the same heat as a stomach or—since they were interested in nourishment, and not just

food—a womb. The substance to be digested was put in a sealed vessel, and the vessel was heated at a constant warmth—either in a bed of warm sand, or a hot bath, or a crate of rotting manure. Sometimes it was just laid out in the sun, and the process was called insolation. The sign for digestion suggests slow steeping $= = =$ just as the sign for vaporizing depicts quick vertical resolution ⏐⏐⏐. Maceration was the commonest kind of digestion: it involved soaking a substance until it weakened and partly decomposed. Maceration nearly always involved horse manure since the manure held a steady warmth that the alchemists imagined was equivalent to the inside of the body.

Digestion is a form of circulation, but without the rising and falling. Its stagnation, and therefore its quiet, is more pervasive $= = =$. Digestion was thought to free a substance's innate powers, which were otherwise trapped inside it, and to render the gross particles of a substance finer and more fluid (just as the solids we eat become more fluid inside us). It made the opaque translucent, and separated dross from pure essence (as in the separation of food into feces and urine).[10] Certainly artists go through periods of digestive thought—slow marinations and steepings, where thoughts gradually diffuse into consciousness, or leach out of it.

In paint, digestion happens in the warm darks, where a solid blanket of color might show a faint nuance, only visible for a moment or in a certain light. When paintings call for large featureless areas of paint, the artist has to decide how to let those areas breathe: how to give them life, in the language of the studio, without letting them have so much internal structure that they break into separate areas. A dark wall behind a painted portrait has to be dim enough not to attract attention, but it also has to breathe and give a sense of air and distance. A stretch of clear sky above a landscape must be instilled with minute variations that the eye takes naturally for distance. No passage can be entirely uniform. That is a skill nearly always unappreciated by nonpainters, and hardly ever missed by painters. There are many square feet of uniform dark backgrounds, blue skies and brown walls by Titian, Rembrandt, and Velázquez, that are as difficult

and compelling as anything else in their paintings. Digestive darks are passages of incipient shapes, of colors about to come into existence, and other colors fading away. To a painter they can be essays in how to stretch a thin coat of paint into what one technician called a "breath-like thinness," and then let it coalesce by degrees into a palpable layer.[11] The paint may be dry in one place, and semi-dry in the neighboring area, and the difference between the two might be too subtle to find: to use an image invented by the poet Edmond Jabès, it might be as if we lived in a world where white was the opposite of white, and the only difference between them was white. Digestive areas are places where things almost are. They can be reminiscent of the monotony of house paint, and they can also adumbrate the full variety of an abstract composition or an imaginary landscape. But they hold everything in suspension, letting the forms draw themselves almost into clarity.

CERATION

Some substances are skin-like—waxy, pliant, glossy, smooth—but most are not. Alchemists valued the rare substances that behave like skin or flesh, and they made things waxy (in the process called ceration) and soapy (saponification) in order to mimic living tissue. Ceration was a kind of loosening, where the hard metals and bitter salts became moist and took on water. Normally, soap is made from animal fat, so that saponification only changes one organic thing into another; but it can also be made from metals: there are iron soaps, aluminum soaps, and even magnesium and strontium soaps. A sudden change into human skin would be inconceivable, but a slight chemical softening can begin the melting that might rescue the metallic back into the world of the human. Soap ◊ and wax ✢ are half-human: they are halfway conditions, on the path to genuine life.

In paint, too, it is essential to make the pigment pliable—not just so that it can be easily spread with a brush, but so that it recalls the texture and feel of human life. In the eighteenth and nineteenth centuries painters wanted their paint "buttery" or "creamy." (That sense

of "cream" comes from Continental and British creams, which are much thicker than American cream. French *crème fraiche* and British jarred cream are more like American pudding or yogurt.) Those are good consistencies for most paintbrushes, but they are also appetizing, and pleasing to the touch. When the object is to make something living, it helps to begin with half-living ingredients. Rembrandt's textures are not appetizing, but they are all in the range of the human and organic. Even today, when some painters find the words "buttery" and "creamy" old-fashioned or unhealthy, paint has lost a little of its organic appeal. Painters sometimes call a paint "fat," but even that word is less common now than fifty years ago. The loss of those words is more important than it seems. Paint has become a little more dead, and painters have to work that much harder to bring it to life.

PRECIPITATION AND SOLUTION

It is common to work with a brew of colors, all melted into one another in such a way that there is no articulation to the paint. Everything flows together, nothing stands out. If a painter sets a small patch of a single color on top of such a mixture, it can suddenly bring out the hidden pigments, as if they had never been completely dissolved in one another. That is precipitation, and in chemistry it can be set off in a clear liquid by the addition of just one grain: as soon as it is dropped into the liquid, grains suddenly materialize and sink to the bottom. What had appeared to be a liquid had actually harbored solid forms—rocks and even angular crystals. Often, the fluid will clear as the precipitate gathers its milky colors and drags them to the bottom. A glass of limy water taken from a spring, if it is left to stand, may suddenly precipitate and give up a chunk of rock.[12] All at once the solution is articulate: it has solid subjects, and a clarified environment for them. A symbol for precipitation ⇌ shows the liquid becoming solid and starting to sink, just as one for sublimation ⇌ depicts the substance rising into the air.

Solution ᔐ is the opposite motion, and it is just as familiar in art-

making. A collection of colors that seems to be well articulated suddenly blurs into a smear. The artist loses control of the colors and they begin to deliquesce into a neutral slush. As in Nolde's seascape, colors that were once set against each other no longer work in opposition: they vanish, and the work collapses into a puddle, a mess. But precipitation and solution are a pair, and alchemy teaches that whatever can collapse can be suddenly clarified: there is nascent structure in even the most empty fluid.

DEATH

Shadowing all these metamorphoses, following them with a dull echo, is the possibility that they may be fatal. Any change is risky, and as painters know, even tried and true methods can go wrong. A painting can be ruined beyond repair merely by adding paint—to the point where even an X painted across its surface would be absorbed into its meaningless sluices of paint. (That is why Nolde crossed out his failed paintings in chalk, or tore them in pieces: it is hard to destroy what has already been destroyed.) Like painters, alchemists were loath to abandon their work even when it showed no signs of life, and they made a science out of reviving ashes and residue and resurrecting them. At the very end of Ripley's experiment, the battered dark powder suddenly flares up into unexpected colors, and in the same way, the least promising lump might be the cornerstone for a new method.

Very rarely, even the alchemists had to admit they had burned every scrap of life from their samples, and then they called their refuse scoria, recrement, or *caput mortuum,* Death's Head. It was sometimes drawn as if it were a modern sign warning against danger ⊗, but more often the *caput mortuum* is a tiny emblematic skull ☺. The vessel becomes its pyre or a coffin, and the substance that is calcined is killed. In alchemical pictures, calcination is a black crow, a raven, a skull, a filthy animal, a mud-soaked man, or a violent murder.[13] From the Death's Head, nothing more can be done, and the alchemist would discard the remains of the experiment and begin again.

As usual there is more here than meets the eye, because the alchemists did not keep clear of the Death's Head, but sought it out whenever they could. The object was to achieve as thorough a death as possible and still be able to resurrect the ashes, because the result would be something even stronger. One of the few common threads that runs through all alchemical procedures is the requirement that the substance be rotted until it is a black putrescent mass, and then revived until it is golden and pure. This is the alchemical death, Putrefaction or *putrefactio*. The substance has to be brought to within a single breath of dying, and then revived—or in the typical hyperbole, it has to be killed and resurrected. "Revivification" is the way the alchemists said "resurrection" when they meant substances instead of human souls. The symbol for putrefaction ℞ is a spiky elaboration of the letter P, intended perhaps to convey the idea that this is not ordinary rotting or death, but something occult. It was amazing for the alchemists to witness the resurgence of life in something apparently dead. To see a body and a spirit rise from "small Invisible Putrefied Atoms," an English author remarks, "doth cause a Religious Astonishment."[14]

"Life is wherever substance exists," writes Frater Albertus, a twentieth-century alchemist who lived in Salt Lake City, "and wherever life and substance are, there we find governing mind or consciousness."[15] Since "all substance is alive—even what which we call dead," substances must be controlled, metempsychosed, nurtured, laid to rest and resurrected, fused and separated. Healthy substances must be burnt to ashes, scorified, before they can be revivified. Once we can see death in every act of burning, then it becomes possible to see life in every unburned object. Sulfur is alive simply because it glows yellow, because it smells awful, and because it can be scratched. Even a putrefying liquid is alive, because it becomes tumescent, swells, and rises above the water. As the medieval alchemist Artephius says, such water must contain "the body made of two bodies, sol and luna," and their mating is what causes the fermentation.[16] There is an exceptionally beautiful experiment that shows why every substance

is alive: the creation of a silver tree.[17] With the right chemicals, it is possible to grow small "trees" made entirely of silver, and when they are observed through magnifying glasses they reveal a bewildering similarity to actual foliage. They are like real trees, but washed and made brilliant. Their scintillating branches and stalks sway in the water, and their leaves gleam and flash as they catch the light. Anyone who has seen a silver tree must forever doubt that rocks are not alive.

Can any parallel to visual art be more immediately persuasive or far-reaching? The substance that artists move around, whether it is clay, bronze, or oil, has to come to life, or mimic life by shining, gleaming, catching the eye and ultimately living on its own. As in alchemy, it is not enough merely to bring life to the inert pigments: the painter also has to toy with death, to bring the paint close to the point of no return in order to make it more convincing in the end. In the alchemical phrase: it is necessary to kill in order to create.

Alchemists and artists have a way of ruining what they make and starting over again nearly from scratch. Just as a painter might rub out a figure in order to make a better one, so an alchemist might burn the contents of a vessel down to white char in order to make a better substance out of the ruins of the old one. "Destroy to create" and "kill the father to revive the son" are mottoes of alchemy that apply just as well to visual art. Painting is deeply involved in self-destruction. Making art is also constantly destroying art, and at times that ongoing destruction can reach such a heartbreaking pitch that a lifetime of work is repudiated or ruined. Painters have a maxim that if there is one really wonderful passage in a painting, it will have to be sacrificed to take the painting forward. That moment of self-sacrifice brings with it a certain generative power that can affect every other passage.

Fermentation is yeasty death. A body that burns becomes lifeless powder, but a body that ferments rots and the room fills with unbearable stench. As it swells, there is a strange and fascinating rhyme between a belly distended with swampy gases and a belly swollen

with a growing child. To the alchemists fermentation was full of digestion, pregnancy, and new life. A vessel called the uterus was considered best for fermentation, but alchemists also mimicked the womb by packing their sealed vessels in manure, and even by placing vials in horses' vaginas. In general, vessels were sealed in imitation of the closed womb, and opened in imitation of Caesarean section. In art this corresponds to the inner drama of the private work, known only to the eyes of the person creating it, and the suddenly public work, rashly opened to public inspection. Everything private and wordless happens in the closed studio. The work is nourished there, kept alive and slowly grown: but there is always the impending moment when the inner dialogue between subjective thought and its silent embodiment will be ripped apart, and the materialized thought will become an object of someone's gaze. One of the truths in the cliché that artworks are like children is the careful cherishing of the work, and another is its quick expulsion.

Minor methods

These are the major metamorphoses, but there are dozens more. Any painter will have favorite images or phrases to describe transformation: the painting may be a "breakthrough" painting, or the paint may "find its way" toward a new form, or "push up against" something solid and invisible. In alchemy there is a whole lexicon of forgotten and not-so-forgotten names. Explosion and implosion also belong on the list, both of them rich in artistic parallels. In alchemy, fusion is simply melting. Calcination is burning until the substance becomes white powder, as in Ripley's Green Lion. Limation is a curious word; it means filing a metal until it is in shards. A decrepitated metal, on the other hand, has been reduced to shards by splitting. When a material is put out in the humid air, and falls apart, it has suffered deliquium. Lixiviation is the separation of soluble from insoluble substances; transudation is making a substance sweat in the distillation bath.[18]

Cooking is never far from the alchemists' thoughts. Coction and decoction are forms of cooking; ebulition is violent bubbling boiling; rectification was a directed form of distillation intended to secure the purest possible state of matter. Basil Valentine's *Triumphal Chariot of Antimony* contains an extensive analogy between beer-making and alchemy, suggesting brewers' parallels for digestion, reverberation, coagulation, calcination, clarification, and sublimation, and making alchemy into a subset of brewery.[19] There are many other parallels to cooking; a whole book could be written on the affinities between them.[20]

Alchemists sometimes got carried away naming nearly meaningless processes, or making endless lists. According to Ripley the twelve signs of the zodiac correspond to twelve "gates" of alchemy. He names calcination, solution, separation, conjunction, putrefaction, congelation, cibation, sublimation, fermentation, exaltation, multiplication, and projection. Charles Mackay, a sniping debunker of alchemy, said that Ripley "might have added botheration, the most important process of all."[21] Past a certain point it is no longer helpful to understand painting by thinking of specific alchemical processes. Each painter, and each painting, finds its own way forward, and the alchemists also made up words and methods as they went. Only the basics remain: fixation, the drying of paint; distillation, the magical change from paint to represented form; sublimation, the hot invisible agent of sudden change; circulation, the airless hermetic recycling of materials and ideas; digestion, the slow rumination that issues in clarity; ceration, the moistening of hard metals; and precipitation, the surprising resolution of liquid possibilities.

There is no end to the strangeness of metamorphosis. In alchemy there is an experiment, attributed to a medieval monk, that tells how to make gold by the unnatural offspring of two male chickens.[22] The monk, Theophilus, tells his readers to construct a subterranean house, all out of stone and with two tiny openings. Through each

opening they are to put one cock, and throw in enough food to keep them alive. Eventually, "when they have become fatted from the heat of their fatness," they will mate and lay eggs. At that point, the alchemist is to remove the cocks and put in toads to keep the eggs warm. (The assumption is that male chickens can't roost, but toads can.) When the eggs hatch, they look at first like normal chickens, but in a few days they grow serpents' tails. If the house weren't stone, Theophilus says, they would tunnel into the earth and escape. They are to be put in brass vessels with copper doors, and the vessels are to be buried for six months. The monsters inside are basilisks, and they spend that time eating the "fine earth" that filters in through the copper covers. After half a year has passed, the alchemist is to dig up the vessels and burn them with the basilisks inside. When they are cool they are pulverized, and the alchemist adds the dried blood of a red-haired man, *hominis rufi,* and mixes the powders with sharp vinegar. If the resulting paste is painted onto copper plates, it will soak in and the plates will become gold.

Theophilus's recipe is only outlandish if it is judged against the standards of science. To painters, unexpected and inexplicable metamorphoses are the stock in trade of everyday work. No one knows what paint does, and when an artist is fooled into thinking paint can be entirely understood, then the studio becomes an annoying tedium where paint has to be pushed into place to make images. There have been painters who thought in those terms, but painting can be far more interesting and dangerous.

6

The studio as a kind of psychosis

IT IS IMPORTANT never to forget how crazy painting is. People who buy paintings, or who write about them, tend to think painting begins in the cosmopolitan world of museums and art galleries, and that its meanings are explored in departments of art history. But painting is born in a smelly studio, where the painter works in isolation, for hours and even years on end. In order to produce the beautiful framed picture, the artist had to spend time shut up with oils and solvents, staring at glass or wooden surfaces smeared with pigments, trying to smear them onto other surfaces in turn. Painting is peculiar in that respect. Writers and composers are much closer to the finished product: their words or notes appear instantly and cleanly on the page—there is no struggle forming the letters A, B, C, or writing ♩. ♪ —but painters have to work in a morass of stubborn substances.

For those reasons, the act of painting is a kind of insanity. It may seem unfashionable to say so, because postmodern doctrine has given up on the old notion that artists are melancholic geniuses prone to manic depression and beyond the reach of ordinary common sense. But even the most commercially minded artist has to wrestle with raw materials, and get filthy in the process. Except for a few nineteenth-century painters who worked in impeccable three-piece suits complete with watch chains and boutonnieres, painters have usually managed to coat themselves in spots and smears, and so

to bring their work home with them like the smell on a fisherman. In an art school or a studio it is always possible to tell which artist spends the most time working, because the paint gradually finds its way onto every surface and every possession. Françoise Gilot tells the story of visiting Alberto Giacometti's atelier. He was working in clay, and his studio resembled his work:

> The wooden walls seemed impregnated with the color of clay, almost to the point of being made out of clay. We were at the center of a world completely created by Giacometti, a world composed of clay.... There was never the slightest color accent anywhere to interfere with the endless uniform grey that covered everything.[1]

Sooner or later every one of a painter's possessions will get stained. First to go are the studio clothes and the old sneakers that get the full shower of paint every day. Next are the painter's favorite books, the ones that have to be consulted in the studio. Then come the better clothes, one after another as they are worn just once into the studio and end up with the inevitable stain. The last object to be stained is often the living room couch, the one place where it is possible to relax in comfort and forget the studio. When the couch is stained, the painter has become a different creature from ordinary people, and there is no turning back.

No one who has not experienced that condition can understand the odd feeling that accompanies it. When every possession is marked with paint, it is like giving up civilian clothes for jail house issue. The paint is like a rash, and no matter how careful a painter is, in the end it is impossible not to spread the disease to every belonging and each person who visits the studio. Some artists keep fighting it, and they turn up for work wearing clothes with only a few discrete stains. Others give way, and they become funny mottled creatures, like GIs in perpetual camouflage.

Working in a studio means leaving the clean world of normal life and moving into a shadowy domain where everything bears the marks of the singular obsession. Outside the studio, furniture is clean and comfortable; inside, it is old and unpleasant. Outside, walls are monochrome or pleasantly patterned in wallpaper; inside, they are scarred with meaningless graffiti. Outside, floors can be mopped and vacuumed; inside, they build up layers of crusted paint that can only be scraped away or torn up with the floor itself. The studio is a necessary insanity. Perhaps writers have insanities of paper, or of erasers, but they cannot compare with the multicolored dementia caused by fluids and stone.

Alchemy is the best model for this plague of paint, for the self-imprisonment of the studio, and for the allure of insanity. Alchemy, first of all, is a master of perversion. Its deviations flaunt the ground rules of sanity, tempting madness by mimicking its symptoms. There is an alarming list of alchemical transgressions. Young boys provide hair, nail clippings, and urine for alchemical recipes. Secundines or "navel-strings" are the lint that gets trapped in the navel, and they were taken from infants to cure epilepsy and kill "malicious animals." In alchemy the Latin word *faeces* meant any refuse. But alchemists also used shit, which Paracelsus called *carbon humanum* or Western Sulfur. Among other uses, it was putrefied "till there are small animals therein," and then distilled as a cure for gout. Powdered mummies were in demand in the seventeenth and eighteenth centuries, and in a pinch alchemists could substitute "hardened man's flesh." It was soaked in water, putrefied for a month and then strained, put in a bladder and mixed with wine, distilled, reverberated, sublimed, separated, and circulated until it became a pure quintessence—and then the "quintessence of mummy" could be mixed with treacle and musk to make an elixir that could cure the plague itself. Alchemists even used "the moss of the skull that grows upon it in the field after slaughter." One recipe calls for "the brain of a young man under twenty-four, who died violently, with all its membranes, arteries,

veins, and nerves, and with all the spinal marrow." The alchemist is
to beat it into a pulp, and immerse it in "cephalic waters" (*aquarum
Cephalicarum*) made from peonies, black cherry blossoms, lavender,
lilies, tile-flowers, and betony, to a depth of four or five inches. After
it stands a while, it is to be distilled by cohobation (that is, repeat-
edly). The calcined remains, called faeces, make a salt, which can be
remixed with the distilled spirit to produce a medicine that makes
another cure for epilepsy. The author of this recipe, Johann Schröder,
adds "you may make also a famous antiepileptic of the brain of the
elk"; at the time, elk's horns, hoofs, brains, and even elk's sleepies
were thought to be good medicines.[2]

There are recipes for urine, philosophical urine, the salt of urine,
the oil of urine, and the mercury and sulfur of urine.[3] Theophilus—the
same who called for the blood of a red-haired man—thought "the
urine of a small, red-haired boy" was best for tempering iron.[4] There
is an entire library worth of manuscripts devoted to the distillation of
human blood, and there are texts calling for the blood of snakes, vul-
tures, and "bloody" plants such as beets.[5] Those oddities and perver-
sions routinely lead toward greater transgressions, always tempting
actual madness.

The most famous such recipe is for the homunculus, the intelligent
embryo born in a test tube. Goethe made the experiment famous in
Faust, where an adept grows a little homunculus in a bottle, but it
is extremely rare in the alchemical literature. Aureolus Phillippus
Theophrastus Bombast of Hohenheim, known as Paracelsus, has
become identified with the recipe, though the idea goes back much
farther.[6] In the recipe, the alchemist puts human sperm into a vial the
shape of a gourd (*zucca*), seals the vial, sets it in a bed of horse dung,
and lets it putrefy for forty days or until the sperm begins to move. At
that point it should have the form of a body, but transparent and
incorporeal. From then on it needs to be fed every day with what
Paracelsus calls the *arcano* of human blood—presumably blood that
has been distilled and purified. Nine months later, Paracelsus says, the
patient alchemist will produce a baby boy, "exactly equal to those

produced by women, but much smaller." He adds that the young homunculus will be eager to learn and must be provided with a good education.

Spit was also a common ingredient. The eighteenth-century alchemist Johan Gottfried Tügel tells about an experiment that turns spit into a corrosive salt able to "open"—that is, dissolve—gold.[7] He collected about twelve quarts of saliva from healthy young men (one can only imagine the amount of spitting that required) and distilled it until he got a dry residue. (That would have filled the laboratory with steam from the spit, and Tügel comments that it does not smell good.) Then he poured the condensed distillate back onto the residue, and distilled it several more times. After six months of cohobation there was no more fluid in the saliva, and he was left with a "foliated grey salt." He then exposed his salivary salt to the sun every day, and to the moon each night, so that it would be well digested and able to be liquefied again. After a month, the vessel was resolved into:

> a red oil and a yellow salt, as big as a hazelnut, growing in the oil. This salt liquefied every night, and became dry salt in the sun, and it increased in volume from day to day, and the red oil became thick like honey and finally like beeswax, so that I could cut it with a knife.

The final product could dissolve silver and gold, and turn them into glass.

There are many of these oddities, but they are mild in comparison to the more serious ideas that lie beneath them. In particular, alchemy joyously rescinds the incest taboo. A book called *The Hermetic Triumph* is the most Sadean in its exuberant directions: "open your mother's breast," it urges, "rummage in her entrails and penetrate her womb."[8] Michael Maier says we should "confidently" join brother and sister (*ergo lubens conjunge*), "hand them the cup of love," and let them be man and wife.[9] In another book, after an incestuous scene, a brother disappears into his sister's womb.[10] Alchemy

might have brought some people to try incest, if only because alchemical operations are sometimes said to be best when they are performed in tandem, by the alchemist and his "mystical sister." (Some "sisters" were wives, but the phrase still applied.) As in any sensational subject, the actual transgressions were probably rare. What makes the incestuous doctrines pernicious, and brings them dangerously close to insanity, is that incest was routinely expanded into a general principle of all alchemical work. Alchemy identifies heat with passion, but then it identifies passion with incest. To insinuate that every union is an incestuous one is either to say that thoughts of incest are hidden in every union (and this is the interpretation that Jung favors) or else (and this is what leads to madness) that union is incest.

The incestuous union produces a monstrous offspring, and even though it is usually killed or "absorbed" before the philosopher's stone appears, it is a center of attention. The commonest name for the child is "hermaphrodite," and other alchemists also call it the rebis (from *res bina,* "two-thing"), the hermetic androgyne, and the Magickal Offspring. It is said to be the union of Sol and Luna, sulfur and mercury, King and Queen, or any two dyadic principles such as soul and body. The hermaphrodite first appears manuscripts in the mid-fifteenth century, and it is common until the eighteenth century.[11]

The confusion about the nature of the hermaphrodite was due in part to the Renaissance confusion between partial and full hermaphrodites, passive homosexuals, and androgynes: few people had ever seen hermaphrodites, and their anatomical nature was open to speculation.[12] The different forms are described as various stages of sexual union, or as less than perfect fusions of the parental principles. The most frequent is a single body with two heads, and there are also figures with matched genitals (although not in the configuration of actual hermaphroditism, but side by side), and asexual figures with unformed bodies. (The last may have been inspired by the legend that bear cubs are born as unformed lumps and licked into shape by their mothers, just as the hermaphrodite needed nurturing if it was to live.)

In each variation the hermaphrodite is a midway stage, a partial fusion of opposites that is on its way to something more perfect. Some hermaphrodites go on to become the perfectly sexually balanced Son of Philosophy, an emblem for the Stone itself. In one plate, the alchemist stands triumphant, dressed as a woman but with a long beard: the ideal composite of opposed principles. Other hermaphrodites are way-stations, and they are melted down to produce the next stages. In that way the incestuous act gets obscured, folded back into the work like an inbred generation lost in a family tree. After a long process with many stages, the incest and its monstrous child may be scarcely visible, like the subtle effects of inbreeding in the third and fourth generation.

In painting, incest becomes a theme whenever the paint refers to itself. Increasingly, that moment seems to occur in every painting: self-reflexivity is endemic in modernism, and it is not possible to imagine an interesting work that does not in some measure speak about itself. Paintings have routinely referred to paintings since Manet, and they have referred to the act of painting since the Renaissance. Modernist painting also refers to what is called its "physicality": to its own canvas, the thickness of its paint, and most famously to the flatness of the picture plane. Cubism, Abstract Expressionism, and Minimalism all play with those possibilities, and postmodern work such as Sherrie Levine's toys with the remaining possibilities. Art historians tend to call those moments "self-reflexive" or "historicist," and they leave the word "incestuous" to pejorative criticism. But in a very real sense, self-reference is self-love: it is solitary masturbation (another charge leveled against painting by unsympathetic critics) or love within the family of painting, and it always carries the taint of taboo and potential insanity. The hermaphrodite is so interesting because it is what the incest produces: it issues from the unnatural, routine bonding of painting with itself.

The hermaphrodite is a queasy embodiment of what a twentieth-century reader has to call psychosis. The alchemists were fascinated by it, and also wary, because it did not fit well with the Christian

frame that alchemy was supposed to fill. As Jung noticed, the hermaphrodite is a concentrated image of the fear that plagued every alchemist who took note of his shaky relation to Christianity. It is strange enough to see a naked figure, fused from the waist down into a fleshy pedestal, with two sets of genitals and two heads. It is more unsettling to see the god Hermes, bearded but wearing a dress and a crown, purporting to be the dependable guide for alchemists who have lost their way. But it is desperately wrong to begin to confuse the hermaphrodite with Christian ideas.

Throughout the history of alchemy, the Church was unsure about whether to prosecute or ignore alchemists who seemed to be on the verge of heresy. (For related reasons, alchemy never became an official subject in universities.) The alchemists prayed to God in such a way that it is clear they conflated Jesus with the Stone, the elixir of life, and especially with salt. Georg von Welling calls Jesus the "holy eternal salt," "living salt," and—in a lovely phrase—"sweet fixed salt of the still soft eternity."[13] Most of those prayers escape heresy by keeping to metaphors: they say Jesus is "our salt," instead of claiming Jesus *is* salt. But the language was not what a church-goer would expect, and the whole project was suspect. Heinrich Khunrath, for example, waxes eloquent about penetrating the "true center" of the philosopher's stone,

> the salty, universal, purest, triune, mercurial prime substance,
> that is the primal, salty, Catholic mercury of the philosophers,
> alone and unique in the world, triumphing over natural things,
> the mercurial salt of wisdom, nature, art, and the wise, prepared
> by pure fire and water.[14]

Are there grounds for excommunication here, or is Khunrath less a demented alchemist than a visionary Christian?

In Jung's reading the Church's anxiety about alchemy was a sign of something deeper than the vague possibility of schism. He argued that the alchemists realized, on an unconscious level, that Christian-

ity is incomplete, and that Christ requires a bride. Alchemy provided what Jung calls the "hermaphroditic psychopomp," meaning the hermaphroditic guide for souls. (Hermes was a "psychopomp" in Greek mythology, leading souls up and down from Hades.[15]) And as the ultimate guide of souls, and the ultimate referent of the ubiquitous metaphors of resurrection, Christ is the inevitable counterpart and companion for the hermaphrodite.

The unconscious hermaphroditic bride of Christ is a fascinating idea, one of Jung's most bizarre claims. From a believer's point of view—and the great majority of alchemists were devout, if eccentric, Christians—the very idea that Christ might have a hermaphroditic alchemical bride (with whom he might sometimes be identified) would be not only doctrinally heretical, as Jung knew, but also an open road to madness. Jung's point is that this ultimate meaning of the hermaphrodite must have remained unconscious, so that the people who created it could not have understood what they were doing. But Jung's books, such as *Psychology and Alchemy,* make it explicit, and by doing so they lead as forcibly away from sanity as any books I know. It is a crazy idea, designed by Jung (perhaps unconsciously?) to be so unsettling that it opens the ground beneath sure knowledge: it is like a signpost leading toward what Jung and Freud called a psychotic break.

The hermaphrodite acts as an embodiment of psychosis in a conceptual field that is attracted by madness. No one working with these symbols could have entirely ignored their potentially schismatic meanings. It is likely that many sensed the strangeness, even the danger, of their pursuits. Alchemy is at home in depression, uncertainty, and melancholy, and the pathos of solitary labor and wasted time, and I wonder if the alchemists could have been as oblivious as Jung imagines them. Alchemy had a strange effect on Jung, or rather, it accompanied and deepened a strange period in his life. Rather than keeping up with his profession Jung sequestered himself for nearly a decade reading alchemical texts that everyone thought were worthless. He took seriously the alchemical injunction to balance the male

and female sides of the soul—more seriously, I might say, than the glib spokesmen for the "men's movement" do. He followed the female spirit, the *anima,* which he saw as an untrustworthy Melusina, a siren who might save the soul or lead it toward disaster. The result of his solitary work was several lectures, two long books (*Psychology and Alchemy* and *Mysterium Coniunctionis*), and a secret diary full of visions and invented characters. That is what I find most admirable about Jung's encounter with alchemy: its absolute immersion, and the tremendous risk of thinking directly about incest, the hermaphrodite, and its uncanny similarity to Christ. Very few books can be counted as genuinely unsettling, and I think Jung's works on alchemy have to be among them—along with some of the alchemical texts he studied. It is easy to read his books and come away with a sense of whimsical eccentricity, but if the ideas are taken seriously they can have a corrosive effect on indispensable ideas in Western thought. "This is the Omega," say the Rosicrucians, "which has caused so many, many evil days and restless nights" (*Dieses O ist es, daß vielen so viele böse Tage und unruhige Nächte verursachet hat*).[16]

Like all truly dangerous ideas, this one seems a little quaint or merely outrageous at first. But the alchemical lesson is that incest is necessary, and even universal, and that its monstrous offspring is nothing less than God. Nothing that spectacular happens in the inward moments of painting. What matters in painting is the *necessity* of self-reference, its forbidden nature, and the many strange marks it leaves on the work. In Rembrandt's self-portrait, his skin is paint, and the paint is his skin. Paint refers to itself, smearing over itself, sliding over itself, caressing itself—its illicit sensuality is constantly apparent, a droning sound under all painting. And what can it possibly mean to say that skin *is* paint?

In the alchemists' terms, the hermaphrodite is a lodestone and a siren for improper thoughts; but it is also necessary, an unavoidable part of the process. Any self-referential mark in painting is the hermaphrodite: any place where a brushmark stands out, reminding the viewer of the paint, or where the canvas shows through, recalling the

unavoidable picture plane. The conditions of incestuous awareness are much more general than it would appear from the art historical examples, and incestuous meaning is latent in any picture. Paint itself is insistently sensual. It is always sullied and impure, never pristine. The harder an artist struggles to pretend that there is no paint, that there has never been a battle with oils and varnishes, that there is no sensual appeal to the smell and feel of paint, the more it becomes obvious that there *has* been a struggle, that the transgressions of the paint can never be successfully subdued. Paint itself is the sign that incestuous work has been underway.

Michael Maier's thirty-ninth emblem is a landscape, telling the story of Oedipus (Figure 7). The foreground figures embody the riddle of the Sphinx: What walks on four legs in the morning, on two at noon, and three in the evening? At the right, Oedipus is killing his father, and behind that, he is taking his mother's hand in marriage. On the left, Oedipus answers the Sphinx's riddle, and she prepares to throw herself off the cliff. In the background, the Sphinx makes a portentous gesture, reminiscent of Jesus's gesture in the Last Judgment (damning with a lowered hand, and blessing with a raised one), and behind her is Thebes, Oedipus's city. The Sphinx in the background isn't an element of Sophocles's story: she is more like Oedipus's psychopomp or *anima,* the siren of his soul that leads him into ruin.[17]

Just by itself, Maier's plate is not out of the ordinary, though Oedipus is an unusual subject for artists in any period. What sets it apart is what he says in the accompanying text.[18] First he reinterprets the Greek story as an allegory of alchemy. Alchemical allegories of myths were Maier's intellectual specialty, and when he wrote this book in 1617, he had recently completed a long volume on that topic.[19] The allegories usually turn on a single resemblance between alchemy and mythology, and then the remainder of the alchemical story has to be forced to fit. In this case, Maier acts as if he has never read Sophocles, and that he is not sure what happened to Oedipus. He says Oedipus's answer to the sphinx "is not known," and he

FIG. 7　The life of Oedipus. From Michael Maier, *Atalanta fugiens*
(Oppenheim: Hieronymus Galler, 1617), emblem XXXIX.

proposes that the "true meaning" involves a square, a hemisphere,
and a triangle. The first signifies the four elements: the second "white
Luna"; and the third means body, soul, and spirit (or else sun, moon,
and mercury). He shows them stamped on the heads of the three fig-
ures, so he must have known Oedipus's answer.[20]

In Greek, the name Oedipus means "swollen feet," because as an
infant he was abandoned on a mountain top with a metal pin
through his ankles.[21] Maier intends Oedipus to symbolize an alchem-
ically "fixed" substance, one that has been treated until it is no longer
volatile (so that it cannot escape from the vessel):

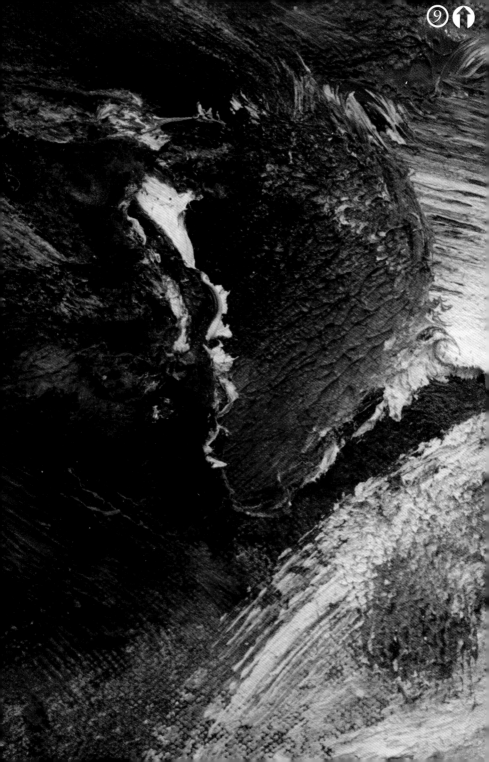

Oedipus has swollen feet, on account of which he cannot run, but can only move like a bear or like a slow toad; behind this is hidden a great secret. On account of his slowness he reduces other things to a solid condition and is not volatile to fire.[22]

In another part of the same book, Maier illustrates a man without feet, walking on the stumps of his ankles. Oedipus's meeting with the Sphinx, therefore, denotes the encounter between the principle of fixation and the inchoate *materia prima,* and the solution to the riddle embodies essential elements of the alchemical work. In accord with alchemical ambiguity, the symbols and the Sphinx can be variously interpreted, but always in harmony with common processes and substances.

This is standard alchemical strangeness; but things get very odd when it comes time to draw the conclusion to the allegory. If Oedipus's life is a mirror of the alchemical work, and if alchemy is the highest path to the secrets of nature and God, then something must be right about what Oedipus did. The Oedipus story is the perfect myth for alchemy, even more perfect than Freud thought it was for psychoanalysis.[23] It contains the idea of dangerous secrecy (in the Sphinx's riddle), the idea that the progenitors must be destroyed (when Oedipus murders his father), and, above all, the injunction of incestuous union. These are each steps that alchemists were encouraged to take, and so—by a twist that would have surprised Freud, and set psychoanalysis on a very different track—the absolute paradigm of tragedy and disaster becomes a model life: Oedipus becomes a hero.

As an alchemical allegory, Oedipus's life has very little that is tragic about it. The marriage to Jocasta is done as a Renaissance-style dance, and Thebes is displayed as a glorious kingdom. The emblem has nothing to say about Oedipus's horrible fate, and that is why Maier pretends not to know what happened to him. There is no desperate moment of revelation when he realizes what he has done, no scene where he plucks out his eyes, and no years of desolate wandering. This Oedipus is not Freud's or Sophocles's: he seems to

know everything that happens to him, and he accepts it as if he were privileged to act it out.

But what can it possibly mean for an alchemist to know all these elements of the tragedy, and do them anyway? What would happen to someone who knew he was killing his father and marrying his mother, or, in Maier's case, to someone who understood all those things, and set them out as models for everyone to follow? Maier hedges his bets a little: he says essentially that things may not be exactly as they appear, and that "the philosophers" know how to understand these images correctly. The reader understands that Maier is not asking him to go out and kill his father. But when it comes down to it, that is perilously close to what Maier means. Everything about Oedipus's life is good and worthy of emulation (as the church fathers say of Jesus). Philosophers "need these despicable means" (*vili medio*) because there is no better way.

I do not think it is possible to overestimate the insanity of this scene. For Freud, the Oedipus complex could only work if the period of "infantile sexual experimentation" were repressed for years, and then unconsciously reintegrated into adult sexuality, or fitfully recalled in neuroses. For Sophocles, Oedipus's life was ruined, and his sufferings fit his crimes, until he was finally swept off the earth in a gust of wind. But for Maier and the alchemists, parricide and incest are goals, and Oedipus is a role model.

Alchemy is replete with such bizarre scenes. In one manuscript a bug-eyed medusa stabs herself in the breast while she rides a pock-marked dragon, and a crowd of cripples and smallpox victims do her "gross reverence."[24] Another shows a peaceful landscape, with a woman turning the screw on a winepress, squeezing the juices out of a spotted boy. She is performing the action ordinarily called juicing or pulping; the alchemists solemnized it with the word extravasation (meaning literally, squeezing the blood out of the vessels). One of the few women alchemists, Dorothea Juliana Wallich, tells a perverse version of the creation story: she says that as soon as Eve was taken

from Adam she was thrown in a flask and distilled, in order to rid Adam of the poisonous mercurial water of his "fluid wife."[25] There are innumerable hermaphrodites, double-headed twins, bicorporate figures sharing a single head, cross-dressing alchemists, and androgynous gods—but in a sense they are all forms of the single unimaginable transgression, the self-involvement that breeds on itself.

This is the realization that painting does not always achieve. Painting is a bodily art, much closer to itself than mythmaking or even the spidery fantasies of alchemical stories. It has to do more intimately with the act itself: the muscles that burn after repeated gestures, the thin sweat of constant activity, the rubbing and caressing of paint against paint. The studio comes before art history: at first painting *is* the illicit scene, and only later a story told about it. Painters don't read about these lurid scenes in some curious book: they live them in everyday life. The studio is the warm womb, packed round with manure, and the artist is the slowly rotting pulp inside. Or to use another image: the studio is the pelican, incurved against itself, and the artist is the fluid continuously rising, condensing, and pouring back into itself. Those are descriptions of digestion and circulation, and other metamorphoses would work as well. Oedipus and the hermaphrodite are distant fables by comparison with the interminable solitary confinement of the studio and its infectious squalor. Waking each morning and going into a room suffused with the penetrating sharp odor of turpentine and oil, standing at the same table so covered with clotted paints that it no longer has a level spot for a coffee cup, looking at the same creaking easel spattered with all the same colors—*that* is the daily experience of serious painters, and it is what tempts insanity. Some artists try to keep the studio at bay by keeping it neat, or by putting their easel in the corner of a larger room, but the effect is like cleaning an infection: no matter how well swabbed the wound may be, it is useless to pretend it is healthy, or that the infection does not exist. They say that we spend twenty years of our lives sleeping, and painters who work steadily might easily spend that much time in the studio. How different must two

people be, one of whom has spent that twenty years in a stuffy paint-filled box, and the other in an antiseptic office.

Alchemy can only match that intimacy in one case: in the deviant modern practice of "sexual alchemy," in which the experimenters' bodies become the ovens and crucibles, and their excretions become the desired Stone. Like "creamy" or "buttery" paint, the hermaphrodite is sometimes juicy and liquid, and that's the connection between metallic and bodily alchemy. According to one traditional alchemist, sulfur and mercury normally combine to make pure offspring; but when they are themselves impure, they create a peculiar liquid:

> When the two embrace one another, shut up close in the rocky places, then a moist, thick vapor rises from them by the action of natural heat ... and it condenses into a mucilaginous and unctuous matter that is like white butter.[26]

Oily and buttery things are also sexual, like the bodily fluids from which all things are born. The same author continues:

> Mathesius calls this substance *gur*. Farm workers find it in their groves, but nothing can be made out of it, because no one knows what nature intended to do with it. It could just as easily have been a marcasite, or a metal.

Gur is the substance that congeals into anything: it is equally fitted, as the author puts it, "for the information of an ass, or an ox, or for any metal."

Modern sexual alchemy explores these same textures, but directly on the body. There is a sequence of alchemies beginning with traditional metallic alchemy (both practical and "spiritual"), continuing across the often blurred boundary to alchemies that use animal parts and vegetables, and ending in sexual or "human alchemy."[27] In spiritual alchemy, what happens in the vessel is an enactment of what

takes place in the mind; but in sexual alchemy, the laboratory mirrors what happens in the body. Like meditative alchemy, sexual alchemy tends to do away with laboratory equipment: it conflates spiritual meditation with bodily enactment, and what is more remarkable, it also conflates laboratory apparatus with bodily parts. Everything that normally takes place in the laboratory (whether literally so, in practical alchemy, or metaphorically, in spiritual alchemy), is moved into the body itself. The bodies of sexual alchemists heat, distill, conjoin, and putrefy, and when they produce the Stone—a fluid rather than a metallic product—it is not merely a metaphor for their minds or bodies, it is also contained within, and born from, their bodies. The fusion or *coniunctio* of the alchemical texts, which was often imagined as a kind of sexual fusion—whether it was between brother and sister, or King and Queen—is made into an actual lovemaking session.

Sexual alchemists have adopted some of the language of alchemy, rewriting it to cover bodily functions. The "Eagle" is the woman, and the "Mother Eagle" are the mucous membranes. The "Lion" is the male, and the "Red Lion" is the semen. (Tantric alchemy is an influence here, since mercury is the semen of Shiva.[28]) In ordinary Western alchemy, menstruum is any fluid that dissolves solid matter. Sometimes it is a gentle bath that soaks and permeates a substance, and in other texts it is a harsh acid that envelops a solid in a bubbling foam. The alchemists were aware of the anatomical meaning of the word, but they did not always make it explicit. According to one dictionary of alchemy, menstruum is the fluid proper to animals, just as plants have rain water and minerals have quicksilver.[29] In general, menstruum just meant solvent, with overtones of sexuality and generation. The sexual alchemists make it explicit: for them menstruum is "the magick solvent of the female organ." In the same fashion, sexual alchemists also reinterpreted phlegm. In traditional alchemy, phlegm normally meant the liquid product of distillation. The alchemists had adopted that usage from medieval medicine, where phlegm was one of the four fluids of the body (the others were black bile, yellow bile,

and blood). The sexual alchemists turned the alchemist's phlegm back into the doctor's phlegm, keeping the connection with distillation, but insisting it is a real, organic, human fluid.

There are various practices in sexual alchemy, some involving orgasm and some not, and many artificially prolonged (in the way alchemists prolonged heating). Using this language, Louis Culling gives a veiled description of a common sexual problem:

> It is the male Lion who is in command of the process of putting the quintessence into the care of the absorbing Mother Eagle i.e., the various mucous membranes, and therefore the Lion should have a conscience about making an undue imposition upon the Eagle when the operation is entirely for the benefit of the Lion.[30]

Vaginal fluid, called "Gluten of the White Eagle," is judged for taste, as semen is in Indian medicine, and the quality and physical origins of orgasm are carefully watched.[31] The vaginal and spermatic fluid that "merges" in the vagina after intercourse is removed and inspected. Its most important quality is its taste (it may be sweet or sour, effervescent, or "electrical"), though it is also judged for texture and color. Sexual alchemists also look for signs of the Stone elsewhere on and in their bodies: in a change in the feel of the skin, in a sense of "irradiation" or "aura," and in the quality of the orgasms. The seven metals are sometimes associated with "invisible colours" given off by seven particularly excitable parts of the body.[32] Various parapsychological and Eastern doctrines are mixed in the idea that the word "secretion" should be traced to "secret ion," motile force of the body's *chakras,* "currents and charged perfumes."[33]

Alchemical experience is ordinarily balanced between theory and practice, substances and allegories, observation and empathy. Sexual alchemy is a conceptually extreme practice, and it shows what happens when those distinctions collapse. Its practices pose curious philosophic problems. Even in the most purely meditative alchemy,

there is a parallelism that provides an indispensable structure to alchemical thought: on the one hand is the chemical apparatus, and on the other is the alchemist, whose mental state follows and mirrors the metamorphoses of the materials. Sexual alchemy breaks that barrier and insists on the radical impossibility of distinguishing observer from observed, subject from object. It is true that in ordinary alchemical practices it is not always certain whether the adept is in the laboratory, watching the vessel, or inside the vessel, looking out. In illustrations the "son of the philosopher" is sometimes pictured inside his own "Hermetic egg." Sexual alchemy collapses even that tenuous distinction and compels the alchemist to watch his own transformation from within his own body.

One of the crucial traits of alchemy, that makes it an apposite metaphor for artistic creation, is the "involvement" of the observer in the process. "Active" alchemical thinking has been compared to Heisenberg's uncertainty principle, and though there are problems with the parallel, its general sense is valid: in alchemy as in quantum mechanics, observation is intervention, and there is no neutral, hands-off description.[34] Alchemists have long insisted on the inseparability of the object and its observer. But sexual alchemy goes further, and actually *conflates* the substance with the agent. Sexual alchemy declines allegory completely, or rather it sets up an inverted allegory, where laboratory processes are to be understood as imperfect versions of what happens in the body.

Sexual alchemy is the most epistemologically chaotic doctrine I know. The sexual alchemist initiates an "experiment" by beginning a sexual session, but from that point onward he or she becomes the *prima materia,* the *doctor philosophiæ,* and the *athanor* (furnace) all at once. Even when the process is complete the traditional dualism is not securely restored, because the fluid that the alchemists inspect (once the orgasms are over, and the alchemists are somewhat detached from their *labor*) is also manifested in and on their own bodies.

Sexual alchemy is the nearest parallel in any field to the involvement of visual artists in their creation. Artists know the feeling that

others can only weakly imagine, of being so close to their work that they cannot distinguish themselves from it. As students, artists routinely suffer from criticism when they do not have a clear awareness of the distance between themselves and what they have made. In that state of mind, there is no distinction between theory and practice, observer and observed, substance and allegory, observation and empathy. They are their work. It is just as intimate, and much more confused, than the relation between a mother and her unborn child. The mother knows that the child is inside her, and she hopes that the child is intact as it grows. An artist, on the other hand, may not be sure of any categories—there is no clear difference between the artist and the half-formed work. Neither is in control, neither clearly "makes" the other. The "experiment" of art changes the experimenter, and there is no hope of understanding what happens because there is no "I" that can absorb and control concepts—nothing has meaning apart from the substances themselves. All that is known with certainty is the flow of fluids, back and forth from the tubes to the palette, from the brush to the canvas.

In this domain nothing is secure. The alchemical or artistic work is strangely *inside,* and the human mind that directs it is also partly its inert substrate. What was once the agent of conceptual control over the work has become the bricks of its furnace, the weave of its canvas. The furnace produces a product that *is* the furnace, and the mind tries to watch a process that *is* the mind. Sexual alchemy is a form of the same disease: both propose a treacherous anarchy of unreason.

In the beginning of the alchemical work, the King and Queen sit demurely, with straight backs, on opposite thrones. Secretly, in glances scarcely visible, they know they are brother and sister. Their feet dangle in a warm pool of menstrual fluid. They will mate, melt, and re-emerge, and afterward melt again many times before the Stone emerges.

Liquids are life, and so it is particularly important that oil painting takes place between solid and liquid, in the realm of the viscous, the

gluey, the phlegmatic. The menstruum is also called the Hermetic stream, heavy water, philosopher's water, and embryo's water. Like placenta, the menstruum is a cannibalistic, invasive fluid: just as real placenta will attach itself to adjacent organs and attempt to invade them, the menstruum eats away at the King and Queen, eventually dissolving them. The pool and thrones are set in a vase, which has been hermetically sealed. The vessel is most obviously a womb, though alchemists call it a brooding chamber, an egg, the House of the Chick or House of Glass, or the Prison House of the King.

For painters the studio is the Prison House, and paints are the fluids that circulate inside it. Alchemy's lesson here is that everything actually takes place within the body. The insanity of the studio is that it is not architecture—it is not made of wood and cement—but it is nothing other than the inside of the body.

7

Steplessness

IN THE BEGINNING there is the formless lump, the rotting slime in a dusky swamp. The flood recedes, the swamp is drained, and the excrement is lovingly conserved, and placed in a warm bath. It has two natures, a sulfurous male side and a silvery lunar side. The two find themselves together, sealed away from the outside world. The moist menstruum circulates around them. It is time for love. They fall on each other, they make love, and a child is born. As the heat continues, the child grows, he becomes sexually aware, he merges with his parents. The energy of continued incest makes them rot, and they are again reduced to dung. A toad, living in the muck, vomits the four elements that were once their bodies. He is distilled, and his fiery blood drips down as milk drops. The toad vomits its milk, its body coalesces and hardens into a white egg. The egg hatches: it is a green lion gnawing on the sun, cutting himself and bleeding.

These are moments in Johann Conrad Barchusen's exhaustive emblematic sequence of alchemy. There are many more episodes, but most of them could not be explained well in words. The great work is finally concluded in eighty-four steps.[1] In another account, the work is only one step long: secret ingredients, a secret vessel, and the work is completed all at once. Gabrielle Falloppio (more famous for describing the Fallopian tubes) tells how to make gold from lead in one short paragraph, as part of an all-purpose set of chemical recipes.[2] John Dee hides the one-step work in a brief Hebrew passage contained within a parenthesis, buried in the middle of his *Hieroglyphical Monad*. The

Hebrew may be a Kabbalistic cipher, quintuply protected by its language, its inaccurate printing, its esoteric Jewish doctrine, its encipherment, and the dense undergrowth of the surrounding text. But for those who know how to read, the *magnum opus* is there—the dream of entire lifetimes, the product of long years of meditation, prayer, and experiments—in only one short line of text.[3]

Painting is also constituted by this vacillation: either it is a fully developed technique, replete with recipes, thick instructional volumes, and generations of accumulated wisdom, or else it is a trackless scene of perpetual isolated reinvention. History favors the first view. In classical oil painting technique, first there is the blank panel, and then a succession of layers: a coat of size (glue) mixed with white (like chalk or marble dust), to make the canvas as brilliant as possible; then the imprimatura (underpainting) over the entire canvas; then the underdrawing; the *grisaille* (a monochrome version of the painting, in full detail); and finally the painting itself—a succession of body colors, painted outlines, details, glazes, and varnish. Each of these has its own logic and its own rules. Late medieval tempera paintings like Sassetta's involve even more layers—at least a dozen from the raw panel to the final coat. The medieval artist Cennino Cennini recommends that the wood panel be coated with five separate layers of glue mixed with chalk and marble dust. Each layer has to be sanded before the next is applied, and at one point a linen cloth is glued down and covered over to strengthen the entire assembly.[4] Only then, after weeks of work, can the painting itself be started. Later, in the Renaissance, it became popular to give paintings a sense of unified atmosphere by painting them with glazes, thin washes of paint mixed with varnish. A golden glaze might help bathe a scene in the glow of a sunset, and a bluish glaze could turn a day scene into a nocturne. (Hollywood does the same with blue filters for night scenes.) Subtler glazes can blend individual leaves into masses, or help unify the loud colors of a rug so it looks like a single piece of fabric. Titian is the most famous for glazes, although his predecessor Giovanni Bellini may have used more of them. Titian is supposed to have boasted that he used "thirty or forty

glazes" per painting, but glazes are so evanescent that even modern conservators cannot decide on how many there were. A microscopic section through a Renaissance painting reveals the astonishing patience that went into their making (COLOR PLATE 10). No twentieth-century painting would have a cross-section like this. The artist, Cima da Conegliano, has put down a dark imprimatura and then at least thirteen layers of yellows, browns, and Copper Resinate Green. Each layer is different: some are fairly thick, and others, including the first one just above the dark imprimatura, are extremely thin. The section is magnified five hundred times, so all the layers put together are still thinner than most modern paintings. The thinnest layers here are almost entirely transparent, and even the thickest ones are translucent. Each one slightly modifies the overall color, like the effect of looking through mylar sheets. There are limits to what thin sections like this can tell conservators: they can't say anything about the paint structure an inch to either side, and they can't report reliably on the total number of glazes. Cima might have finished this portion of his painting with the thin surfaces glazes for which Titian is famous—but they might have been so thin, and so irregularly distributed over the surface, that they do not show up in this section at all.

You might think that with something as well-known as oil painting, the techniques would all be written down, so that anyone could study them and try to paint like Titian or Rembrandt. But oil painting methods have always been semi-secret, like alchemical recipes. Painters have gone to their deathbeds without telling their secrets, and when certain ways of painting went out of fashion, the methods tended to be forgotten along with them. The result is that painting techniques have been lost on at least three different occasions since the middle ages. The first loss was in the fifteenth century, when Jan Van Eyck's method—the envy of many painters, and the first successful oil technique—was not passed on to enough people, and was eventually entirely forgotten. Then there was the loss of the famous Venetian technique practiced by Titian, Giorgione, Veronese, and

Cima: it died slowly over several generations as painters used methods that were less and less like the original techniques. Eventually, when painters in the nineteenth century wanted to paint in the Venetian manner, they found that there was no one left to teach them and no books to consult. The third loss was the academic method developed mostly in the French Academy up to the time of the French Revolution. It was an elaborate, exacting technique, which had grown out of the late Renaissance—but after the Revolution, when painters decided that the academies might not have been all that bad, it was too late. In the twentieth century what goes under the name of oil painting would not have been recognizable to painters from the Renaissance and Baroque. It is about as much like their painting as the civilization in the Mad Max movies is to ours.[5]

Today only the idea of classical layering remains. Henri-Georges Clouzot's 1956 film, *The Mystery of Picasso,* records Picasso showing off for the camera, repeatedly destroying and recreating his images. He was not layering in the older fashion, since he covered over his mistakes with opaque paint instead of translucent veils; but he was layering in a temporal sense, because the finished painting rested on the layered memory of discarded ideas. Steps, layers, preparation, and planning can be components of the concept of painting even when they are absent from its practice.

In the late nineteenth century there were scholars in Germany and France who were especially well-informed and methodical in their attempts to recapture the forgotten methods of Venetian Renaissance painting. They read the old painters' manuals, analyzed paintings in museums, and wrote down instructions for making paintings in the way that Van Eyck, Botticelli, Bellini, Titian, and El Greco had done. Those recipes propose specific sequences of paint layers—sometimes up to twenty of them—from initial size to final varnish. Max Doerner, one of the most careful students of Old Masters technique, reports that his students made perfect replicas of a painting by El Greco following these eleven steps:[6]

(1) Begin with a uniform white,

(2) Then add a "luminous brown imprimatura," with no white in it. The imprimatura may be a glaze, thinned with mastic, or egg tempera, which must then be varnished so it can support layers of oil paint.

(3) On top of that, make the drawing, either in tempera or directly on the imprimatura in white chalk.

(4) Paint white into the existing dark, using a white tempera composed of egg yolk, white lead, and oil. Begin with the sharpest highlights and spread out, scumbling, in "semi-opaque layers" into all the light areas, creating passages where the dark imprimatura shows through in "optical greys" (that is, tones that are the product of several translucent layers, like plastic sheets, seen all at once). At this point, the picture as a whole should be much lighter than the original.

(5) Give the entire painting a "light intermediate varnish," and then

(6) Set the local colors with large brushes, making sure they are all lighter than the original.

(7) "Easily and deftly" draw contours into them, and "refine" them with loose reflected lights.

(8) If the colors become as dark as the original, they are finished; but in general, maintain lighter tones than the original painting.

(9) Next deepen the shadows, and

(10) Let the painting dry. Finish with an overall glaze (in this case Doerner used a blue-green glaze, modified with a rag, to indicate the nocturnal setting of the painting he was copying).

(11) Over the glaze, paint in the "strong accents" of light and dark.

There is no doubt that many older paintings were done in an exacting sequence of steps. But they could not possibly have been made as mechanically as people like Doerner suppose. In my experience,

at least, Doerner's instructions are good for a few passages in El Greco, but they help very little in reconstructing any major work. Like many academicians, Doerner's research was exhaustive but overly systematic.

Anyone who doubts that the methods of oil painting have been lost needs only look closely at a pre-modern painting. COLOR PLATE 11 is a portion of Titian's *Venus with a Mirror*. (It's a navel and an elbow.) Some time between the sixteenth and the eighteenth century the painting may have been exposed to water, or dropped, and paint chips fell off, leaving holes in the lower arm and the side. An inept restorer tried to match the color and fill in the holes, but he used impermanent pigments and they faded to the color of browned butter: and worse, he used a slow-drying medium (perhaps an oil other than linseed oil), so that the paint ran out of the holes before it dried. The result looks like nothing so much as suppurating wounds—not a very flattering condition for Venus. It may have been the same restorer who thought he could improve Titian's sense of harmony by adding patches of light brown glaze: one is visible here on the front of the elbow, and there are others scattered across her body like big pale birthmarks. To think about Titian's technique, it is necessary to ignore those blemishes as much as possible. What, then, can we deduce about his method? It began with a pale brown imprimatura in an earth tone, the equivalent of modern Raw Sienna. That tone is unmistakable in the navel, between the pit of the navel and the shadow to its right, and again on the elbow, just right of the shadow at the ulna. Those two places are very thin, and they take their brightness from the white canvas size just beneath them. That much is clear enough. But then what? The brightest portions of the belly are pastose paint, very thick, and it is typical for Titian to reserve his densest paint for flesh tones. (He changed his mind about this painting several times, even painting out a male figure who was next to Venus, and that also contributes to the density.) Sometimes painting techniques can be gleaned from the exotic kinds of photographs conservators take. But X-Rays can't help much when the

paint gets this thick because the lead in the Lead White becomes an opaque shield, hiding whatever structure the painting might have.

It is reasonable to suppose that there are many layers here—but how many? The only way to begin to guess that is to look closer to the shadows, where the paint is thinner. In my experience the way to recreate Titian's flesh textures is to build up slowly from the imprimatura, in fairly dry thin layers that are almost scrubbed on to the canvas. There is some evidence of that in the ribbed look of the paint closest to the imprimatura. As the paint gets thicker, the color gets brighter. Shadows are built in layers of thin dark paint, and the paint stays thin as the shaodows get deeper. The upper part of the shadow on the flank has been painted that way, and even though it is thin, Titian might have gone over it a dozen times to get the look he wanted. Rubbing with the brush and even with a cloth helps blend the layers one into the next—and that is another reason why microscopic sections are powerless to decide the issue of technique. A sample taken from Venus's belly would only show one or two layers, but Titian's boast of thirty or forty might well be right. One sign that the paint was rubbed is that the only sharp lines are provided by brushstrokes added at the very end of the process—the ones used to define the contours and cast shadows. Titian went over the arms and abdomen with a wavering contour, and he put triangular brown shadows to the right of the navel and on the point of the ulna. Those marks must have been about the last things he did, unless he gave the whole figure a single light glaze to unify it. Over the whole he put a varnish of natural resin, perhaps with a hint of brown tone in it.

The method is typical of Titian up until the last decade of his life: the glazes and thin layers are all about smoothing, softening, and blurring. Each layer adds a cloudy harmony, blurring lights into shadows and slurring one form into another. Sharp forms are made toward the beginning, and again at the end. Everything else is slurring, glazing, and veiling, working to unify the paint across the entire canvas. When Titian's hand movements can be inferred from the

painting, they often fit that description: they are rubbing and caress-
ing gestures, or gestures like washing and stroking.

It may seem that I have not said very much, but I have said essen-
tially all there is to know about what Titian did. This is one of the
kinds of oil painting whose techniques are essentially and perma-
nently lost. The history of oil painting methods is exactly parallel in
this respect to the history of alchemical methods. Because they were
often secret, or known only to a few people, alchemical recipes were
easily lost. As a result later alchemists and painters tended to over-
value the fragmentary reports of elaborate methods. Curators, con-
servators, and art historians tend to believe such stories (what else
can they believe?), and they describe paintings like Titian's as if they
have multiple glazes, carefully planned translucent layers, and a full
monochrome *grisaille* underneath the body color. Often the paintings
themselves give very little evidence of fully finished *grisailles,* or of
any glazes at all, but that does not deter the historians and conserva-
tors from their convictions.

Like alchemy, painting has always been insecure about its most
basic store of information. Perhaps the alchemical *labor* is the work
of a full, long lifetime, spent scouring the libraries of Europe and
preparing elaborate, year-long experiments—as Michael Maier did
when he tried to make the Stone. But on the other hand, it might be
a matter of a flash of inspiration or a moment of supreme profound
comprehension, more like a religious epiphany than a tiresome schol-
arly routine. In painting, it may be that the scattered painting manu-
als and the old letters and anecdotes are mostly right, and that
classical painting was an elaborate body of knowledge, something
that had to be learned slowly, from the ground up, in a four-year cur-
riculum or a long apprenticeship. But it may also be that painting is
intuitive, and that studio instruction only provides hints and strate-
gies. Perhaps a great painting can happen suddenly, with no planning
or working by stages.

A painting student who follows Doerner or one of the other man-

uals soon encounters this dilemma, since any given step is either triv-
ial (such as "paint a white layer of gesso on the panel") or so large as
to encompass the entirety of skill and experience in one rule (as in
"complete the figures by painting down into the darks and up into
the lights"). Even the supposed glazes and *grisaille* underpaintings
can be omitted in many cases with no visible effect. Restorers do not
try to simulate the layers when they patch damaged paintings: they
just match the overall look of the paint, and fill it in with a single
layer. The thirteen or so layers in the section of Cima's painting
would be replaced by an average tone. Many times force of habit, and
reverence for the supposed knowledge of Old Masters, leads histori-
ans to postulate layers that have no effect on the eye and may very
well not have existed. In Cima's painting, other portions might well
be simpler, and still others more complex: there might not have been
a uniform method, applied across the painting or even across one
portion of it.

 When painting is effectively done without separate steps—as virtu-
ally all modern painting is, beginning with the Impressionists—then
there is very little that can be said about its method. The unease that
many parents feel when their children set out to study art is partly
because they sense that there is no systematic technical instruction in
contemporary art schools. In a large sense, that is correct because
there is no longer a succession of definite kinds of information that
must be learned in a certain order. Painting might take years of prepa-
ration and experience, but a truly great painting might also happen in
a few minutes of intense work. Artists first became aware of this
around the turn of the century, and Whistler is the one who made it
famous by proclaiming that his patrons paid for the lifetime of expe-
rience that went into the painting, not the half hour it took to paint
it. In the same vein the German Impressionist Max Liebermann said,
"there is no Technique. There are as many techniques as there are
painters."[7] In the twentieth century painting is a one-step process
since the "steps" all blend into one another, and there are rarely more

than two or three actually distinct layers that might be separately described. To paint is to work continuously on an image from many directions and without breaks for separate steps.

All this is ingrained in modern art, and I am certainly not pining for the old academies. The new *alla prima* methods, where the paint goes onto the canvas all at once, open a tremendous range of possibilities for painting that never existed before. But they also create a fundamental anxiety that has accompanied modernism since the final decay of the academies at the end of the nineteenth century: it is no longer clear that painting is something that requires a body of knowledge, that can be learned and studied. It may be stepless, beyond the reach of any routine education. Painting and alchemy are arts, backed by massive literatures on technique and tradition, but they feel like they might collapse at any moment into ruleless experience. Like an alchemist's shelves, a palette can be very orderly, with all the pigments arranged according to hue, value, and chroma—or it can be a wasteland of mottled smudges with no rhyme or reason. A painter's or an alchemist's method can be an orderly progression from the *prima materia* up to the final crowning step—or it can be a constant thrashing-about in a ruleless place where history and scholarship are no help at all. Alchemical and painterly methods share a giddy possibility: even though they are arcane and exquisitely difficult to master, they might also be shams, so that the years spent learning them might be useless and misguided.

The fundamental anxiety of painterly or alchemical method is that it may not exist. Both artists and alchemists have traditionally worked to obscure this harsh choice by debating the exact nature of their processes. For alchemists, the controversy centers on the number of steps required by the great work. Of all numbers, four is the one most insisted upon. One of Johann Daniel Mylius's emblems shows the four "alchemical sisters" or "virgins of the sun" sitting at an outdoor table (Figure 8). They balance on symbols of the four Greek elements. Above them a vaulting arc indicates the sun's yearly

FIG. 8 The alchemical sisters. From Johann Daniel Mylius, *Philosophia reformata* (Frankfurt: Lucas Jennis, 1622), emblem 10.

movements. The *labor* is sometimes imagined as a natural cycle (*opus circulatorium*), so that it would take place in a year. The sisters are seated at the cardinal points of the zodiac. On their heads are the hermetic vessels, each with the appropriate stage: black or *nigredo*, symbolized by an "little inky man"; white or *albedo*, symbolized by a white rose; yellow or *citrinitas*, symbolized by an eagle "winging toward the sun"; and red or *rubedo*, symbolized by "the glowing lion." This is called, in esoteric doctrine, the "quartering of philosophy." The four-step work can be summarized in a table. Jung, who promoted this version of alchemy, thought that each color stage was also a *coniunctio* (a sexual fusion), making the alchemical work very neat, almost like a routine exercise:

Nigredo and 1st *coniunctio*	*Albedo* and 2nd *coniunctio*	*Citrinitas* and 3rd *coniunctio*	*Rubedo* and 4th *coniunctio*
adulthood	middle age	middle age	death
earth	moon	sun	heaven
black	white	yellow	red
earth	water	air	fire
shit	phlegm	urine	blood

All this is very satisfying, but most alchemical texts do not describe such a sequence at all. Some name different colors, and others have three colors or an indeterminate number. A book could be filled with directions that do not correspond to the four-step sequence.

The work may be one step, or three or four; but it can also be five, seven, twelve, eighty-four, or an indeterminate number. The "Philosophical Hand," invented by Johann Isaac Hollandus, posits alchemy as a matter of five substances and two principles. Over each finger there are fish, clods of earth, lanterns, and crystals of salt—symbols for saltpeter, copper, sal ammoniac, alum, and common salt, and on the palm of the hand there are symbols for quicksilver (standing for the male principle or "seed") and sulfur (standing for the female principle of "earth").[8] Often there are seven steps, pictured by ladders with seven rungs (one occurs in Dürer's print *Melencolia I*) or symbols of the seven planets. Antoine-Joseph Pernety promoted the division into twelve steps, so that the work could correspond to the zodiac.[9] Dorothea Wallich compared the steps to Hercules's twelve labors.[10] Barchusen's 84 plates cannot be reasonably interpreted as 84 steps, because they are repetitive and confusing, though he probably intended at least 70 steps. Eventually the competing theories tend to undermine each other, casting the whole notion of stages into doubt. There are also books where the number of steps might as well be infinite. The authors name stages, but do not place them in order, or say where they begin or end. The usual state of affairs is a combina-

tion between an insistence on steps and the evasion of anything explicit: an author will allude to steps, but make sure that no comprehensible sequence can be found in the text.

The sequence of the work is never fully legible in alchemical texts, nor is it simply disguised: it is approached, alluded to, distorted, and undercut. Readers like Jung who hope to find the single sequence underlying the hermetic clues tend to think the alchemists were just not reporting everything they knew, as if they had a four- or twelve-step sequence but were holding back. Like art historians and conservators who want to understand Renaissance painting, hopeful students of alchemy want to think there was some certain knowledge, or at least a body of consistent themes and ideas that could be learned and passed on. Sometimes there were (though many of them were unhelpful or mistaken), but most often the confusions and elaborate directions in the old books are really just strategies for staving off the frightening possibility that there may be no sequence at all: the *labor* may be stepless.

Alchemy and painting may have recondite and intricate systems requiring years to master, or they may have nothing. They may call for elaborate material, or they may need nothing. They may be systematic branches of knowledge, where students can march year after year up Mount Parnassus, or they may be unteachable. In either painting or alchemy, there is a lifetime of things to learn, and generations of wisdom to absorb: after all, the substances are impossibly complex. But all that may not add up to anything. Like marks on a canvas, the methods of painting may keep adding to one. In the end there is nothing but the painter, the paint, the brushes, and the blank canvas. More than any other art, painting expresses the place between rule and rulelessness in which we all find ourselves.

8

The beautiful reddish light
of the philosopher's stone

THE FINAL GOAL of alchemy, the Stone, is one of a family of transcendentally difficult compounds with different properties. The alkahest is the universal dissolvent, capable of reducing any solid to a fluid. The elixir is the universal medicine, curing any disease and prolonging life. Rectified or philosopher's gold is the perfected form of ordinary gold, and there is also fixed mercury that cannot be boiled away. Precious oil (*pretiosissimum oleum*) and fixed water (*aqua permanens*) are also goals. Lower down in the family hierarchy are various tinctures, seeds, and essences of mercury, sulfur, silver, and gold. Many people counted themselves lucky to have succeeded in creating exotic products like the Animated Spirit of Mercury ☿ or the Stellated Regulus of Antimony ⚹, an otherworldly poisonous black star, fixed in the bottom of a beaker.[1] That, at least, is as far as I have ever gotten.

Each of these is a step on the path to the Stone. Together they form a family of nearly impossible objects: they exist on earth, but only barely, in the recipes and legends of the alchemists. There are alchemists alive today who claim to have made fixed mercury and the seeds of the principles, and I have made lesser substances myself. Gold look-alikes are especially easy to manufacture.[2] For one experiment, black paper or aluminum foil is taped over all the windows in the laboratory, so that it is completely dark. Then a hole is cut in the covering in one window, and a large burning glass or fresnel lens is

fitted into it, so that it focuses a single beam of sunlight into the middle of a large glass bottle.[3] The bottle is filled with dilute nitric acid and flakes of silver chloride. The light is enough to heat the vessel, making the silver rise and fall like tiny snowflakes. Where the light focuses, the effect is blinding, but by looking very closely it is possible to see that as the silver floats through the light it is transmuted miraculously into minuscule flakes of gold.

Another experiment is a recipe for the famous Mosaic gold (*aurum musivum*), one of the mysterious gold-substitutes that the alchemists devised.[4] To give the flavor of the old texts I reproduce it here the way it might have been printed in an old alchemical text—except that I have made it readable by spelling out the names of the symbols. (In the original books, the symbols stood alone and it was up to the neophyte to figure out what they stood for.) It takes 2 days ♂♂ and requires tin powder ♃ ☿̶, mercury ☿, sulfur powder ♁ ☿̶, and sal ammoniac ✳, as well as a breakable round-bottomed flask or crucible ♋, a mortar and pestle, and a towel and hammer. You begin by heating two parts of ♃ ☿̶ in the ♋, using a gentle flame ∿. As soon as the ♃ has melted fully, remove the heat, add one part of ☿ and stir the mixture with a glass rod until it has cooled into a granular mass. Grind this amalgam \overline{aaa} in a mortar with a little more than one part of ♁ ☿̶ and one part of ✳.

When a homogeneous ☿̶ has been obtained, place the mixture into a glass flask with a round belly and a long neck, and heat it gradually H on a sand bath ∴⅍ until white fumes and yellow droplets arise into the neck of the flask.

Keep the heat constant at that degree H (250–300° C) for three hours ♉ ♉ ♉, after which time the white and yellow colors will have been replaced by black and red sublimate ♂ᵇ. Then gradually increase the heat over the course of another ♉ ♉ ♉ until the very bottom of the flask approaches a very dull red heat ⊖ (400–500° C). Turn off the heat, and allow to cool.

When it is cool, remove the flask from the ∴⅍ and (having wrapped it in a cloth) break the bulb of the ♋ with a hammer blow.

The mosaic gold rests as a hemispherical lump at the bottom of the ☿, often accompanied by a few fine black or grey fuzzy particles ☉ which can be separated and discarded. A black or very dark red ring of sublimed cinnabar (Vermilion) ♂♂ ☿ is sometimes found in the throat.[5]

This experiment results in a scintillating crystalline gold, with speckles of red and green mixed in (COLOR PLATE 12). According to modern chemistry, the "gold" is stannic sulfide, SnS_2, but in alchemical terms it is almost more beautiful than gold itself. It was exotic results like this that kept the alchemists going: if three of the most basic ingredients of alchemical work—sulfur, mercury, and sal ammoniac—could produce such wonderful substances, then surely real gold, and even the Stone, could not be impossible. And it's no surprise that painters are not far away: Mosaic gold was also used as a substitute for actual gold in illuminated manuscripts.[6]

The famous Stone is only stone in the most undefined sense. Really it is neither a stone, nor a kind of stone, nor stone as opposed to rock or mineral or metal, but stone as the principle underlying the universe of substances—the entire world, and everything in it. It would have no place in Ǧābir's classification of earthly materials. When the sum total of kinds of substances is exhausted, there remains one that cannot be on the list: the philosopher's stone itself. The stone is not gold, and even the gold allowed into the alchemists' laboratories was not "common gold" or "vulgar gold" (*aurum vulgaris*) but "sophic gold," or the purified "seeds of gold." Substances come in several varieties, passing gradually from everyday life to unheard-of rarity and beauty. In the case of mercury, first there are the lumps of earth, the plants and animals in which mercury is locked away, hidden in impurities and combinations. Then there is ore, and especially the rocks that yield the mineral cinnabar. Cinnabar itself "sweats" the liquid mercury when it is heated, leaving a smelly sulfurous residue. The perspiration is pure metallic mercury. When that is distilled and cohobated it yields the "seed" or "sophic seed" of mercury, meaning

the generative principle proper to mercury and fit for alchemical experiment. Then comes "living mercury" and the nearly supernatural tinctures of mercury, which are shining liquids or "crystalline bodies," and finally the fixed mercury of the philosophers.

The Stone itself is one step further toward the supernatural. It sparkles with a beautiful reddish light, and has a fragrant smell. One alchemist claims it is "saffron-colored powder, very heavy," glittering like "splinters of glass."[7] Another says it is red and shines like a ruby.[8] Yet the Stone is not entirely supernatural, since according to alchemical legends some people possessed it, and carried it around for years in secret pouches. They gave some away to worthy strangers, who took it and used it to make ordinary gold without any previous knowledge.

The basic reason why the Stone is not fully supernatural is that Christ himself is the goal and subject of the alchemical work, and he was incarnated and walked on the earth. Most of what gets said about the Stone can be interpreted as a reference to Christ: like him, the Stone is the perfection of everything earthly, and it can perfect the earth in turn (by changing ordinary rocks into gold). The resurrected Christ makes many appearances in alchemical texts, where he mingles with odd alchemical companions. In Heinrich Khunrath's *Amphitheater of Eternal Wisdom,* one of the most elaborate alchemical texts ever printed, Jesus stands in splendor at the center of concentric rings of symbols and Hebrew texts (COLOR PLATE 13). This is one of the rarest of all alchemical books, and in this copy—it is one of two in the world—the illustrations have been painted with gold and silver. The silver has darkened to black, but the gold is still brilliant, and the plates glow and shimmer with unearthly light. Here Jesus is nude, like the unfinished hermaphrodites and homunculi, and he stands in a fiery aureole, on a flaming phoenix, the alchemical symbol of resurrection. Around him are the signs of his divinity: sentences in Latin, proclaiming him the Son of God, and his holy names in Hebrew. Khunrath's books are daring mixtures of Christian and alchemical thinking, dangerously close to the ground of heresy.

This is where the idea of hypostasis really matters, since the Stone is a hypostatical substance: a literal substantiation and incarnation in the manner of Jesus Christ. It is half-real and half-heavenly, and it perches just on the edge of the world of possible substances. The Harvard-trained alchemist George Starkey, who took the hermetical name Eirenaeus Philalethes, captured this semidivine status by saying that the stone is of the species of gold, but more pure: "If we say that its nature is spiritual, it would be no more than the truth; if we describe it as corporeal, the expression would be equally correct."[9] Some substances are natural, others unnatural, and others hover inbetween. Before the discovery of phosphorus, the only fluorescent or phosphorescent substances known were decaying plants, and wood from two trees found in Mexico and the Philippines. The Mexican tree, *Eysenhardtia polystachya,* will glow with a peacock blue when it is put in water.[10] The two woods are drunk as medicines, and went under the name *lignum nephriticum,* kidney wood. When phosphorus was discovered late in the history of alchemy, it sparked a new interest in the mingling of natural and supernatural. The title page of Johann Heinrich Cohausen's *New Light of Phosphorus* evokes the mysterious new light (Figure 9).[11] The setting sun is reflected in a heavenly mirror and concentrated, as phosphorus, in an orb. The plate has all the sources of light that existed before phosphorus: a starry sky, a fire-breathing dragon, an owl and a cat with glowing eyes, fireflies (over the water), and a rising moon; Haephestus, with a flaming crucible; a woman with a tympanum of alchemical fire, ringed by an *ouroboros;* another woman who has plucked her flaming heart (symbol of Christian faith) from her chest; and Death, carrying a smoking torch. The alchemical ingredients are all there as well: Poseidon, Saturn, and Mars (representing water, lead, and iron); and the symbols for mercury and sulfur on the ground. Some of the lights are natural, and others divine, and all of them have the aura of the unnatural. It is the alchemist's goal to control and fix the new light, bringing it into the domain of artifice, and letting it burn, as the epigraph says, without flames. With phosphorus, it became possible to

preserve lights and shadows, and its discovery prompted some of the first thoughts about photography.[12]

There are more synonyms for the Stone than for any other substance; one source lists over six hundred names.[13] Like the *materia prima,* the stone is the perfection (*summa perfectionis*) of all creation, and therefore embodies all substances and qualities in their highest forms. It is the "triune microcosm," the perfect balance of sulfur, mercury, and salt, signifying the Father, the Son, and the Holy Spirit; and it also shares the individual properties of every substance.[14] In Khunrath's language, the Stone is the semi-corporeal near-incarnation of the divine microcosmic soul, and the perfection of the macrocosmic world of substances. Like the monad, it slips like a ghost between insubstantial ideas and forceful reality. Basil Valentine's book *On Natural and Supernatural Things* is largely about tincture, another relative of the Stone; he says it has a "supernatural, fleeting, fiery spirit," so that it does not pertain to the world of visible and tangible nature. But at the same time it can be found in all metals, and so it is partly natural.[15] Everything mundane except the Stone simply exists. Only the Stone can occupy the impossibly thin membrane between the mundane and the transcendental.

That is what perfect painting is: neither entirely dull water and stone, nor weightless representation. Not merely a wooden panel coated with cracked and abraded paint, nor entirely a madonna and child. Or as in Rembrandt, not just a slather of oil, nor simply a face. Perfect painting is imperfectly transcendent. Less interesting painters do not know what to do with the choice between substance and illusion. Poor painting does not push the equivocation as far as it can go, until the paint teeters on the edge of transcendence. An unsuccessful picture might have a passage where the paint doesn't matter at all, and the forms might just as well have been photographed instead of rendered in oil. Then in another place the paint might suddenly

FIG. 9 Title page from Johann Heinrich Cohausen, *Lumen novum phosphoris accensum* (Amsterdam: Joannem Oosterwyk, 1717).

become obtrusive, and distract the viewer from the contemplation of some distant landscape, bringing the eye sharply back to the surface of the canvas. It may be that the human mind can only think of one aspect at a time: either a painting is what it represents, or it is a fabrication done on a flat surface.[16] Or perhaps it is possible to think of both the surface and what seems to be behind it at once, in a "twofoldness" of attention that takes in both equally.[17] Like the Stone, genuinely entrancing painting wavers between the two possibilities. It is easy to be entirely bound up in substances, and think nothing of transcendence: every clod of earth is mundane, and every chunk of cinnabar, and even every bottle of mercury. Oil paint is as low and earthy as it is possible to be. On the other hand, it is easy to be unnatural and divine: for some alchemists Jesus is the Stone and the heavenly salt, and the world is suffused with angels and souls. In painting it is a simple matter to achieve an illusion of depth, and to conjure a world beyond the canvas. (Historians tend to think it is difficult, but it can be hard *not* to create some illusion with oil paint.) So painters do not work for either the divine or the mundane, just as alchemists did not labor over ordinary substances, or try to make wholly supernatural ones. What matters in painting is *pushing* the mundane toward the instant of transcendence. The effect is sublimation, or distillation: just as water heats up and then suddenly disappears, so paint gathers itself together and then suddenly becomes something else—an apparition hovering in the fictive space beyond the picture plane. The boiling point, just before the substance evaporates, is the crucial moment, and it is vexed.

When paint is compelling, it is uncanny: it hovers on the brink of impossibility, as if nothing that close to incorporeality could exist. Like the hypnotic red powder of the Stone, paint can reach a pitch of unnaturalness where it seems that it might lose every connection with the tubes and palettes where it began. That is the state that counts, and not the choice between fictive space and canvas, or between illusion and paint. It's not the choice, but the narrowness of the gap: the incredible tension generated by something so infinitesimally near to perfection. Among painters Tintoretto is especially

famous for his diaphanous figures, floating ghostlike across vast stretches of luminous dark canvas. They are painted so lightly, so quickly, that they almost disappear, but at the same time Tintoretto painted so loosely, and with such broad strokes, that is never possible to forget that they are merely paint. COLOR PLATE 14 is from a corner of a Tintoretto painting.[18] The looseness of his hand is apparent on the right, where some fabric from another garment meets the lavender robe. Its dark brown stripes do not fold neatly under the lavender, but come up at odd angles. One goes too far, and another doesn't quite make it. Each one is given a quick spot of Lead White for accent. Behind is an orange Realgar field, now mostly chipped off. The lavender robe itself is a marvel; it reminds me that Tintoretto was named after his father, a dyer of fabrics. It was painted with hanging, curling gestures, not unlike the motion where I lift my hands after washing dishes, and bring them down in the air to shake the water off. The paint comes down from above, rapidly, and then swerves to the left, and it does so repeatedly, each time leaving a thin white veil over the darker Ultramarine. The motions are loose, and they are not aligned to one another. At the center left there is a particularly dense pair of strokes, one above the other. The white paint has been squeezed out to the sides of the brush, making sharp borders. Those marks, in turn, ran over others that did not make the sharp turn, but continued straight down. One is visible where it crosses the shadow below, and another in the shadow at the upper left. They are slightly drier, and so they look more granular where they skip over the weave of the canvas. Both of them continue under the two curving marks. And those granular straight marks lie on top of yet other marks. At the far top left, there is a shadow, a curve of white, and another shadow, parts of the deepest layer that is still visible. One of the granular white strokes begins to cross the shadow at an angle.

On the left half of the detail, it is possible to do some sleuthing and find at least these three layers. But Tintoretto is elusive. The central passage is entirely enigmatic. The brushstrokes fall like silk ribbons, one over another with no breaks. Each time the brush passes, it carries a slightly different color: there are hints of greens, pinks,

FIG. 10 The philosopher's garden. From Christianus Balduinus, *Aurum superius & inferius auræ superius & inferius hermeticum* (Frankfurt and Leipzig: Georg Heinrich Frommann, 1675).

purples, and browns. At the top margin, just right of center, is a smooth rosy patch that must have been painted toward the end, but other than that nothing can be untwined. Some shadows are deep in the fabric—like the ones at the top left—but some others lie in defiance of the ordinary rules of painting, on top of the other marks. The distinct shadow just to the lower-right of the center of the detail is painted over all the folds of white: the proof is its right margin, where a bright brushstroke passes underneath it. A second dark shadow at the extreme bottom is also painted on top of the other marks.

This is sublime painting. Its shimmering layers and evanescent tints are the stuff of painting: they are entirely and insistently paint, and yet at every moment they seem to deliquesce and melt away into

air. The paint is at the moment of evaporation, where it will leave the canvas behind and become what Tintoretto needed it to be—a robe in a painting of the Golden Calf. But it never quite evaporates. When I say that painting is at its best when it pushes toward transcendence, but does not escape from itself, this is what I mean. It is the pushing, rather than the old rabbit-duck choice between illusion and materiality, that makes paint itself so expressive. This is a captivating passage, an apparition trapped at the exact instant it disappears.

Christianus Adolphus Balduinus's small etching of the philosopher's garden is one of the sweetest alchemical utopias (Figure 10).[19] Here is the end of all transmutations. The philosopher's stone is the sun and also a winged genius, "hovering," as a contemporary writer says, "over the philosopher's rose garden just before descending into its glittering pool."[20] The water of the pool is composed of "golden gold" (*AURUM AURÆ*), made out of pure sunlight. The alchemist waits at the garden gate.

There is impeccable calm and balance. The "things above" (*sursum*) are the same as the "things below" (*deorsum*). A receding movement (*seorsum*) is the same as an approaching movement (*horsum*). The seven metals below are mirrored by the seven planets above. The Seal of Solomon, sign of the harmony of the four elements, presides over the water. Its inversion or reflection (*retrorsum*) is the same in the pool as out of it. And the entire vision is symmetrically framed by the four elements.

One goal of the alchemical processes is balanced stillness. But the philosopher's garden is never a pure heaven. Even when it is symbolized by a single rose, the rose has thorns and attracts bees, moths, and spiders; and when it is pictured in a landscape as Balduinus does, it is surrounded by difficult, parched country. The alchemist's sister hurries down from the Planetary Mountains, carrying the key to the garden. Inside, all is calm and serene: but outside, she must hurry. The mountains are stark and endless. Alchemists never forget what lies outside the garden, or what infests it from within.

9

Last words

IN THE END, what is painting? Is it the framed object, with its entourage of historical meanings, the gossip about its painter, and the ledgers and letters and files and reports and reviews and books it inspired? Or is painting a verb, a name for what happens when paint moves across a blank surface? Neither is complete without the other, but I have written hoping to convince people who spend time looking at pictures that it is not right to stress the first and neglect the second. The fundamental fact that argues for the importance of the act of painting, is that painters spend their entire lives working with paint. There must be a reason: the practice of painting cannot possibly be just an annoyance, or an efficient way to get images onto canvas. (As a way of telling stories or depicting objects, it is almost outlandishly inefficient. Practically anything else would be faster.) As I imagine it, an historian might think that a painter spends most time trying to get the representation just right (assuming the painting is not abstract). Certainly depicting things is a huge preoccupation, but it floats on the top of awareness. Oil paint can't be entrancing just because it can create illusion, because every medium does that. No: painters love paint itself, so much that they spend years trying to get paint to behave the way they want it to, rather than abandoning it and taking up pencil drawing, or charcoal, or watercolor, or photography. It is the paint that is so absorbing, so deeply attractive, that a life spent in the studio can be a bearable life.

It is no wonder that painters can be so entranced by paint. Sub-

stances occupy the mind profoundly, tethering moods to thoughts, tangling stray feelings with the movements of the body, engaging the full capacity of response and concentrating it on unpromising lumps of paint and color. There is no meaning that cannot seem to flow from the paint itself. From the spectator's standpoint, looking at the finished paintings, marks can become eloquent records of the painter's body, and through that body come undependable but powerful ideas about the painter's feelings and moods. Paint incites motions, or the thought of motions, and through them it implies emotions and other wordless experiences. That is why painting is a fine art: not merely because it gives us trees and faces and lovely things to see, but because paint is a finely tuned antenna, reacting to every unnoticed movement of the painter's hand, fixing the faintest shadow of a thought in color and texture.

So I have tried to make a few points that will have seemed very simple and self-evident to painters. Painting, I said, takes place outside science and any sure and exact knowledge. It is a kind of immersion in substances, a wonder and a delight in their unexpected shapes and feels. When nothing much is known about the world, everything is possible, and painters watch their paints very closely to see exactly what they will do. Even though there is no contemporary language for that kind of experience, the alchemists already had names for it centuries ago. They knew several dozen varieties of the *materia prima,* the place where the work starts, and their terms can help us understand there are different ways of beginning the work. They had names for their transmutations, and those can help give voice to the many metamorphoses painters try to make in paint. Alchemists tried to give order to their nameless substances, and their names correspond to artists' colors and media. They worried about their knowledge, and whether it might be a sham (does it take a lifetime to make the Stone, or only a moment?); and the same anxieties are traditional in painting. And, of course, alchemists spent time thinking about the Stone, the ineffable goal of all their work; its qualities can also be ways to think about painting.

From an artist's point of view, I think the most important lesson of alchemy may be the alchemist's willingness to risk insanity. It is easy to forget the weird isolation and filth of studios, and the strangeness of spending so much time in silent congress with oil. Again, art historians resist that, and there are theories about how studios were really social places, where artists worked alongside their patrons and friends. Sometimes: but the great majority of the paintings on the walls of museums could not possibly have been made to the accompaniment of social niceties. Often enough the paintings that prove most interesting are the ones that were prodigious efforts of imagination and technique—hardly the products of a public studio. No, I think studios have always been mainly isolated places, disorienting for people who are not used to them, and potentially oppressive even for the painters. There are risks in self-imposed isolation, and they tend to be ignored by historians and critics who spend their time in clean, fresh-smelling offices and homes. Here alchemy is not a solace, but a predecessor.

There is an alchemical book that sums up the strangeness and obsession of the studio, and the way that substances trap the mind and keep it trapped for years. It is Johann Ernst Burggrav's *Lampadem vitæ et mortis;* it describes how to take some of your blood, distill it, and use it to feed a small oil lamp. Burggrav says the lamp will flare up when something good happens in your life, and it will gutter when you fall on hard times. The lamp will stay lit as long as you are alive, and when you die, it will go out.[1] What a mesmerizing thing such a lamp would be—who could take their eyes off it?—and what better illustration of the weird intimacy, the pitch of fascination, the life-long commitment that painters make to paint?

These analogies are the core of what I had to say. I do not think that they are new, but I hope that some of the unusual concepts I have borrowed from alchemy might help coax mute experiences from their isolation in the studio and let them find words.

•

Perhaps it is best to end this book twice: once with painting, and again with alchemy. Because it has been maligned so long, I will let alchemy have the last word.

Here, then, is a horseman, riding through a summer field (COLOR PLATE 15). The landscape around him is softly glowing, with the kind of glow that happens in mid-summer when the humid air of spring has not quite dried away. Underfoot some of the grass is beginning to parch into Ochre and Manganese Violet. A far hill is still Emerald Green. The light is like a glassine envelope, wet and lucent. Originally, there was no horse or rider, and the field was uniform Raw Sienna and Viridian. A few strokes of Lead White gave the rider a spectral presence, but the painter left the rider's body empty, so it has the color of the meadow. His horse is a dark smudge of Burnt Sienna. From the knees down, the rider begins to merge into the horse—or rather the meadow seeps down the horse's back and then fades to the color of the horse. Above them, the sky is smeared with bright clouds, in ribbed and scumbled streamers. To the left the clouds, or the brushmarks, are mainly flat; on the right, they tumble and rise from the copse like heat waves over a fire. It's a thick sky, with all the weight of Lead White and Ochre, and all the heaviness of the slowly drying oils.

There is no escaping medium. This can never be just a horse, or a landscape in France. It can never just be about the happiness of peasant life, or any of the other things art historians write about. It is always also a picture of the leaden sky swirling, shining, and drying, with dust gathering brown in its crevices, and a long thin crack bearing down. It is about a rider who is just thin wisps of paint, and whose body coalesces into a shadow, that is also a horse. It is a world of paint, where the airiest clouds are resinous smears, and the most verdant field is a compound of rock and oil. The streaming air is not air at all, but tracks left by the brush, and their tufts are not cloudy castles but tiny serrations and crescents where the sticky medium clung to the bristles. A silent rain falls vertically through the

picture, given form by the warp of the canvas. As Hubert Damisch says: painting is a cadmium yellow window onto the world.

From this distance, the paint and what it denotes are imbricated. If I step up even closer—and this is a tiny sample of a smallish painting— then there is nothing but paint. The sky becomes a stifling glissade of varnish. The meadow deliquesces into a wash of oil. Yet even in this airless realm where paint refers only to itself, there is still a tremendous richness of meaning, and it is the meaning proper and intrinsic to oil painting. I can imagine some historians thinking that my discussions of the paintings are too close, too exacting and formal, too shut away from the world where the paintings were made. Yet the body is what made them, and it is everywhere in the paint. No reading can be too close, because painters spend agonizing hours over just the kinds of nearly invisible passages I have photographed. It is sometimes hard for nonpainters to realize how much energy and thought can be poured into a few square inches of canvas, but that is where painters' attention is focused, and where their thoughts and gestures contact the canvas. The artist, Jean-Baptiste Camille Corot, could have just written about the meadow, or he could have painted it in watercolors, or etched it in copper. But he chose oil, and the reason has to do with the meanings of the colors and textures themselves. There are expressive gestures even in this small excerpt. Near the horizon, the sky is done in tender, slightly curling sideways motions ending in little hooks. They are an artist's version of the mechanical swipes that are most efficient in house painting: they retain enough of their utility to cover a large area, but they are also sensitive enough to give some variety to a surface. Some variety is all that is needed. The picture's marks speak about gentle monotony, and gently sustained attention. The meadow is scumbled and brushed into shape: not too carefully, but not too sloppily either. The hand that made it was at leisure.

Notice, from here, how easy it is to slip into the painter's mind, and how terribly unreliable. I haven't said much about painters' minds in this book, but I haven't avoided the subject either. To me,

the mere fact that the marks in this part of this painting were executed by a relaxed hand argues for—no, it urges me to fall into—a tranquil frame of mind. Even without the meadow and the summer light, the paint expresses relief, and a measure of laziness. For me, if art historical research can support that conclusion, so much the better: but since I cannot stop myself from feeling it when I see the marks themselves, I cannot deny it. Substances can express any feeling, any motion.

And now a few last words about alchemy. Since it is such an out-of-the-way subject, it may be a surprise to learn that the world is still full of alchemists. There are plant alchemists and metallic alchemists in every major city, and there are schools of alchemy in the United States, England, Germany, and India. At least two schools in the United States offer five- and even eight-year courses in alchemy. Practicing alchemists usually keep far away from universities, though there are occasionally cases of professors propounding alchemical doctrines; as recently as 1993 at Texas A&M there was a chemistry professor who supported alchemical research.[2] From the point of view of science, virtually all alchemists are cranks, and there is no shortage of sad stories about their encounters with professional chemists and patrons who demanded gold. In past centuries, many alchemists were jailed and executed—one was even crucified on a cross covered with gold leaf as a brutal reminder of his fraud. More often, alchemists who made spectacular claims just faded away. There are stories of alchemists who dipped coins into secret solutions and brought them out half golden—and there are even collections of coins that are half gold and half lead.[3] (The alchemist would have switched coins, and handed over one that was actually half gold.) Stephen Emmens, whose recipe for slug gold is in chapter 3, went to Washington in 1899 and changed his alchemically-produced "Argentaurum"—which he said was the primordial matter from which gold and silver are made—into 954 U.S. dollars. Apparently he couldn't repeat his demonstration, and the ensuing media attention

died away rapidly. His history has never been researched.[4] Charles Henri, who wrote a book on color theory that influenced Seurat and the Postimpressionists, also spent time writing about the numerological significance of the numbers 1, 2, 3, and 4, and—in the words of a biographer—he "ended his days worn out by chemical experiments and mathematical calculations in an endeavor to discover a reagent capable of converting water into petrol."[5] C. Louis Kervran claimed special things happen to atoms in the bodies of plants and animals that cannot be understood in terms of chemistry or physics.[6] According to the "Kervran effect," atoms can transmute within the body, so that people can be killed when their nitrogen atoms spontaneously become carbon monoxide.[7] Kervran's spiritual predecessor, Louis-Nicolas Vauquelin, believed that hens transmuted corn into calcium to make their eggshells. He is lampooned in Gustave Flaubert's *Bouvard and Pécuchet,* along with the other follies of the world.[8] There are hundreds of other stories like these, enough to fill several books.[9]

Alchemy is a discredited pseudoscience. It took a long time dying, but the end was in sight early on, as the sciences began to move forward after the Renaissance. Oswald Croll, a seventeenth-century German alchemist, wrote a book with a picture of himself emerging from the alchemical vessel and striking a kingly pose. It is supposed to be an image of the Philosophical King, the very embodiment of the Stone. Croll calls his likeness "the earthly treasure and earthly God" but he is a flabby, nude, fifty-year-old man, and he looks pathetic—like an overweight suburbanite who stepped into a pot by mistake.[10] Even then, in the golden age of alchemy, there were those who suspected that alchemy might be hollow. As modern chemistry got going, alchemy lost ground, and in the nineteenth century scientists stripped it even of the dubious prestige it had once had. In the last fifty years things have gotten even worse, because now alchemy is either mummified within Jung's heavy psychological theories of the mind, or evaporated into New Age dreams.

In a perverse way, some alchemists reveled in the ruins of their discipline. If things looked bad, and they were expelled from court,

or called quacks or "puffers," then that meant their art must have some miraculous secret. Because it seemed empty, it must be full. Because it was despised, it must be magnificent. Countless books begin with versions of the epigram "What good are glasses to those who cannot see?"—implying that the book will not be understood by anyone unless they already believe in it. As the criticism from outside became more strident, the alchemists dug deeper into their unwavering convictions and unconscious self-deceptions. Current alchemy happens far from serious chemistry, physics, philosophy, and literature: that is the price it pays to keep its hopes alive.

The weight of history is against the alchemists, but in a sense they are right, because there is truth in alchemy even if it does not reside in vague recipes or ecstatic prayers. I hope I have made it clear that alchemy is not just a fusty old activity fit for cranks, or a mystical New Age pursuit suitable for adolescents. It has its truths, and they were hard-won in encounters with unknown substances. Above all, alchemy is the record of serious, sustained attempts to understand what substances are and how they carry meaning. And for that reason it is the best voice for artists who wrestle every day with materials they do not comprehend and methods they can never entirely master. Science has closed off almost every unsystematic encounter with the world. Alchemy and painting are two of the last remaining paths into the deliriously beautiful world of unnamed substances.

Notes

NOTES TO THE INTRODUCTION

1. The project of this book is set in the wider context of art history and visual theory in my *Our Beautiful, Dry, and Distant Texts: Art History as Writing* (University Park, PA: Pennsylvania State University Press, 1997), 33–60; pp. 46–59 are a revision of "Histoire de l'art et pratiques d'atelier," *Histoire de l'art* 29–30 (1995): 103–12.

2. This was first argued in John Pope-Hennessy, *Sassetta* (London: Chatto and Windus, 1939), 149.

3. These qualities are explored in my essay, "On Modern Impatience," *Kritische Berichte* 3 (1991): 19–34, revised in *Streams into Sand: Links between Renaissance and Modern Painting,* with a commentary by Loren Partridge (New York: Gordon and Breach, forthcoming).

4. Yve-Alain Bois, paraphrasing Hubert Damisch, in *Painting as Model* (Cambridge, MA: MIT Press, 1990).

5. Strictly speaking, Jung was not the first to propose a psychological interpretation of alchemy. See S. Foster Damon, "De Brahm: Alchemist," *Ambix* 24 (1977): 77–87; and Martin Luther, "A History of the Psychological Interpretation of Alchemy," *Ambix* 22 (1975): 10–20. But for the twentieth century, Jung is the decisive instance.

6. Disagreements over the glass of antimony are an example. See Lawrence Principe, "Über die Bereitung des Antimon-Essigs," *Essentia* 8 (1982): 20–22; Principe, "'Chemical Translation' and the Role of Impurities in Alchemy: Examples from Basil Valentine's *Triumph-Wagen,*" *Ambix* 34 no. 1 (1987): 22–30; and David Schein, *Basilius Valentinus und seine Tinkturen aus dem Antimon,* Ph.D. dissertation, Ludwig-Maximilians-Universität zu München (Munich: T. Marczell, 1977). Helmut Gebelein reports achieving the glass of antimony according to Basil Valentine's recipe without iron impurities (personal communication, 1994). Another early source is Cristophe

Glaser, *Traité de la chymie, enseignant par une brieve et facile méthode toutes les neces-saires préparations,* 2nd ed. (Paris: J. d'Hory, 1673 [1663]).

7. Only the most determined "puffers" or "spagyrists"—alchemists who took the day-to-day recipes literally, and understood everything at face value—would think *only* of the laboratory. Most understood that the exotic materials and odd names were ciphers, pointing vaguely at something beyond. But the exoticism of the subject cannot be burned away, leaving the indelible spiritual core, without also losing the texture and fascination of everyday work. That is why I return to the literal sense throughout this book: without it, the actual textures, weights, and smells of the laboratory (or the studio) tend to evaporate in the name of a transcendental goal that cannot make sense without their support. Some readers—practicing alchemists, and especially "spiritual" alchemists—have objected that I spend too much time with literal-minded recipes. This is the defense: that to understand the fascination of substances, it is necessary to take them—for a while, and with reservations—exactly as they present themselves. Without that attention to the grain of everyday life, the essential tension between substance and sign is prematurely broken.

8. Among them the best is Abraham Pincas et al., *Le Lustre de la main, esprit, matière et techniques de la peinture* (Paris: École nationale supérieure des Beaux-Arts, 1991).

9. George Chapman, *Homer's Batrachomyomachia, Hymns and Epigrams, Hesiod's Works and Days* (London: J.R. Smith, 1858). The *Batrachomyomachia* is conventionally attributed to Homer, just as the *Iliad* and *Odyssey* are.

10. In this respect Paracelsus has the advantage of being less programmatic than Jung; Paracelsus used alchemical concepts for many things beside his doctrine of spagyric medicine. See, for example, Philippus Theophrastus Bombast von Hohenheim [Paracelsus], *Elf Traktat (Von Farbsuchten, Andere Redaktion),* in *Theophrast von Hohenheim genannt Paracelsus Sämtliche Werke,* edited by Karl Sudhoff and W. Matthiessen, 14 vols. (Munich and Berlin: R. Oldenbourg, 1922–33), vol. 1, p. 56, comparing diseased skin colors to alchemical colors. The passage is also cited in Massimo Luigi Bianchi, "The Visible and the Invisible: From Alchemy to Paracelsus," in *Alchemy and Chemistry in the XVIth and XVIIth Centuries,* Proceedings of the Warburg Colloquium, 1989, edited by Piyo Rattansi and Antonio Clericuzio (Dordrecht: Kluwer, 1994), 17–50, 41 n. 49.

11. Bloom, *Kabbalah and Criticism* (New York: Seabury, 1975).

12. There is a connection to my interests here: the treatise called *Aesch-Mezareph,* a work of Jewish kabbalistic alchemy (as opposed to the more common Christian kabbalism). The anonymous author makes comparisons between *hochmah* and lead, *binah* and tin, and so forth. See Christian Knorr von Rosenroth, *Kabbalah denudata*

(Sulzbach: A. Lichtenthaler, 1677–84), reprinted (Hildesheim: G. Olms, 1974); Gershom Scholem, *Alchimia e kabbalah,* translated [from the German] by Marina Sartorio (Torino: G. Einaudi, 1995). For Christian kabbalism see François Secret, *Les kabbalistes chrétiens de la Renaissance* (Paris: Dunod, 1964). There are several English editions of the *Aesch-Mezareph;* see for example *Aesch-Mezareph,* translated by a lover of Philalethes [1714], edited by Sapere Aude, in the series *Collectanea hermetica,* edited by William Wynn Wescott, vol. 14 (London: Theosophical Publishing Society, 1894), reprinted (New York: Occult Research Press, [1956]).

13. The best introductions to alchemy are not biased for or against either science or Jungianism. It is essential, in first encountering the literature, not to read at random, or fall into one of the several competing regimes of interpretation. Good first choices are: Robert Halleux, *Les Textes alchimiques,* Typologie des Sources du Moyen Âge Occidental, fascicle 32, edited by L. Genicot (Turnhout, Belgium: Brepols, 1979); Wilhelm Ganzenmüller, "Wandlungen in der geschichtlichen Betrachtung der Alchemie," *Chymia* 3 (1950): 143–54, also in his *Beiträge zur Geschichte der Technologie und der Alchemie* (Weinheim, 1956): 349–60; and J. Weyer, "The Image of Alchemy in Nineteenth and Twentieth Century Histories of Chemistry," *Ambix* 23 (1976): 65–79. Of these, Halleux is the most knowledgeable and nonjudgmental, though even he falters when it comes to the recent non-academic literature. First he says it should be judged "du strict point de vue de l'historien," but he ends up concluding that scholarly knowledge of alchemy's history "est une exigence de santé mentale." Halleux, *Les Textes alchimiques, op. cit.,* 57. A useful introductory bibliography is Alan Pritchard, *Alchemy: A Bibliography of English-Language Sources* (London: Routledge and Kegan Paul, 1980). Since the history of alchemical writings is so difficult—so full of unacknowledged reprints, anonymous translations, pirated and undated editions, and pseudonymous treatises—I have made the notes as specific as possible. Refer to the first citation of a given text for the fullest bibliographic information.

NOTES TO CHAPTER 1

1. On this question see Anne Wagner, "Why did Monet Give up Figure Painting?," *The Art Bulletin* 76 no. 4 (1994): 613–29.

2. Larkin, "Water," *The Whitsun Weddings* (London: Faber and Faber, 1964), 20.

3. Robert Herbert, "Method and Meaning in Monet," *Art in America* 67 no. 5 (1979): 90–108.

4. Painters' "tricks" are explored in my *Pictures, And the Words that Fail Them* (Cambridge: Cambridge University Press, forthcoming), chapter 2.

5. On instantaneity in Monet, see Steven Levine, "The 'Instant' of Criticism and Monet's Critical Instant," *Arts Magazine* 55 no. 7 (1981): 114–21.

6. A different argument on narcissism is proposed in Rosalind Krauss, "Impressionism: The Narcissism of Light," *Partisan Review* 43 no. 1 (1976): 102–12; and see Steven Levine, *Monet, Narcissus, and Self-Reflection: The Modernist Myth of the Self* (Chicago: University of Chicago Press, 1994).

7. Alchemical themes exist here and there throughout Western painting, but they are virtually never of central importance in the paintings. This is argued in my "On the Unimportance of Alchemy in Western Painting," *Konsthistorisk tidskrift* 61 (1992): 21–26, and in the ensuing exchange of letters with Didier Kahn; my reply is "What is Alchemical History?," *Konsthistorisk tidskrift* 64 no. 1 (1995): 51–53.

8. Williams, "Asphodel, That Greeny Flower," I, in *The Collected Poems of William Carlos Williams, Vol. 2, 1939–62* (New York: New Directions, 1988), 318.

9. Earle R. Caley, "Ancient Greek Pigments," *Journal of Chemical Education* 23 (1946): 314–16; quotation on p. 315.

10. *Artists' Pigments, A Handbook of their History and Characteristics* (Washington, DC: National Gallery of Art, 1986–93), vol. 2, distributed by Oxford University Press (1993), edited by Ashok Roy, p. 162. For early nineteenth century examples of alchemical artists' materials see *The Artist's Companion, and Manufacturer's Guide* (Boston: J. Norman, 1814).

11. A. Kurella and I. Strauss, "Lapislazuli und natürliches Ultramarin," *Maltechnik restauro* 89 no. 1 (1993): 34–54, especially 38–39; and Edward Norgate, *Miniatura or the Art of Limning, Edited from the MS in the British Library* [Bodleian MS Tanner 362] *by Martin Hardie* (Oxford: Clarendon, 1919), reprinted (New Haven: Yale University Press, 1997).

12. Roy, *Artists' Pigments, op. cit.,* 38–39, 68.

13. Edward Bancroft, *Experimental Researches concerning the Philosophy of Permanent Colors,* 2 vols. (Philadelphia: Thomas Dobson, 1814 [1794]), vol. 1, pp. 305, 317.

14. See Alexander Eibner, *Über fette Öle, Leinölersatzmittel und Ölfarben* (Munich: B. Heller, 1922).

15. Heinrich Conrad Khunrath, *Ampitheatrum Sapientiæ Æternæ, Solius Veræ* (Hamburg: s.n., 1595, 1604, 1609, *et seqq.*); Michael Maier, *Symbola aureæ mensæ duodecim nationum* (Frankfurt: Typis Antonij Hummij, 1617), reprinted (Graz: Akademische Druck, 1972).

16. John Read, *Prelude to Chemistry, An Outline of Alchemy, its Literature and Relationships* (Cambridge, MA: MIT Press, 1966 [1937]), 17–18, paraphrasing Aristotle's theory of vapors and smoke. See *Aristotle's Generatione et corruptione,* translated by C.J.F. Williams (Oxford: Oxford University Press, 1942), book ii; and *Aristotle, Meteorologica,* translated by H.D.P. Lee (Cambridge, MA: Harvard University

Press, 1962). Lee is a typical rationalist: "That the *Meteorologica* is a little-read book," he says, "is no doubt due to the intrinsic lack of interest of its contents. Aristotle is so far wrong in nearly all his conclusions that they can, it may with justice be said, have little more than antiquarian interest" (*Ibid.*, xxv–xxvi).

17. *An Introduction to Materials,* edited by Helen Wilks, in the series Science For Conservators, vol. 1 (London: Crafts Council, 1984), 98. Several of the phrases, including "mobile liquid" and "slimy liquid," are quotations.

18. Georg Agricola, *De ortu et causis subterraneorum* (Basel: Froben, 1546), lib. iv, and Agricola, *De re metallica* (Basel: E. König, 1657), 512 ff. See also Anselmus Boetius de Boodt, *Gemmarum et lapidum historia* (Leiden: Joannis Maire, 1636), 13, 24, 29. For further references see David Murray, *Museums: Their History and their Use, With a Bibliography and List of Museums in the United Kingdom,* 3 vols. (Glasgow: J. MacLehose and Sons, 1904), vol. 1, n. 2.

19. Nicolaus Steno, *Prodromus . . . English'd by H.O.* [Henry Oldenburg] (London: F. Winter, 1671), preface.

20. Agricola, *De natura fossilium,* translated by Mark Chance Bandy and Jean A. Bandy (New York: Geological Society of America, 1955), lib. ii, and Agricola, *De re metallica, op. cit.,* 578b. See also Leibniz, *Summi polyhistoris Godefrodi Guileilmi Leibniti Protogaea* (Göttingen: I.G. Schmid, 1749), §36; and Johann Schröder, *Pharmacopoeia Medico-Chymica* (Leiden: F. Lopez d'Haro, 1672), book iii, p. 42. There are further citations in Murray, *Museums, op. cit.,* vol. 1, p. 73, n. 1.

21. Pierre Gassendi, *Viri illustris Nicolai Claudii Fabricii de Peiresc, senatoris Aquisextiensis vita,* 3rd ed. (The Hague: Adiani Vlacq, 1655), 90, 151–52, 156. See Murray, *Museums, op. cit.,* vol. 1, p. 92, nn. 1, 2.

22. Johann Christian Kundmann, *Rariora naturæ et artis, item in de re medica* (Breslau: Michael Hubert, 1737), 62, 72, 110.

23. Matthew MacKaile, *The Oyly-Well; or, a topographico-spagyricall Description of the Oyly-Well at St. Cathrinis-chappel, in the paroch of Libberton* (Edinburgh: Robert Brown, 1664), 136, also described in Murray, *Museums, op. cit.,* vol. 1, p. 197. The *Oyly-Well* is a translation of MacKaile, *Fons Moffetensis* (Edinburgh: Robert Brown, 1659).

24. For several schemata see Murray, *Museums, op. cit.,* vol. 1, p. 212 ff.

25. See John Kentmann's catalogue of his collection, published in Conrad Gesner, *De omni rerum fossilium genere* (Tiguri: I. Gesnerus, 1566), reprinted in Murray, *Museums, op. cit.,* vol. 1, p. 212.

26. Pliny, *Historia naturalis* xxxvi.27.

27. The list is reported in Murray, *Museums, op. cit.,* vol. 1, pp. 213–14.

28. Jean Chretien Ferdinand Hoefer, *Histoire de la chimie,* 2 vols. (Paris: Bureau de la revue scientifique, 1842–43), vol. 2, pp. 135–46, as quoted in Allen G. Debus,

"Renaissance Chemistry and the Work of Robert Fludd," in *Alchemy and Chemistry in the Seventeenth Century* (Los Angeles: William Andres Clark Memorial Library, 1966), 1–29, especially 23.

29. Artephius, *The Secret Book,* in Lapidus, *In Pursuit of Gold: Alchemy in Theory and Practice, Additions and Extractions by Stephen Skinner* (London: Neville Spearman, 1976), 41–64, especially 56. For the original see *Artephius Arabis Philosophi Liber Secretus nec non Saturni Trismegisti, sive F. Helix de Assisio Libellus,* 2nd ed. (Frankfurt [?]: s.n., 1685 [?]). There is also a seventeenth-century translation: *Artephii liber secretus,* translated by William Salmon (London: Thomas Hawkins and John Harris, 1692).

30. "*Der grosse unbeschreibliche Feuergeist, in Ewigkeit unerforschlich.*" *Geheime Figuren der Rosenkreuzer* (Altona: J.D.A. Eckhardt, 1785 [–1788]). The original edition is extremely rare (a copy is in the Duveen collection); see also the facsimile and translation, *Secret Symbols of the Rosicrucians of the 16th and 17th Centuries,* translated by George Engelke (Chicago: Aries Press, 1935).

31. *Marius: On the Elements,* edited by R.C. Dales (Berkeley: University of California Press, 1976), 154, translation modified.

32. In typical alchemical fashion, the book was not originally called *Summa perfectionis,* and it was not written by Ğābir but by Paul of Taranto, a thirteenth-century scholar who lived in Assisi. See the exemplary scholarship on this subject by William Newman, *The* Summa perfectionis *of Pseudo-Geber: A Critical Edition, Translation, and Study* (Leiden: E.J. Brill, 1991). The list that follows is from *Ibid.,* 111–15.

33. The lack of connection between science and art on this score is the subject of my "The Drunken Conversation of Chaos and Painting," *Meaning* 12 (1992): 55–60.

34. From Adam McLean, "Working with Practical Alchemy, No. 1," *Hermetic Journal* 14 (1981): 37–39.

35. Jerry Donohue, *The Structures of the Elements* (Malabar, FL: Robert E. Krieger, 1982), 354–69. I thank Roald Hoffmann for bringing this to my attention; he points out that one of Erämetsä's sixteen sulfurs was red—a goal of several alchemical recipes.

NOTES TO CHAPTER 2

1. See my "Art History and the Criticism of Computer-Generated Images," *Leonardo* 27 no. 4 (1994): 335–42 and COLOR PLATE, and "There are No Philosophic Problems Raised by Virtual Reality," *Computer Graphics* 28 no. 4 (1994): 250–54.

2. A different approach to this subject, involving the history of counting in the ancient Near East, is explored in my *Pictures, and the Words that Fail Them* (Cambridge: Cambridge University Press, forthcoming).

3. Stuart Schneiderman, *Jacques Lacan, Death of an Intellectual Hero* (Cambridge,

MA: Harvard University Press, 1983), 7 ff.; Lacan, *Le Séminaire,* edited by Jacques-Alain Miller, vol. 20, *Encore* (Paris: Editions du Seuil, 1975), 122 and *passim,* cited in Ellie Ragland-Sullivan, "Counting from 0 to 6: Lacan, 'Suture,' and the Imaginary Order," in *Criticism and Lacan,* edited by P.C. Hogan and L. Pandit (Athens and London: University of Georgia Press, 1990), 31–63, especially 30.

4. For lists of terms used by Iamblichus, see "The Pythagorean Titles of the First Ten Numbers, From the Theology of Numbers by Iamblichus," translated by David Fideler, in *The Pythagorean Sourcebook and Library,* edited by Kenneth Sylvan Guthrie et al. (Grand Rapids: Phanes Press, 1987), 321–24. (*The Pythagorean Sourcebook* was first printed in 1920; "The Pythagorean Titles" was added for the 1987 edition.)

5. *Monas hieroglyphica Ioannes Dee* (Frankfurt: Apud Iohannem Wechelum et Petrum Fischerum consortes, 1591), originally (Antwerp: G. Silvius, 1564); Conrad Hermann Josten, "A Translation of John Dee's 'Monas Hieroglyphica' (Antwerp, 1564), With an Introduction and Annotations," *Ambix* 12 nos. 2–3 (1964): 84–221, especially 128–29, translation modified.

6. The concept comes from Plotinus; see Ubaldo Ramún Pérez Paoli, *Der plotinische Begriff von Hypostasis und die augustinische Bestimmung Gottes als Subiectum* (Würzburg: Augustinus-Verlag, 1990).

7. Damisch, *La Fenêtre jaune cadmium, ou, Les dessous de la peinture* (Paris: Seuil, 1984).

8. Matthew Moncrieff Pattison Muir, *A History of Chemical Theories and Laws* (New York: J. Wiley and Sons, 1907), reprinted (New York: Arno, 1975), 4 ff.

9. "Unarius non est numerus, & ex ipso numerus omnis consurgit." This sentence is the subject of a commentary by Dee's contemporary Gerhard Dorn [Gerardus Dorneus], in the *Theatrum chemicum,* 6 vols. (Strassburg: E. Zetzner, 1659–61 [1602]), 390–91. See Josten, "A Translation," *op. cit.,* 108.

10. Iamblichus, *Theology of Arithmetic,* translated by R. Waterfield (Grand Rapids: Phanes Press, 1988), 38. For the original see Τα Θεολογουμενα της Αριθμητικης, edited by V. de Falco (Leipzig: Teubner, 1922).

11. See Marcelin Berthelot and Charles Ruelle, *Collection des anciens alchimistes grecs,* 3 vols. (Paris: Steinheil, 1887–88); and H.G. Sheppard, "The Ouroboros and the Unity of Matter in Alchemy: A Study in Origins," *Ambix* 10 no. 1 (1962): 83–96. An ouroboros is illustrated in Thoeodoros Pelecanos, *Synosius* [1478], Bibliothèque Nationale, MS. grec 2327, fol. 297, reproduced in Count Stanislas Klossowski de Rola, *Alchemy, The Secret Art* (London: Thames and Hudson, 1973), pl. 1.

12. Michael Maier, *Atalanta fugiens* (Oppenheim: Hieronymous Galler, 1617), emblem XIV. Translation modified from *Atalanta Fugiens, An Edition of the Fugues, Emblems and Epigrams,* edited by Jocelyn Godwin (Grand Rapids: Phanes Press, 1989),

129. There is no full, reliable English translation. See the MS translations in the British Library, MS Sloane 3645, and at Yale, Mellon MS 48.

13. *Clangor buccinae,* in *Artis auriferæ, quam chemiam vocant,* 2 vols. (Basel: Conrad Waldkirch, 1572), vol. 1, p. 530, cited in Helena Maria Elisabeth de Jong, *Atalanta Fugiens: Sources of an Alchemical Book of Emblems* (Leiden: E.J. Brill, 1969), 131–32.

14. Senioris Zadith, Filii Hamuelis, *Tabula chimica,* in *Theatrum chemicum, op. cit.,* vol. 5, p. 233, also cited in de Jong, *Atalanta Fugiens, op. cit.,* 132.

15. Gottlieb's pictographs are studied in my *Domain of Images: The Art Historical Study of Visual Artifacts* (Ithaca: Cornell University Press, forthcoming).

16. It depicts the boat from which Jesus's disciples caught fish, as described in John 21:4–9. The boat tips because the fish were caught by casting a net to the right, and the disciples lean that way to haul in the net.

17. In addition a large portion of the paint surface has been lost and restored—perhaps up to one-quarter of it. The area of this detail is unaffected. I thank Sarah Fisher of the National Gallery, Washington, for this information.

18. Raffaele Soprani, *Le vite de'Pittori, Scultori, ed Architetti Genovesi,* 2nd ed., edited by Carlo Giuseppe Ratti (Genoa: Nella Stamperia Casamara, 1769), quoted in Valentina Magnoni, *Alessandro Magnasco* (Rome: Edizioni Mediterranee, 1965), 11. For similar examples see Philip Sohn, *Pittoresco: Marco Boschini, His Critics, and Their Critique of Painterly Brushwork in Seventeenth- and Eighteenth-Century Italy* (Cambridge: Cambridge University Press, 1991).

19. A lovely example of the application of this idea is Karli Frigge, *Alchemy and Marbling* (Joppe, The Netherlands: Karli Frigge, 1996), large 4to, which explores marbleized endpapers as an alchemical metaphor.

20. Iamblichus, *Theology of Arithmetic, op. cit.,* 44–45.

21. See *Marius: On the Elements,* edited by R.C. Dales (Berkeley: University of California Press, 1976), 15, n. 16, which lists the first two Latin sources as the *Liber Apollonii* (c. 1143) and Avicenna's *De mineralibus*—for which see *Avicenne De congelatione et conglutione lapidum* [late 12th c.], translated by Alfred Sarashel, edited by Eric John Holmyard and Desmond Christopher Mandeville (Paris: P. Guethner, 1927).

22. Arthur J. Hopkins, *Alchemy: Child of Greek Philosophy* (New York: Columbia University Press, 1934); R. Hookyaas, "Chemical Trichotomy before Paracelsus," *Archive Internationale d'Histoire des Sciences* 28 (1949): 1063–74; and Hookyaas, "Die Elementenlehre des Paracelsus," *Janus* 39 (1935): 75–88.

23. John Read, *Prelude to Chemistry, An Outline of Alchemy, its Literature and Relationships* (New York: MacMillan, 1937), reprinted (Cambridge, MA: MIT Press, 1957), 19.

24. Andreas Libavius, *D.O.M.A. Alchemia . . . opera e dispersis passim optimorum autorum* (Frankfurt: Iohannes Saurius, 1597), translated into German as *Die Alchimie des Andreas Libavius* (Weinheim: Verlag Chimie, 1964), Erster Trakt, Kap. L [XLIX], p. 316.

25. A.K. Ramanujan, *Speaking of Siva* (Harmondsworth: Penguin, 1973), 48–49. I thank Steven Feite for this information.

26. There is a longstanding connection between alchemy and gnosticism, which turns on this dualism. See for example Jean-Jacques Gilbert, *Propos sur la chrysopée* (Paris: Dervy Livres, 1995), 209–69; H.J. Sheppard, "Origin of the Gnostic-Alchemical Relationship," *Scientia* 97 (1962): 146–69; and Sheppard, "Gnosticism and Alchemy," *Ambix* 6 (1957–58): 86–101. I thank Mike Dickman for bringing these to my attention.

27. Read, *Prelude to Chemistry, op. cit.*, 26.

28. See especially a MS attributed to Raymond Lull, *Commentum super lapidem philosophorum,* mentioned in Michela Pereira, *The Alchemical Corpus Attributed to Raymond Lull,* Warburg Institute Surveys and Texts, no. 18 (London: Warburg Institute, 1989), 68, no. I.11.

29. Basil Valentine, *Von den Natürlichen und ubernatürlichen Dingen. Auch von der ersten* Tinctur, *Wurtzel und Geiste der Metallen und Mineralien,* edited by Johann Tholden (Leipzig: Bartholomæus Voigt, 1624), 87–88. In the large literature on Basil Valentine see first Karl Sudhoff, "Die Schriften des sogennanten Basilius Valentinus: Ein Beitrag zur Bibliographie der Alchemie," *Philobiblion* 6 (1933): 163–70; and J.R. Partington, *A History of Chemistry,* 4 vols. (London: MacMillan and Co., 1961), vol. 2, pp. 190–95, especially 190 n. 7.

30. Leonhardt Thurneysser von Thurn, *Historia Unnd Beschreibung Influentischer, Elementischer und Natürlicher Wirckungen* (Berlin: Michael Hentsken, 1578); and see J.C.W. Moehlen, *Beiträge zur Geschichte der Wissenschaften in der Mark Brandenburg . . . I. Leben Leonhard Thurneissers zum Thurn . . . II. Fragmente zur Geschichte der Chirurgie von 1417 bis 1598 . . . III. Verzeichnis der Dohm-und Kollegiatstifter* (Berlin and Leipzig: George Jakob Decker, 1783), Part One reprinted as *Leben Leonard Thurneissers zum Thurn* (Munich: Werner Fritsch, 1976). Thurneysser also wrote an explicitly alchemical work; see Peter Morys, "Leonhard Thurneissers *De transmutatione veneris in solem* [1585]," in *Die Alchemie in der europäischen Kultur- und Wissenschaftsgeschichte,* edited by Christoph Meinet (Wiesbaden: Harrassowitz, 1986), 85–95.

31. Josten, "A Translation," *op. cit.,* 107, 158–59, translation modified.

32. *Marius: On the Elements, op. cit.,* 128–31.

33. *Turba philosophorum,* originally in *Artis auriferæ, op. cit.* An English translation is *Alchemy, the Turba Philosophorum or Assembly of the Sages, Called also the*

Book of Truth in the Art and the Third Pythagorical Synod, translated by Arthur Edward Waite (London: George Redway, 1896), reprinted (London: Vincent Stuart and John M. Watkins, 1970), 11–12.

34. In a Greek source they are given as "virgin earth, igneus earth, carnal earth, and sanguineous earth," and in the *Turba* more simply as water, fire, earth, and air. *Alchemy, the Turba Philosophorum or Assembly of the Sages, op. cit.,* 21–22.

35. John Maxson Stillman, *The Story of Alchemy and Early Chemistry* (New York: Bover, 1924), reprinted (New York: Dover, 1960), 321.

36. In Aristotle they are "contraries," εναντια or "differentiæ," διαφοραι. See Mary Louise Gill, *Aristotle on Substance, The Paradox of Unity* (Princeton: Princeton University Press, 1989), 68.

37. Robert Fludd, *Anatomiæ ampitheatrum effigie triplici, more et conditione varia* (Frankfurt: Theodor de Bry, 1623), 25; Fludd, *Philosophia Moysaica* (Gouda: Petrus Rammazenius, 1638), translated as *Mosaicall Philosophy* (London: H. Moseley, 1659), 69 ff.; and Allen G. Debus, "Renaissance Chemistry and the Work of Robert Fludd," in *Alchemy and Chemistry in the Seventeenth Century* (Los Angeles: William Andres Clark Memorial Library, 1966), 1–29, 28 n. 32, which lists these sources.

38. Some of these are from Antoine-Joseph Pernety, *Dictionnaire mytho-hermétique, dans lequel on trouve les allégories fabuleuses des poètes, les métaphores, les énigmes et les termes barbares des philosophes* (Paris: s.n., 1758), *v.* "nature," 324–25. The rivers of Eden are from D.L.B., *Traité de la poudre de projection, divisé en deux lettres* (Brussels: s.n., 1707), 5. For the latter see Denis Duveen, *Bibliotheca alchemica et chemica. An Annotated Catalogue of Printed Books on Alchemy, Chemistry and Cognate Subjects in the Library of Denis I. Duveen* (London: E. Weil, 1949), reprinted (London: Dawsons of Pall Mall, 1965), 586.

39. In the alchemy of Ǧa'far al Ṣādiq, the three principles are treated in order, and then united, avoiding the internal contradictions of methods that alternate between three principles and four elements. See Julius Ruska, *Arabische Alchemisten, II. Ǧa'far al Ṣādiq, der Sechste Imām,* Heidelberger Akten der Von-Portheim Stiftung, vol. 10 (Heidelberg: Carl Winter's Universitätsbuchhandlung, 1924), 56–57.

40. D.L.B., *Traité de la poudre, op. cit.,* 13.

41. Albertus Magnus, *De ortu et metallorum materia,* in *Theatrum chemicum, op. cit.,* vol. 2, p. 123.

42. "In profundo naturæ mercurii est sulfur." From *Chrysopoiea: Being a Dissertation on the Hermetical Science* (London, 1745), 11. The author is quoting Bernard Trevisan, who was quoting Ǧābir.

43. Basil Valentine, *Der Triumph-Wagen antimonii,* edited by Johann Tholden (Hamburg [not Leipzig, as it is usually given]: J. Apels, 1604), in Latin as *Currus*

Notes to Chapter 2 211

Triumphalis Antimonii (Toulouse: Petrum Bosc, 1646), 1–114. There are at least three English translations, all as far as I have seen from the Latin version: see *The Triumphant Chariot of Antimony*, translated by I.H. Oxon [John Harding] (London: Printed for W.S., 1661); or *The Triumphal Chariot of Antimony*, translated by Arthur Edward Waite (London: James Elliott & Co., 1893).

44. Massimo Luigi Bianchi, "The Visible and the Invisible: From Alchemy to Paracelsus," in *Alchemy and Chemistry in the XVIth and XVIIth Centuries*, Proceedings of the Warburg Colloquium, 1989, edited by Piyo Rattansi and Antonio Clericuzio (Dordrecht: Kluwer, 1994), 17–50, especially 22, citing especially Paracelsus, *Elf Traktat (Von der Wassersucht. Andere Redaktion)*, in *Theophrast von Hohenheim genannt Paracelsus Sämtliche Werke*, edited by Karl Sudhoff and W. Matthiessen, 14 vols. (Munich and Berlin: R. Oldenbourg, 1922–33), vol. 1, p. 13.

45. Jung, *Psychology and Alchemy*, translated by R.F.C. Hull (New York: Routledge, Kegan, Paul, 1953), revised edition (Princeton: Princeton University Press, 1968), 229–31, mentions the three-step sequence as well. The four colors come originally from Pliny, *Historia naturalis* xxxv.31. Another common four-color sequence is black-green-white-red. See Joachim Tancke, *Promptuarium alchemiæ*, 2 vols. (Leipzig: Henning Grossn, 1610–14), facsimile edition (Graz: Akademische Druck, 1976), vol. 2, p. 70.

46. Read, *Prelude to Chemistry, op. cit.*, fig. 11, p. 132.

47. For example, Eric John Holmyard, *Alchemy* (London: Penguin Books, 1957). Sędziwój's chart is reproduced in Read, *Prelude to Chemistry, op. cit.*, fig. 14, p. 209, from Sędziwój [Sedeimir, Sdziwjz, Sendivogius, Cosmopolite, Angelus Doce Mihi Ius, etc.], *Novum Lumen Chemicum e naturæ fonte et manuali experientia depromptum*, reprinted in *Musæum Hermeticum Reformatum et Amplificatum ... continens tractatus chimicos XXI præstantissimus* (Frankfurt: s.n., 1749 [1625]), 545–84. The treatise originally appeared as *De lapide philosophorum* in Prague in 1604, but I have not seen a copy of that edition. See *Novum Lumen Chymicum*, 2nd ed. (Paris: Apud Renatum Ruillium, 1608), and many later editions. The first English translation is *A New Light of Alchimie*, translated by J.F.M.D. (London: Richard Cotes, 1650). For further information see Zbigniew Szydło, *Water Which Does Not Wet Hands: The Alchemy of Michael Sendivogius* (Warsaw: Polish Academy of Sciences, 1994), 37; *Roman Bugaj, Michał Sędziwój (1566–1636), Życie i Pisma* (Wrocław: Ossolineum, 1968); and Josef Svatek, *Culturhistorische Bilder aus Böhmen* (Vienna: W. Braumüller, 1879).

48. On this subject see also Brian Rotman, *Ad infinitum: The Ghost in Turing's Machine, Taking God out of Mathematics and Putting the Body Back in, An Essay in Corporeal Semiotics* (Stanford: Stanford University Press, 1993).

49. Levi, *The Periodic Table*, translated by Raymond Rosenthal (New York: Schocken, 1984).

50. Robert Boyle was the beginning of this turn away from imaginative contact with elements: he critiqued the three- and four-fold classifications in favor of often undefined simple elements. For a summary of his views, see E.J. Dijksterthuis, *The Mechanization of the World Picture,* translated by C. Dikshoorn (Oxford: Clarendon Press, 1961), 433–35; and for the full anti-Paracelsan argument, Boyle, *The Sceptical Chymist* (London: J. Cadwell for J. Crooke, 1661).

51. The best source for alchemical symbols is H.C. Bolton, "Symbolism in Alchemy and Chemistry, A History of Chemical Notation," Library of Congress, MS 1218. The most thorough single primary text is the *Medicinisch-chymisch-und alchymistische Oraculum* (Ulm: s.n., 1772), reprinted (Zurich: Bibliothèque Ethnographique et Métaphysique, 1981). See also G.W. Geßmann, *Die Geheimsymbole der Alchymie, Arzneikunde und Astrologie des Mittelalters* (Ulm: Arkana, 1959).

52. See Oswald Croll [Crollius], *Basilica Chymica* (Frankfurt: Gottfried Tampachen, 1609); Nicaise le Febure, *A Compleat Body of Chymistry,* translated by P.D.C. (London: Thomas Ratcliffe, 1664); Robert Hooke, *The Diary of Robert Hooke, 1672–1680,* edited by Henry Robinson and Walter Adams (London: Taylor and Francis, 1935); Nicolas Lemery, *Cours de chymie* (Paris: Lemery, 1675); John Harris, *Lexicon Technicum* (London: Daniel Brown et al., 1704), *v.* "Characters"; and D. McKie, "Some Early Chemical Symbols," *Ambix* 1–2 (1937–46): 75–77, for the latter part of this history.

53. In the seventeenth century Salmasius suggested that the symbols derive from the names of the deities, so that the first two letters of Saturn (Κρονοσ) provide his symbol. Claudius Salmasius, *Plinianæ exercitationes* (Utrecht: J. van de Water, 1689), 872 ff.; and see Ulrich Friedrich Kopp, *Palæographia critica,* 4 vols. (Mannheim: the author, 1817–29), vol. 3, p. 341; and J.R. Partington, "Report of Discussion upon Chemical and Alchemical Symbolism," *Ambix* 1–2 (1937–46): 61–64, especially 64.

54. See the list in Partington, "Report of Discussion," *op. cit.,* 62.

55. A good place to start is nineteenth-century books on pigments, since they are most thorough and give some historical depths. See Heinrich Ludwig, *Die Technik der Oelmalerei,* 2 vols. (Leipzig: W. Engelmann, 1893), vol. 2, pp. 138–77, for a list of the pigments available in Germany in 1893; a slightly earlier list is in Friedrich Jaennicke's *Handbuch der Ölmalerei* (Stuttgart: P. Neff, 1878), 40–74.

NOTES TO CHAPTER 3

1. Emmens, Argentaurana *or Some Contributions to the History of Science* (Bristol and London: Geo. Du Boistel and Co., 1899), 32, reprinted with commentary in Truman A. Schwartz and George B. Kauffman, "Experiments in Alchemy," *Journal of Chemical Education* 53 (1976): 136–38, 235–39, especially 238. Text modified.

2. For example in *Aurifontina chymica: Or, a Collection of Fourteen Small Treatises Concerning the First Matter of Philosophers,* edited by John Frederick Houpreght (London: William Cooper, 1680).

3. A longer list, and an analysis of body metaphors, is in my *Pictures of the Body, Pain and Metamorphosis* (Stanford: Stanford University Press, forthcoming).

4. For shit and bodily fluids in the context of twentieth-century art, see also Yve-Alain Bois and Rosalind Krauss, *Formless: A User's Guide* (New York: Zone, 1997), 22, 29–31, 238, and 286 n. 10, citing Sartre's *visqueux,* in *Being and Nothingness,* translated by Hazel E. Barnes (New York: Washington Square Press, 1956), 774, 776.

5. Translation from *Secret Symbols of the Rosicrucians of the 16th and 17th Centuries,* translated by George Engelke (Chicago: Aries Press, 1935). For the original see chapter 1, n. 30.

6. The letter is dated 11 April 1995.

7. For example Eirenaeus Philalethes [George Starkey], *De metallorum metamorphosi,* in *Musæum Hermeticum Reformatum et Amplificatum ... continens tractatus chimicos XXI præstantissimus* (Frankfurt: Hermann van de Sande, 1678 [1625]), translated in *Three Tracts of the Great Medicine of the Philosophers* (London: Cosmopolita, 1694), and as "The Metamorphosis of Metals," in *The Hermetic Museum, Restored and Enlarged,* edited by Arthur Edward Waite, 2 vols. (London: Elliott and Co., 1893), vol. 2, pp. 227–45. Waite's translation has been reprinted several times, for example *The Hermetic Museum,* 2 vols. in 1 (York Beach, Maine: Samuel Weiser, 1991. See further William Newman, "The Corpuscular Transmutational theory of Eirenaeus Philalethes," in *Alchemy and Chemistry in the XVIth and XVIIth Centuries,* Proceedings of the Warburg Colloquium, 1989, edited by Piyo Rattansi and Antonio Clericuzio (Dordrecht: Kluwer, 1994), 161–82, especially 163.

8. *Die Alchimie des Geber,* edited by E. Darmstaedter (Berlin: Springer, 1922), 39.

9. Rudolf and Margot Wittkower, *Born Under Saturn: The Character and Conduct of Artists* (New York: W.W. Norton, 1963).

10. Allen G. Debus, "Renaissance Chemistry and the Work of Robert Fludd," in *Alchemy and Chemistry in the Seventeenth Century* (Los Angeles: William Andres Clark Memorial Library, 1966), 1–29, especially 17, citing Robert Fludd, *Anatomiæ ampitheatrum effigie triplici, more et conditione varia* (Frankfurt: Theodor de Bry, 1623), 20–23.

11. Cleidophorus Mystagogus, *Trifertes Sagani, Or Immortal Dissolvent* (London: W. Pearson, 1705), 11. Denis Duveen, *Bibliotheca alchemica et chemica* (London: Dawsons of Pall Mall, 1965), 139, comments "I must confess that a careful perusal of the work did not convey sense to me." Karin Figala, "Zwei Londoner Alchemisten um 1700: Sir Isaac Newton und Cleidophorus Mystagogus," *Physis* 18 (1976): 245–73, identifies Cleidophorus with a physician named W.Y. Worth.

12. *Medicinisch–chymisch–und alchymistische Oraculum* (Ulm: s.n., 1772), reprinted (Zurich: Bibliothèque Ethnographie et Métaphysique, 1981).

13. This is a reduced and simplified version of Dee's emblem, which should be studied in its full complexity. See Dee, *Monas hieroglyphica in theatrium chemicum* (Antwerp: G. Silvius, 1564); and for an example from a later century, see Francis Barrett, *The Magus; or, Celestial Intelligencer* (London: Lackington, Allen, 1801), facsimile edition (Leicester: Vance Harvey, 1970).

14. See Anton Joseph Kirchweger, attr., *Aurea catena Homeri* [1723], edited by Hermann Kopp (Braunschweig: F. Vieweg, 1880). The subject comes from a passage in Homer's *Iliad* where Zeus brags that if he let a chain down from heaven, all the other gods could not pull him down, but he could pull all of them up. For an alternate attribution of the *Aurea catena,* see Herwerd von Forchtenbrunn of Croman, Moravia, attr., *Annulus Platonis, oder, physikalisch-chymische Erklärung der Natur* [1781] (New Haven: Research Publishers, 1973).

15. Joachim Tancke, *Promptuarium alchemiæ,* 2 vols. (Leipzig: Henning Grossens, 1610–14), facsimile edition (Graz: Akademische Druck, 1976), vol. 2, pp. 298–311, especially 307.

16. Lull [Llull], *Quid sit materia lapidis,* MS, Florence, Biblioteca nazionale centrale, Pal. 792, summarized in Michela Pereira, *The Alchemical Corpus Attributed to Raymond Lull,* Warburg Institute Surveys and Texts, no. 18 (London: Warburg Institute, 1989), 68.

17. Béroalde de Verville, *Le Voyage des princes fortvnez, Oeuvre steganographique, receuilli par B.* (Paris: L. Gaultier, 1610); and his *Le Palais des Curieux* (Paris: La Veufue M. Guillemot, 1612). For further information see Neil Francis Kenny, "Béroalde de Verville: Transformations of Philosophical Writing in the Late Renaissance," Ph.D. dissertation, Oxford University, 1987, unpublished.

18. Lull, *Libellus de mercurio solo,* MS, Naples, Biblioteca nazionale, VII.D.17, summarized in Pereira, *The Alchemical Corpus, op. cit.,* 73.

19. Titus Burckhardt, *Alchemy,* translated by William Studdart (London: Vincent Stuart and John M. Watkins Ltd., 1967), reprinted (Longmead, Shaftesbury, Dorset: Element Books, 1986), 143, 146. The original is *Alchimie, Sinn und Weltbild* (Olten, Switzerland: Walter-Verlag, 1960).

20. Petra Jungmayr, *Georg von Welling (1655–1727), Studien zu Leben und Werk,* Heidelberger Studien zur Naturkunde der frühen Neuzeit, edited by Wolf-Dieter Müller-Jahncke and Joachim Telle, vol. 2 (Stuttgart: Franz Steiner, 1990), 52–59.

21. Glauber, *Glauberus concentratus, oder, Kern der Glauberischen Schrifften* (Leipzig: M. Hubert, 1715), 512, quoted in Jungmayr, *Georg von Welling, op. cit.,* 55. Glauber's bibliography is fairly confused; the 1715 edition of *Glauberus concentratus*

contains a partial reprint of a different book with the same title: *Glauberus concentratus* (Amsterdam: Johan Waesberge, 1668). See Kurt F. Gugel, *Johann Rudolph Glauber, 1604–1670, Leben und Werk* (Würzburg: Freunde Mainfrankischer Kunst und Geschichte, 1955).

22. "… die drey Anfänge ⊖ ♀ und ☿ , i.e. Schamajim, das ist △ , wie auch ▽ , nemlich das geheime ⊖ , oder das von Gott dem Allmächtigen einzig geschaffene Wesen, das da auch drey ist, in vieren offenbar worden." Georg von Welling, *YHWH: Opus Medico-Cabalisticum et Theologicum* (Frankfurt and Leipzig: Anton Heinscheidt, 1735), reprinted (Frankfurt: In der Fleischerischen Buchhandlung, 1784), 105.

23. Martin Ruland the Elder, *Lexicon alchemiæ* (Frankfurt: Zachariah Palthenius, 1612), translated by Arthur Edward Waite as *A Lexicon of Alchemy* (London: s.n., 1892), 220 ff. There is also a facsimile edition (Hildesheim: G. Olds, 1964). For entertaining lists see also Sigismund Bacstrom, *Bacstrom's Alchemical Anthology,* edited by J.W. Hamilton-Jones (London: John M. Watkins, 1960).

24. Tachenius [Fra Marc-Antonio Crassellame Chinese, pseud.], *Lux obnubilata suapte natura refulgens* (Venice: Apud Alexandrum Zatta, 1666), reprinted (Milan: Archè, 1968), III.viii. The original is in Italian, with a Latin commentary. The translation is after Peter van den Bossche, unpublished English version of the French translation, *La Lumière sortant par soi-même des ténèbres,* translated by Bruno de Lansac (Paris: Laurent d'Houry, 1687). I thank Adam McLean for drawing the French and English texts to my attention.

25. Fludd, *Philosophicall Key* (unpublished MS), discussed in Allen G. Debus, *Robert Fludd and his Philosophicall Key* (New York: Science History Publishers, 1979); and see Norma E. Emerton, "Creation in the Thought of J.B. van Helmont and Robert Fludd," in *Alchemy and Chemistry in the XVIth and XVIIth Centuries, op. cit.,* pp. 85–102.

26. "Era dal Nulla uscito / Il tenebroso Chaos, Maßa difforme / Al primo suon d'Onnipotente Labro: / Parea, che partorito / Il Disordin l'havesse, anzì, che Fabro / Stato ne fosse un Dio; tàto era informe." Tachenius, *Lux obnubilata, op. cit.,* I.i.

27. Panopolis is modern Akhmim, in Upper Egypt. The quotation is from F.S. Taylor, "The Visions of Zosimos," *Ambix* 1–2 (1937–46): 88–92, especially 89 (translation modified); and see Marcelin Berthelot and Charles Ruelle, *Collection des anciens alchimistes grecs,* 3 vols. (Paris: Steinheil, 1887–88), vol. 3, pp. 107–112, 115–18; Michele Mertens, "Project for a New Edition of Zosimus of Panopolis," in *Alchemy Revisited, Proceedings of the International Conference on the History of Alchemy at the University of Groningen,* edited by Z.R.W.M. von Martels. Collection de Travaux de l'Académie Internationale d'Histoire des Sciences, edited by John D. North, vol. 33. (Leiden: E.J. Brill: 1990), 121–26l and, most recently, *Les alchimistes grecs,* edited by Robert Halleux (Paris: Belles Lettres, 1981–95), vol. 4, part 1, *Zosime de Panopolis: mémoires authen-*

tiques, edited and translated by Michele Mertens. The modern interest in Zosimos dates from Jung; see his "Die Visionen des Zosimos," *Eranos-Jahrbuch* 5 (1937): 15–54.

28. For the interpretation, see Berthelot and Ruelle, *Collection des anciens alchimistes grecs, op. cit.,* vol. 3, p. 118, n. 3.

29. The following description is William Newman's version of a recipe in Robert Halleux, *Les alchimistes grecs, op. cit.,* vol. 1, p. 181, n. 4 (personal communication, 1991).

30. These are recommended by Schwartz and Kauffman, "Experiments in Alchemy," *op. cit.,* 236, who use 10 g each of sulfur and CaO or Ca(OH)$_2$ and 150 ml of water, heated for about 15 minutes.

31. Quoted in François Le Targat, *Kandinsky* (New York: Rizzoli, 1987), 9.

32. For general thoughts on the physicality of the horizontal format, see Rosalind Krauss, *The Optical Unconscious* (Cambridge, MA: MIT Press, 1993), chapter 6.

33. This aspect of the paintings is analyzed in more detail in my *Pictures of the Body, op. cit.,* chapter 1.

34. Stella, *Working Space* (Cambridge, MA: Harvard University Press, 1986). The claims Stella makes are also discussed in my "Abstraction's Sense of History: Frank Stella's *Working Space* Revisited," *American Art* 7 no. 1 (winter 1993): 28–39, revised in *Streams into Sand: Links between Renaissance and Modern Painting,* with a commentary by Loren Partridge (New York: Gordon and Breach, forthcoming).

35. A theory of pictorial chaos is advanced in my *Pictures, and the Words that Fail Them* (Cambridge: Cambridge University Press, forthcoming).

36. Said, *Beginnings, Intention and Method* (Baltimore: Johns Hopkins University Press, 1978).

NOTES TO CHAPTER 4

1. Titus Burckhardt, *Alchemy,* translated by William Studdart (London: Vincent Stuart and John M. Watkins Ltd., 1967), reprinted (Longmead, Shaftesbury, Dorset: Element Books, 1986), 139. The original is Burckhardt, *Alchimie, Sinn und Weltbild* (Olten, Switzerland: Walter-Verlag, 1960).

2. There is some truth to this: for actual techniques of gold extraction, see Orson Cutler Shepard and Walter Dietrich, *Fire Assaying* (New York: McGraw-Hill, 1940); and C.W. Ammen, *Recovery and Refining of Precious Metals* (New York: Van Nostrand Reinhold, 1984).

3. Mircea Eliade, *Forgerons et alchimistes* (Paris: Flammarion, 1956), translated by Stephen Corrin as *The Forge and the Crucible: The Origins and Structure of Alchemy* (New York: Harper and Row, 1971).

4. *Die Alchemie des Andreas Libavius,* edited by the Gmelin-Institut für Anorganische Chemie und Grenzgebiete in der Max-Planck-Gesellschaft zur Forderung der Wissenschaft, in Verbindung mit der Gesellschaft Deutscher Chemiker, Frankfurt am Main (Weinheim: Verlag Chimie, 1964), Trakt 1, Kap. L[XLIX], p. 315.

5. *Marius: On the Elements,* edited by R.C. Dales (Berkeley: University of California Press, 1976), 152–53.

6. For example Paracelsus, *Liber metallorum,* in *Theophrast von Hohenheim genannt Paracelsus Sämtliche Werke,* edited by Karl Sudhoff and W. Matthiessen, 14 vols. (Munich and Berlin: R. Oldenbourg, 1922–33), vol. 13, pp. 134–37: "ignis, sal, und balsamis [mercury]." This is cited in Massimo Luigi Bianchi, "The Visible and the Invisible: From Alchemy to Paracelsus," *Alchemy and Chemistry in the XVIth and XVIIth Centuries,* Proceedings of the Warburg Colloquium, 1989, edited by in Piyo Rattansi and Antonio Clericuzio (Dordrecht: Kluwer, 1994), 17–50, especially 39 n. 41.

7. *Die Alchimie des Andreas Libavius, op. cit.,* Trakt 1, Kap. L[XLIX], p. 315.

8. Burckhardt, *Alchemy, op. cit.* (English edition), 144–45.

9. Edward Whitmont, "Non-Causality as a Unifying Principle of Psychosomatics-Sulphur," *Io* 31 (1983): 190, quoting Jung, "De sulfure," lecture before the Swiss Paracelsus Society, 21 December 1947, privately printed, n.p.

10. Jon Eklund, *The Incompleat Chymist, Being an Essay on the Eighteenth-Century Chemist in his Laboratory, With a Dictionary of Obsolete Chemical Terms of the Period,* Smithsonian Studies in History and Technology, no. 33 (Washington, DC: Smithsonian Institution, 1975), 38. After the mid-eighteenth century salt began to be defined as a chemical process, the product of reactions between acids and bases. That meaning is not the central one in alchemy.

11. Blaise de Vigenère, *Traicté du feu et du sel,* 2nd ed. (Paris: Chez Jacques Cailloue, 1642), 241. The first edition was 1608; there is also an English translation, *A Discovery of Fire and Salt* (London: Richard Cotes, 1649). Another important treatise is "Son of Sendivogius" [pseud. for Michał Sędziwój = Sendivogius], *Der Verlangete Dritte Anfang der mineralischen Dinge, oder vom philosophischen Saltz* (Amsterdam: Christoffel Luycken, 1656); for the attribution see Zbigniew Szydło, *Water Which Does Not Wet Hands: The Alchemy of Michael Sendivogius* (Warsaw: Polish Academy of Sciences, 1994), 145–55, Appendices C and H.

12. *Die Alchimie des Andreas Libavius, op. cit.,* Trakt 1, Kap. L[XLIX], p. 315.

13. Paracelsus, *De mineralibus,* in *Theophrast von Hohenheim, op. cit.,* vol. 3, p. 47, calls salt "balsam": "sal . . . , das auch balsamum heißt." See Bianchi, "The Visible and the Invisible," *op. cit.,* 39 n. 43.

14. It is visible in a photograph in Thomas Perkins, *Churches of Rouen* (London: George Bell and Sons, 1900).

15. Steven Z. Levine, *Monet, Narcissus, and Self-Reflection: The Modernist Myth of the Self* (Chicago: University of Chicago Press, 1994), 168.

16. Abtala [Abdullah] Jurain [Aklila Warckadamison], *Hyle und Coahyl; Aus dem Aethiopischen ins Lateinische, und aus dem Lateinischen in das teutsche translatiret und übergesetzet durch D. Johann Elias Muller* (Hamburg, 1732), chapter IX, translation modified from Jung, *Psychology and Alchemy* (Princeton: Princeton University Press, 1980 [1968]), 246–47.

17. *Archidoxorum Aureoli Ph. Theophrasti Paracelsus de secretis naturæ mysteriis libri decem* (Basel: P. Pernam, 1570), lib. vi. There is also a seventeenth-century translation: Paracelsus, *Archidoxis, Comprised in Ten Books,* translated by John Harding (London: Thomas Brewster, 1660).

18. Constantine of Pisa, *Liber seretorum alchimie,* c. 1257, translated as *The Book of the Secrets of Alchemy,* edited by Barbara Obrist (Leiden: E.J. Brill, 1990), 73. Translation mine except the last line, which is from *ibid.,* 235. See also Khalid, *Liver trium verborum,* in *Artis auriferæ, quam chemiam vocant,* 3 vols. in 1 (Basel: Conrad Waldkirch, 1610), p. 229.

19. The list is from Matthew Moncrieff Pattison Muir, *A History of Chemical Theories and Laws* (New York: Arno, 1975), 20.

20. Jean Chretien Ferdinand Hoefer, *Histoire de la chimie,* 2 vols. (Paris: Bureau de la revue scientifique, 1842–43), vol. 2, p. 398.

21. Jean-Paul Marat, *Recherches physiques sur le feu* (Paris: Cl. Ant. Jombert, 1780).

22. Marcelin Berthelot, *Les Origines de l'alchimie* (Paris: Steinheil, 1885), 267–68; and Pattison Muir, *History of Chemical Theories, op. cit.,* 10 and n. 1.

23. Pattison, Muir, *History of Chemical Theories, op. cit.,* 6, 9.

24. Jungius, *Zwei Disputationen über die Prinzipien der Naturkörper,* translated by Emil Wohlwill (Hamburg: Hartung, 1928); Boyle, *The Sceptical Chymist* (London: J. Cadwell for J. Crooke, 1661). The original of Jungius's book is *Disputationem de principiis naturalium* (Hamburg: Heinrich Werner, 1642).

25. Vladimír Karpenko, "The Discovery of Supposed New Elements: Two Centuries of Errors," *Ambix* 27 no. 2 (1980): 79–102.

26. Khunrath, *Naturgemes-Alchymisch Symbolum, order, gahr kurtze Bekentnus* (Hamburg: Heinrich Binders Erben, durch Philip von Ohr, 1598), 6. For Khunrath see Christian Gottlob Joecher, *Allgemeines Gelehrten-Lexicon,* 7 vols. (Hildesheim: Georg Olm, 1960 [1750–51]), vol. 2, pp. 2081–82.

27. Josten, "William Backhouse of Swallowfield," *Ambix* 4 no. 1 (1949): 1–33, especially 9.

28. Josten, "A Translation of John Dee's 'Monas Hieroglyphica' (Antwerp, 1564),

With an Introduction and Annotations," *Ambix* 12 nos. 2–3 (1964): 84–221, especially 160–61.

29. An example is analyzed in my *Pictures of the Body* (Stanford: Stanford University Press, forthcoming).

30. "... vous tirerez vne eau du plus beau jaune du monde." The recipe is from Joseph Du Chesne [Josephus Quercetanus, Joseph Du Chesne, Sieur de la Violette], *Recueil des plus curieux et rares secrets touchant la medicine metallique et minerale* (Paris: Simeon Piget, [1648]), 63–65; translated as *Metallic and Mineral Medicines,* in the series Restorers of Alchemical Manuscripts Society, edited by Hans Nintzel (Richardson, Texas: Self-published, 1986), 14.

NOTES TO CHAPTER 5

1. Helena Maria Elisabeth de Jong, *Atalanta Fugiens: Sources of an Alchemical Book of Emblems* (Leiden: E.J. Brill, 1969), 206. The *Duenech Allegory* appears in the *Theatrum chemicum,* 4 vols. (Ursel, 1602), vol. 3, pp. 756–57.

2. *Duenech Allegory,* as translated in de Jong, *Atalanta Fugiens, op. cit.,* 211.

3. See for instance John French, *The Art of Distillation: Or, A Treatise of the Choicest Spagyrical Preparations Performed by way of Distillation* (London: Richard Cotes, 1651); Philip Ulstadt, *Coelvm Philosophorvm sev de Descretis naturæ* (Strassburg: Johann Grüninger, 1528); Giambattista della Porta, *De distillatione lib. x* (Rome: Ex Typographia Reu. Cameræ Apostolicæ, 1608); and M. Déjean, *Traité raisonné de la distillation, ou, La distillation réduite en principes,* 4th ed. (Paris: Chez Bailly, 1777).

4. Nicholas Tiho Mirov, *Composition of Gum Turpentine of Pines* (Washington, DC: Department of Agriculture, 1961).

5. For more on plant alchemy, see Manfred Junius, *Praktisches Handbuch der Pflantzen-Alchemie* (Interlaken, Switzerland, 1982), 171–218, discussing Baro Urbigerus, *Aphorismi Urbigerani, Or Certain Rules ... To Which Are Added, Three Ways of Preparing the Vegetable Elixir or Circulatum minus ...* (London: Henry Fairborne, 1690). The translation is Urbigerus's own; he also published the book in German (Erfurt: Johann Caspar Birckner, 1691); Junius's book appeared in English as *A Practical Handbook of Plant Alchemy,* translated by Leone Muller (New York: Inner Traditions International, Ltd., 1985), and also (Rochester, VT: Healing Arts Press, 1993).

6. This recipe is given in George Ripley, *Bosome-Book* (15th c.) in *Collectanea Chemica,* edited by Christopher Love Morley and Theodorus Muykens (London: William Cooper, 1684), 101–24. *Collectanea chemica* also appeared as *Collectanea chimica leydensia* (Leiden and Frankfurt, 1693); it was reprinted, with abridgements and additions, as *Collectanea chymica, Being certain Select Treatises on Alchemy and*

Hermetic Medicine (London: J. Elliott and Co., 1893), which was in turn reprinted several times, for example (Edmonds, WA: Alchemical Press, 1991). The practical procedure is by Lawrence Principe (personal communication, 1991).

It takes a day and requires:

> lead oxide, PbO 8 g.
> glacial acetic acid, CH_3CO_2H 50 ml
> potassium nitrate, KNO_3 12.5 g.

"Take 50 g. of lead oxide ... and pour over it 50 ml of water and 50 ml of glacial acetic acid. Stir or swirl occasionally until all (or nearly all) the oxide is dissolved (the flask will grow hot as dissolution occurs; note how Ripley says 'when cold again' in the first paragraph). Decant the clear solution into an evaporating dish and evaporate the solvent at a very gentle boil. When the syrupy liquid begins to crystallize, stir it with a glass rod, remove the heat, and continue stirring until cold. This salt is Ripley's Green Lion; green not in color, but, as he writes in another text, because it is immature and 'unripe.'

"Place the salt in a distilling flask, set it in a heating mantle or sand bath on a hot plate, stopper the flask, insert the side arm into a condenser, and place a receiver on the end of the condenser. (By no means seal the apparatus as Ripley advises, pressure release must be allowed as heating proceeds.) Heat the salt; it will first melt into a boiling liquid, white fumes will be evolved which condense into a clear liquid in the receiver, and then, in a moment, the liquid solidifies and rises in the flask to thrice its former volume, producing a white 'biscuit.'

"Continue heating another twenty minutes (until the 'biscuit' dries out), then carefully open the flask, and, using a long glass rod, pushing it down to the bottom of the flask again. Restopper the flask, and continue heating until the material in the flask is black. The receiver contains the 'blessed liquor,' a strongly smelling volatile liquid, predominantly acetone and water. (If desired, a careful distillation of the 'blessed liquor' from a steam bath will provide Ripley's 'fragrant ardent water' which is purified acetone.)

"When the flask has cooled, take out the black residue, spread it out (about one-quarter inch thick) on a brick or pane of glass, and place a small fragment of glowing charcoal on it. The powder will burn like a cinder, turning yellow, red, and orange. (The black residue can often be started with a match.)

"Note: lead salts are toxic. Use special care in working with the white salt. Ignite the black residue only with very good ventilation; lead fumes are produced in its burn-

ing. Also, keep an eye on the various appearances (color and texture) as the process develops. These wide variations must have impressed Ripley."

7. For variations, see Marcelin Berthelot and Charles Ruelle, *Collection des anciens alchimistes grecs,* 3 vols. (Paris: Steinheil, 1887–88), vol. 1, pp. 144–49. For a Greek formula calling for a kerotakis, see Robert Halleux, *Les alchimistes grecs* (Paris: Belles Lettres, 1981), vol. 1, p. 120 § 31. Berthelot's analyses should be treated with circumspection; see Edmund Oskar von Lippmann, *Entstehung und Ausbreitung der Alchemie,* 3 vols. (Berlin, J. Springer, 1919–54), vol. 1 (1932), pp. 647–59; and Robert Halleux, *Les Textes alchimiques,* Typologie des Sources du Moyen Âge Occidental, fascicle 32, edited by L. Genicot (Turnhout, Belgium: Brepols, 1979), especially 53–54.

8. César Isidore Henri Cros, *L'Encaustique et les autres procédés de peinture chez les anciens, histoire et technique* (Paris: Librairie de l'Art, 1884), reprinted (Puteaux: EREC, 1988), includes ancient artists' tools.

9. Beckett, *Molloy, Malone Dies, The Unnamable* (London: Calder, 1994), 418.

10. Junius, *Praktisches Handbuch, op. cit.,* 172.

11. Max Doerner, *The Materials of the Artist, And their Use in Painting with Notes on the Techniques of the Old Masters,* translated by Eugen Neuhaus (New York: Harcourt, Brace, and Company, 1934), 346. Doerner's book first appeared as *Malmaterial und seine Verwendung im Bilde, Nach den Vortragen an der Akademie der bildenden Kunste im München* (Munich: Verlag für Praktische Kunstwissenschaft, 1921), and was revised at least nine times; the ninth edition is (Stuttgart: F. Enke, 1949).

12. Matthew MacKaile, *The Oyly-Well; or, a topographico-spagyricall Description of the Oyly-Well at St. Cathrinis-chappel, in the paroch of Libberton* (Edinburgh: Robert Brown, 1664).

13. This summary is based in part on Allison Coudert, *Alchemy: The Philosopher's Stone* (London: Wildwood House, 1980), 44 ff., following the list of twelve processes given by Antoine-Joseph Pernety, *Dictionnaire mytho-hermétique* (Paris: s.n., 1758).

14. Cleidophorus Mystagogus, *Trifertes Sagani, Or Immortal Dissolvent* (London: W. Pearson, 1705), 21.

15. Preface to Richard Ingalese, *They Made the Philosopher's Stone ... with an introduction by Frater Albertus* (Salt Lake City: Para[celsus] Publishing Co., 1973), 2.

16. Artephius, *Artephius Arabis philosophi Liber Secretus: nec non Saturni Trismegisti, sive Fratri Helix de Assisio libellus,* 2nd ed. (Frankfurt: Apud. Iennisium Francofurti, 1685 [1678]), 16: "Nam in ipsa aqua corpus ex duobus corporibus solis, & lunæ, fit ut infletur, tumeat, ingossetur, elevetur, & crescat accipiendo substantiam, & naturam animatam, & vegetabilem." Artephius's *Liber secretus* appeared in English as "The Secret Books of Artephius," in *Nicolas Flamel, His Exposition of the*

Hieroglyphicall Figures ... , translated by Eirenæus Orandus (London: T.S. for Thomas Walsley, 1624).

17. This recipe was recommended by William Newman (personal communication, 1991). It can be done in an afternoon. (The symbols are mine.)

Make an amalgam \overline{aaa}, without heat, of 16 g of leaf ☽ with 8 g of ☿. Dissolve the \overline{aaa} in 100 ml, or a sufficient quantity of pure nitric acid ▽ of moderate strength; dilute this solution in about a pound and a half of distilled water; agitate the mixture, and preserve it for use in a glass bottle with a ground stopper.

"When this preparation is to be used, the quanitity of one ounce is put into a phial, and the size of a pea of \overline{aaa} of ☉ or ☽, as soft as butter, is to be added; after which the vessel must be left at rest. Soon afterwards small filaments appear to issue out of the ball of \overline{aaa} which quickly increase, and shoot out branches in the form of shrubs.

"For elective affinity I have my students read Query 31 of Newton's *Optics*."

To view the silver tree, it is best to have binocular dissecting microscopes with strong illumination. The dentritic forms and "leaves" then show up to great effect. It should be possible to watch the "tree of Diana" growing under the microscope, though I have not been able to do so. A fume hood should be used if the reaction is still proceeding.

When the solution of nitric acid is too strong, the reaction will proceed too quickly for the formation of trees. A strong solution and a copper leaf, for example, will produce immediate profusion of bubbles and a fuzzy coating. Such a demonstration makes an instructive contrast to the "organic" growth of the silver tree.

For those with a home chemistry set, similar results can be obtained by mixing sodium silicate and water, and then adding small quantities of aluminum sulfate, ammonium sulfate, cobalt chloride, ferric ammonium sulfate, ferrous ammonium sulfate, or nickel ammonium sulfate. Each of them makes a differently colored tree. There are also gold trees; see French, *The Art of Distillation, op. cit.,* book 6.

18. For more terms see Jon Eklund, *The Incompleat Chymist, Being an Essay on the Eighteenth-Century Chemist in his Laboratory, With a Dictionary of Obsolete Chemical Terms of the Period,* Smithsonian Studies in History and Technology, no. 33 (Washington, DC: Smithsonian Institution, 1975).

19. Basil Valentine, *Fratris Basilii Valentini Benedicter Ordens Geheime Bücher oder letztes Testament. Vom grossen Stein der Uralten Weisen und anderen verborgenen Geheimnussen der Natur* (Strassburg: Caspar Deitzel, 1645). This appeared in English as *The Last Will and Testament of Basil Valentine,* translated by John Webster (London: S.G. and B.G. for Edward Brewster, 1670), reprinted in 2 vols. (Hildesheim: Dr. H.A. Gerstenberg, 1976), see vol. 1, 321–23.

20. Martine Noalhyt, "D'Une Homologie rélative entre alchimie et grande cuisine au XVIIeme siècle en France," Ph.D. dissertation (Nouveau Doctorat), Université de Paris 5, 1992, unpublished.

21. Charles Mackay, *Extraordinary Popular Delusions and the Madness of Crowds* (s.l.: L.C. Page & Company, 1932), 130. The book originally appeared as *Memoirs of Extraordinary Popular Delusions,* 2 vols. (London: Richard Bentley, 1841).

22. This recipe is attributed to Theophilus the Monk (12th c.). See John Maxson Stillman, *The Story of Alchemy and Early Chemistry* (New York: Dover, 1960), 229–29; and Michel Caron and Serge Hutin, *Les alchimistes* (Paris: Seuil, 1959), in English as *The Alchemists,* translated by Helen R. Lane (New York: Grove Press, 1961), 150–52. The text here is from Truman Schwartz and G. Kauffman, "Experiments in Alchemy," *Journal of Chemical Education* 53 (1976): 136–38, 235–39, especially 239.

NOTES TO CHAPTER 6

1. Gilot and Carlton Lake, *Life with Picasso* (New York: Signet, 1964), 194.

2. Johann Schröder, *The Compleat Chymical Dispensatory, in Five Books,* translated by William Rowland (London: John Darby, 1669), 517–22; the original edition, Schröder, *Medico-Chymica. Sive Thesaurus Phramecologicus* (Ulmæ Suevorum: Johannis Görlini, 1662), 287–99, has a list of symbols. Elk recipes are discussed in my *Things and their Places: The Concept of Installation from Prehistoric Tombs to Contemporary Art,* work in progress.

3. Cleidophorus Mystagogus, *Trifertes Sagani, Or Immortal Dissolvent* (London: W. Pearson, 1705).

4. Allison Coudert, *Alchemy: The Philosopher's Stone* (London: Wildwood House, 1980), 131. She also mentions Pliny, *Historia naturalis,* for prescriptions of boys' urine.

5. Hans-Joachim Romswinkel, "'De Sanguine Humano Destillato,' Medizinisch-alchemistische Texte des 14. Jahrhunderts über destilliertes Menschenblut," Ph.D. dissertation, Rheinischen Friedrich-Wilhelms-Universität Bonn (Bonn: Horst Wellm, 1974).

6. Paracelsus's recipe is cited in Alessandro Olivieri, "L'homunculus di Paracelso," *Atti della Reale Accademia di Archaeologia, Lettere e Belli Arti,* Naples n. s. 12 (1931–32): 375–97, especially 378; and see Edmund Oskar von Lippmann, *Der Stein der Weisen und Homunculus,* Beiträge zur Geschichte der Naturwissenschaft und der Technik (Berlin: J. Springer, 1923). Paracelsus describes several species of homunculus. One is the product of sodomy; another is the "alreola" or "mandragora." Paracelsus, *De vita longa,* fol. 63b. [in Olivieri, "L'homunculus," op. cit., 379–80.]

7. The recipe follows an English edition: Tügel, *Experimental Chemistry* (1766), translated by Sigismund Bacstrom (1798), in the series Restorers of Alchemical

Manuscripts Society, edited by Hans Nintzel (Richardson, Texas: n.d. [c. 1985]), 18–21. I have been unable to trace the original.

8. *Le triomphe hermetique,* quoted in Jacques van Lennep, *L'Art et l'alchimie: Étude de l'iconographie Hermetique et ses influences* (Brussels: Éditions Meddens, 1966), 25.

9. Maier, *Atalanta fugiens* (Oppenheim: Hieronheim Galler, 1617), facsimile edition (Kassel: Bärenreiter, 1964), emblem IV, p. 25.

10. *Ænigmata ex Visio arislei,* in *Artis auriferæ, quam chemiam vocant,* 3 vols. (Basel: Conrad Waldkirch, 1610 [1572]), vol. 1, pp. 94–98 (pp. 146–54 in the 1572 edition). Arislæus or Arisleus is the pseudonymous name of the author of the *Turba philosophorum,* in *Ibid.,* [1610], vol. 1, pp. 1–42. See further Julius Ruska, "Die Vision des Arisleus," in *Historische Studien und Skizzen zur Natur- und Heilwissenschaft,* edited by Karl Sudhoff (Berlin: J. Springer, 1930).

11. The first published example is 1572. See Incertus author, *Liber de arte chymica,* in *Artis auriferæ, op. cit.,* [1610], vol. 1, pp. 369 ff. (p. 391 ff. in the 1572 edition).

12. James Saslow, *Ganymede in the Renaissance: Homosexuality in Art and Society* (New Haven: Yale University Press, 1988).

13. Welling, *YHWH: Opus Medico-Cabalisticum et Theologicum* (Frankfurt: In der Fleischerischen Buchhandlung, 1784), 6, 38, 31, quoted in Petra Jungmayr, *Georg von Welling (1655–1727), Studien zu Leben und Werk,* Heidelberger Studien zur Natur-kunde der frühen Neuzeit, edited by Wolf-Dieter Müller-Jahncke and Joachim Telle, vol. 2 (Stuttgart: Franz Steiner, 1990), 57.

14. Khunrath, *Ampitheatrum Sapientiæ Æternæ, Solius Veræ* (Hamburg: s.n., 1595), quotation as in Khunrath, *The Ampitheatre Engravings of Heinrich Khunrath,* translated by Patricia Tahil, edited by Adam McLean (Edinburgh: Magnum Opus Hermetic Sourceworks, 1981), 36.

15. Karl Kerényi, *Hermes der Seelenführer,* Albæ Vigilæ no. 1 (Zurich: Rhein-Verlag, 1944); the English translation is *Hermes, Guide of Souls: The Mythologem of the Masculine Source of Life,* translated by Murray Stein (Zurich: Spring Publishers, 1976), 9.

16. *Geheime Figuren der Rosenkreuzer* (Altona: J.D.A. Eckhardt, 1785 [–1788]), n.p.

17. See Sophocles, *Œdipus Rex* V.955ff.

18. Maier, *Atalanta fugiens, op. cit.,* 166–67.

19. Maier, *Arcana arcanissima, hoc est Hieroglyphica Aegyptio-Græca* ([Oppenheim]: s.n., 1614).

20. This is not a "mistake" on Maier's part; see Coudert, *Alchemy, op. cit.,* 139.

21. John Boswell, *The Kindness of Strangers: The Abandonment of Children in Western Europe from Late Antiquity to the Renaissance* (New York: Pantheon, 1988), 76 n. 77.

22. Helena Maria Elisabeth de Jong, *Atalanta Fugiens: Sources of an Alchemical Book of Emblems* (Leiden: E.J. Brill, 1969), 258, translation modified; Latin from Maier, *Atalanta fugiens,* 2nd ed. (Oppenheim: Hieronymus Galler, 1618), 167.

23. Freud, *Gesammelte Werke* (Frankfurt: S. Fischer, 1940–), vols. 2–3, p. 270; vol. 9, p. 100; vol. 14, pp. 166–67.

24. *Das Neu erleuchteten Mosqueteurs Vierfache Stumme Rede-Kunst des Fermontischen Steines Nach der arth der Vier Elementen Vermittelst die Vier Vnheilbahren Krackheiten, nach der Vierfachen Jnfluenz des Himmels, als da ist Die Gravitetische Wasser-Sucht, Das Ehrbahre Podagra, die geschminckten Frantzosen, vnd gepuderte Pestilentz Mit verleihung der Gnaden Gottes, durch den Lapidem Fermonticum sambt denen Arcanibus Specificis vel Magneticis, auf vierfache Arth konnen geheÿlet, vnd gewendet werden.* 18th century. Glasgow University, Ferguson MS 11, n.p.

25. Wallich, *I. Das Mineralische Gluten, Doppelter Schlangen-Stab . . . , II. Der Philosophische Perl-Baum . . . ,* [and] *III. Schlüssel zu dem Cabinet der geheimen Schatz-Kammer der Natur* (Frankfurt and Leipzig: Georg Christoph Wintzer, 1722), 10: "Nimm von diesem Mann, wenn er schläfft, sein Weib, seine Riebe, distillire das flüchtige Weib, das gifftige ☿al Wasser von ihm."

26. Johann Grasshoff [Chortolassæus, Grasshoffer, Grossæus, Condeesyanus, Crasseus], *Arcæ arcani artificiosissimi de summis naturæ mysteriis,* in *Theatrum chemicum,* 6 vols. (Strassburg: E. Zetzner, 1659–61 [1602]), vol. 6, p. 294 ff., especially 305.

27. See further Israel Regardie, *The Tree of Life* (Wellingborough: Aquarian Press, 1969); Regardie, *The Philosopher's Stone* (Saint Paul, MN: Llewellyn Publications, 1978).

28. The Sanskrit word is *harabija,* literally the "creative seed" of Shiva. I thank Steven Feite for this information.

29. Antoine-Joseph Pernety, *Dictionnaire mytho-hermétique* (Paris: s.n., 1758), *v.* "nature," 320.

30. Culling, *Sex Magick* (St. Paul, MN: Llewellyn Publications, 1989), 57 and 60; and see his *The Complete Magick Curriculum of the Secret Order G:.B:.G* (St. Paul, MN: Llewellyn Publications, 1969).

31. Peter Redgrove, *The Black Goddess and the Unseen Real* (New York: Grove Press, 1987), 200 n. 86.

32. *Ibid.,* 144.

33. For the mixture of doctrines, see Culling, *Sex Magick, op. cit.*

34. Helmut Gebelein, *Alchimie* (Munich: Diederichs, 1991), 32, 368, 371.

NOTES TO CHAPTER 7

1. Johann Conrad Barchusen [Barckausen], *Elementa chemiæ* (Leiden: Theodorum Haak, 1718), which may derive from *The Crowne of Nature or the doctrine of the souereigne medecene declared in 67 Hieroglyphycall figurs by a namlesse Author,* MS, second half of the 16th c. New York, Sidney M. Edelstein Foundation Library. On Barchusen see O. Hannaway, "Johann Conrad Barchusen (1666–1723)—Contemporary and Rival of Boerhaave," *Ambix* 19 no. 2 (1967): 96–111; and on the MS, Johannes Fabricius, Alchemy: the Medieval Alchemists and their Royal Art (Copenhagen: Rosenkilde and Bagger, 1976), 216, n. 1 to page 17.

2. Falloppio, *Neu eröffnete vortreffliche und rare Geheimnüsse der Natur ... Geheimnüssen aus der Chymia* (Frankfurt: Henning Grossens, 1690), 277.

3. See Conrad Hermann Josten, "A Translation of John Dee's 'Monas Hieroglyphica' (Antwerp, 1564), With an Introduction and Annotations," *Ambix* 12 nos. 2–3 (1964): 84–221. Gershom Scholem apparently found the passage illegible, as have other editors; see for instance Dee, *La Monade hiéroglyphique,* translated by Grillot de Givry (Milan: Archè, 1975), 47 n. 2: "Dee a violé ici le secret du grand œuvre dans une assez mauvaise phrase hébraïque qui ... est devenue à peu près illisible."

4. Cennini, *The Book of the Art of Cennino Cennini,* translated by Christiana J. Herringham (London: Allen and Unwin, 1930 [1899]); and Daniel Thompson, *The Practice of Tempera Painting* (New Haven: Yale University Press, 1936).

5. This subject is pursued in my book *Our Beautiful, Dry, and Distant Texts: Art History as Writing* (University Park, PA: Pennsylvania State University Press, 1997).

6. Doerner, *The Materials of the Artist, And their Use in Painting with Notes on the Techniques of the Old Masters,* translated by Eugen Neuhaus (New York: Harcourt, Brace, and Company, 1934), 344–48.

7. Max Liebermann, *Die Phantasie in der Malerei, Schriften und Reden,* edited by Günter Busch (Frankfurt: S. Fischer, 1978 [1916]), 60. The passage is also quoted in Lorenz Dittmann, "Prinzipien der Farbgestaltung in der Malerei des 19. Jahrhunderts im Hinblick auf die künstlerichen Techniken," in *Das 19. Jahrhundert und die Restaurierung,* edited by Heinz Althöfer (Munich: Georg D.W. Callwey, 1987), 76–87, especially 76.

8. Hollandus, *Defs weit und breit berühmten Johannis Isaaci Hollandi ... Die Hand der Philosophen* (Frankfurt: In Verlegung Thomæ Matthiæ Gotzens, 1667). In some versions, the fish, the dirt, and the hand become a kind of *tria prima,* a set of esoteric first principles. See also Oswald Croll, *D.O.M.A.... Chymisch Kleynod* (Frankfurt: Gottfried Schonwetter, 1647), 68–74; and Justus Simplicius Hortulanus, *Die Philosophische Hand, das ist: Wahre und gründliche Philosophische Hand-Leitung zu dem berühmten und hochgepreisenen Stein der Weisen* (Leipzig, 1719). Croll's *D.O.M.A.*

was originally published as *Basilica Chymica* (Frankfurt: Gottfried Tampachen, 1609).

9. For a history of the idea that the alchemical work comprises twelve steps, see Hermann Kopp, *Die Alchemie in älterer und neuerer Zeit,* 2 vols. (Hildesheim: G. Olm, 1971 [1886]), vol. 2, p. 9 ff.

10. Wallich, *I. Das Mineralische Gluten, Doppelter Schlangen-Stab . . . , II. Der Philosophische Perl-Baum . . . ,* and *III. Schlüssel zu dem Cabinet der geheimen Schatz-Kammer der Natur* (Frankfurt and Leipzig: Georg Christoph Wintzer, 1722), 19.

NOTES TO CHAPTER 8

1. The procedure to make the stellated regulus of Mars (metallic antimony) is adumbrated in Michael Maier, *Atalanta fugiens* (Oppenheim: Hieronymus Galler, 1617), emblem II; by Isaac Newton (c. 1675), reported in Betty Jo Teeter Dobbs, *Foundations of Netwton's Alchemy; or, The Hunting of the Greene Lyon* (London and New York: Cambridge University Press, 1975), 251–53; and by Eirenæus Philalethes [George Starkey], *Brevis manuductio ad rubinum cœlestum,* in *Musæum Hermeticum Reformatum et Amplificatum,* edited by Hermann van de Sande (Frankfurt: Hermann van de Sande, 1677), 647–99, translated as "A Brief Guide to the Celestial Ruby," in *The Hermetic Museum,* translated by Arthur Edward Waite (London: Watkins Books, 1953 [1893]), vol. 2, pp. 246–60. The practical procedure is by Lawrence Principe (personal communication, 1991); and I thank Anthony M. House for further discussion.

It takes a day and requires:

> iron, nails 8 g.
> antimony trisulphide, Sb_2S_3 18 g.
> potassium nitrate, KNO_3 12.5 g.

"Place 8 g. of iron . . . in a crucible. Cover, and heat with a Fisher Burner until red-hot. Then introduce, in approximately 2 g. portions, 18 g. of antimony trisulphide. Cover the crucible after each addition, and allow the trisulphide to melt before each subsequent addition. After all 18 g. are added and melted, use a long glass or iron rod to stir the pasty mixture as well as possible (a considerable lumpy mass of unreacted iron nails will remain at this point).

"Then cautiously add 6 g. potassium nitrate in about 1 g. portions. Operate carefully, on each addition of postassium nitrate, there will be a strong deflagaration—lift off the crucible lid a little with tongs, and cast in the portion of nitrate quickly all at once, and close the lid immediately, When each deflagaration is finished, add the next portion.

"After all the nitrate has been added, stir the mixture well, and heat the crucible

(covered) strongly for seven or eight minutes. Stir once gently, and then pour out the contents into another crucible. Much viscous material will remain in the melting crucible, but the easily liquid molten antimony should pour out into the other crucible fairly easily. If the crucible containing the scoriae is soaked in water for a few hours, most of the unwanted material dissolves or softens, and often a few additional buttons of antimony metal can be retrieved.

"Purification and the 'rising of the star':

"Grind the metallic antimony coarsely, and add to it 2.5 g. of potassium nitrate. Mix well, and place the mixture into a crucible, cover, and heat. When the material is molten, pour it out into another crucible, allow the metal to cool, separate the golden slag by either chipping or washing it away, and take the metal. Repeat this operation using another 2.5 g. of potassium nitrate. Repeat the operation one last time, and when the mixture is completely molten (it will look like quicksilver with oil floating on it) pour it quickly into a hot crucible and cover it immediately.

"Let it cool slowly, and then use hot water to wash away the whitish slag. The star, sometimes looking more like a fern, will be clearly visible on the surface of the metal (wherever it was covered by the slag while cooling). (Note: the larger the quantity of metal, the better the star will appear.)

"Note: the fumes of volatile white antimony oxide which are given off whenever the material is molten, are toxic. Work in good ventilation, such as a fume hood."

2. Vladimír Karpenko, "The Chemistry and Metallurgy of Transmutation," *Ambix* 39 no. 2 (1992): 47–62, especially 56–59.

3. From *A Compendium of Alchemical Processes* (York Beach, Maine: Samuel Weiser; and Denington Estate, Wellingborough, Northhamptonshire: Aquarian Press, 1981 [1894]), in the section "Some Modern Alchemical Experiments," 18–19.

4. This recipe is from Lawrence Principe (personal communication, 1991); I have altered his description slightly and added the symbols. Mosaic gold is also called *aurum musitum, aurum musicum,* and Porporina.

5. Principe adds: "Note: exercise extreme caution in carrying out this process. Mercury and its compounds are all extremely poisonous. Do not touch the mercury or mercury-tin alloy with bare hands. The heating must be carried out in a fume hood, as toxic fumes are released. Dispose of the broken glass safely, as mercury compounds will be adhering to it."

6. *The Strassburg Manuscript: A Medieval Painter's Handbook,* translated by Viola and Rosamund Borradaile, foreward by John Harthan (London: Alec Tiranti, 1966), 27 and 95 n. 21, with a reference to Cennino Cennini.

7. Jean [Jan]-Baptise Van Helmont, *Ortus medicinæ* (Amsterdam: Ludovico Elzevir, 1648), quoted in Jacques Sadoul, *Alchemists and Gold,* translated by O. Sieveking

(London: Neville Spearman, 1972), 138–39. *Ortus medicinæ* appeared in English in *Van Helmont's Works,* translated by John Chandler (London: Printed for Lodowick Lloyd, 1662).

8. Abraham von Frankenburg, *Raphael oder Artzt-Engel* (Amsterdam: Jacob von Felsen, 1676), 45. Frankenburg is discussed in my *Domain of Images: The Art Historical Study of Visual Artifacts* (Ithaca: Cornell University Press, forthcoming).

9. Philalethes, "A Brief Guide to the Celestial Ruby," *op. cit.,* p. 249, also quoted in John Read, *Prelude to Chemistry, An Outline of Alchemy, its Literature and Relationships* (New York: MacMillan, 1937), 129.

10. The Philippine tree is *Pterocarpus indica,* Burmese rosewood. D.J. Mabberly, *The Plant Book* (Cambridge: Cambridge University Press, 1987). I thank Curtis Bohlen for this reference.

11. *Lumen Novum Phosphoris Accensum* (Amsterdam: Joannem Oosterwyk, 1717), title page.

12. Johann Heinrich Schulze, *Scotophorus pro phosphoro inventus, seu experimentum curiosum de effectu radiorum solarium,* Acta physico-medica Academiæ Cæsareæ Leopoldino-Carolinæ naturæ curiosum, vol. 1, obs. CCXXXIII (Nürnberg: Prostat in Officina W.H. Endteriana, 1727), reprinted, with a German translation, in J.M. Eder, *Quellenschriften zu den frühesten Anfangen der Photographie bis zum XVIII. Jahrhundert* (Halle: s.n., 1913). Schulze is cited, for example, in Helmut and Alison Gernsheim, *A Concise History of Photography* (New York: Grosset and Dunlop, 1965), 16. I thank Jim Hugunin for this reference. In good alchemical fashion, urine was often used as a source of phosphorus; see, for example, Petrus Nicolaus Lotrichius, *Dissertationem physico-medicam inauguralem de phosphorus et phosphoro urinæ* (Leiden: Apud Gerardum Potvliet, 1757).

13. Antoine-Joseph Pernety, *Dictionnaire mytho-hermétique* (Paris: s.n., 1758), 272. A few are given in Read, *Prelude to Chemistry, op. cit.,* 128.

14. This is stressed in Read, *Prelude to Chemistry, op. cit.,* 110, 129, 133, following George Ripley, *The Compound of Alchymy* (London: Thomas Orwin, 1591 [c. 1471]), reprinted (Amsterdam: Theatrum Orbis Terrarum, 1977).

15. Basil Valentine, *Von den Natürlichen und ubernatürlichen Dingen. Auch von der ersten* Tinctur, *Wurtzel und Geiste der Metallen und Mineralien,* edited by Johann Tholden (Leipzig: Bartholomæus Voigt, 1624), 26.

16. E.H. Gombrich, *Art and Illusion* (Princeton: Princeton University Press, 1960).

17. Richard Wollheim, *Painting as an Art* (Princeton: Princeton University Press, 1987).

18. The painting is assigned to Tintoretto's workshop, or said to be done with his collaboration, by two out of twelve scholars cited in Fern Rusk Shapley, *Catalogue of*

the Italian Paintings [in the National Gallery of Art, Washington] (Washington, DC: National Gallery of Art, 1979), vol. 1, 372. Shapley also thinks it is partly the work of assistants. I side with Longhi, Berenson, Venturi, Suida, and others that it is Jacopo's work.

19. Balduinus, *Aurum superius & inferius auræ superioris & inferioris hermeticum* (Frankfurt and Leipzig: Georg Heinrich Frommann, 1675).

20. Johannes Fabricius, *Alchemy: the Medieval Alchemists and their Royal Art* (Copenhagen: Rosenkilde and Bagger, 1976), 160.

NOTES TO CHAPTER 9

1. Burggrav, *Lampadem vitæ et mortis omniumque graviorum in microcosmo pathon indicem, hoc est, Biolychnium sive luceman* (Leiden: Arnold Doude, 1678), with two engravings. John Ferguson, *Bibliographical Notes on Histories of Inventions and Books of Secrets* (London: Holland Press, 1959), part 4, p. 34, points out that the original is in Christopher Irvine, *Medicina magnetica, Or, The Rare and Wonderful Art of Curing by Sympathy* ([Edinburgh:] C. Higgins, 1656), 98, and that the story also appears in Albertus Magnus der Andere [pseud.], *Das Ist: Geheimnisse der Nature und Kunst vor alle Stände, also für Künstler, Jäger, Oekonomen, Professionisten, Handwerker &c* (Altona and Leipzig: Johann Heinrich Kaven, 1797).

2. Robert Pool, "Alchemy at Texas A & M," *Science* 262 (26 November 1993): 1367.

3. Vladimír Karpenko, "Coins and Medals Made of Alchemical Metal," *Ambix* 35 (1988): 65–76. It is easy to turn a copper penny into silver or gold. Put 5 g of zinc dust in a dish; dissolve 240 g NaOH in 1 liter of water, add enough to cover the zinc, and heat to near boiling. A thoroughly cleaned copper penny (minted before 1980), dipped into this mixture, will turn silver. If the penny is dried and put on a hot plate, it will turn gold. The first step only coats the penny in a silvery sodium zincate, and the second step bonds the zinc with the copper to make a golden brass alloy.

4. Reported in Kurt Karl Doberer, *The Goldmakers, 10,000 Years of Alchemy,* translated by E.W. Dickes (London: Greenwood, 1948), reprinted (Westport, CT: Greenwood, 1972).

5. Georges Bohn, "Quelques souvenirs sur Charles Henry," *Cahiers d'Etoile* (Paris, 1930), 74 ff. The quotation is from Sven Lövgren, *The Genesis of Modernism* (Stockholm: Almqvist & Wiksell, 1959), 68; revised edition (Bloomington, IN: Indiana University Press, 1971), 87.

6. C. Louis Kervran, *Biological Transmutations* (London: Crosby Lockwood, 1972), esp. 3 ff.; the original is *À la découverte des transmutations biologiques* (Paris: Le Courrier du Livre, 1966).

7. *Ibid.*, discussed in Hans Gebelein, *Alchimie* (Munich: Diederichs, 1991), 350 ff. The equation is $^{14}_{7}N + ^{14}_{7}N \rightarrow ^{12}_{6}O + ^{16}_{8}O$.

8. Louis-Nicolas Vauquelin (c. 1799), cited in Kervran, *Biological Transmutations, op. cit.*, 45 ff.

9. See the section on alchemists in Charles Mackay, *Memoirs of Extraordinary Popular Delusions*, 2 vols. (London: Richard Bentley, 1841), reprinted (s.l.: L.C. Page & Company, 1932).

10. Croll, *D.O.M.A.*. . . . *Chymisch Kleynod* (Frankfurt, 1647), 72, fig. 8, and 73.

Index